WHY
YOUR
FIVE
YEAR
OLD
COULD
NOT
HAVE
DONE
THAT

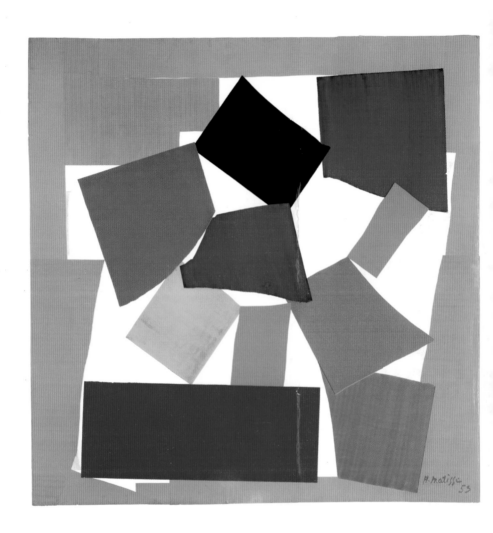

WHY YOUR FIVE YEAR OLD COULD NOT HAVE DONE THAT

MODERN ART EXPLAINED

Thames & Hudson

Susie Hodge

CONTENTS

CHAPTER ONE
OBJECTS / TOYS
10

CHAPTER TWO
EXPRESSIONS / SCRIBBLES
54

INTRODUCTION
SUSIE HODGE

In 1563 in Florence, encouraged by the artist, architect and writer Giorgio Vasari, Cosimo I de' Medici, the Grand Duke of Tuscany, founded the first academy of art, the Accademia e Compagnia delle Arti del Disegno (Academy and Company for the Arts of Drawing). For the first time, a consistent standard for the teaching of art was established. Vasari believed that true art was the faithful imitation of nature, enhanced with an ideal form that portrayed 'grace and decorum', and recommended that students learn practical artistic techniques, accompanied by lectures on anatomy and geometry. These classes he called the 'arti del disegno', and the approach was based on the practices of High Renaissance masters, especially Leonardo da Vinci, Michelangelo and Raphael.

Fourteen years after the founding of the Florentine academy, the Accademia di San Luca opened in Rome. This school subsequently became the model for the Académie Royale de Peinture et de Sculpture, established in Paris in 1648, which was later renamed the Académie des Beaux-Arts. Across Europe numerous other art academies opened; they all offered to educate art students according to Vasari's 'arti del disegno' and sought to create a clear distinction between fine artists

and craftsmen engaged in manual labour. For several centuries, students studied the intellectual elements of art and followed rigid rules and conventions concerning aesthetics, drawing, perspective, composition and paint application, as well as the shaping of bronze or marble.

After the invention of photography in 1839, some artists began to question the need for rigid adherence to pictorial accuracy because cameras could do a similar job with much less effort. It was not easy to defy the rules of the academies, and most 19th-century artists who tried met with huge opposition. However, they were not deterred, and from the 1870s to the beginning of World War II, as capitalism and commercialism encroached upon many societies, radical and momentous changes occurred in the art world. Based on the belief that art could express human experience and need not imitate nor represent natural objects or events, the accepted understanding of what art was began to alter.

As the rules that had been imposed upon art students by the academies were increasingly flouted, creative approaches and interpretations began to diversify enormously. Technology continued to develop rapidly, and events such as the two world wars had an even greater impact on the art world. Art always reflects the significance of its time, and from the early 20th century numerous art movements emerged. These were either labelled by others (often derogatively) or expressly proclaimed in manifestos written by groups of revolutionary young artists who sought to trounce old academic traditions and create a brave new art world. The earliest movements included Futurism, Expressionism and Dada, whereas later movements included Abstract Expressionism, Minimalism and Arte Povera. As each movement proliferated, it was pilloried by the academies, critics, other artists or the public—but the spirit of rebellion continued. Dada, in particular, was an 'anti-art' movement. It emerged as a direct reaction to the atrocities of World War I and the hypocrisies

of the societies that allowed it to happen, and was designed to shock, enrage and unsettle. More than any other movement, Dada influenced the development of art in the 20th century, and made irreverence, the use of banal materials and an absence of logic recurrent components in a great many modern artworks. Alongside these changes in objectives, the interaction of the viewer with the work became more important. No longer were people expected to look at art passively: they were invited to reconsider their understanding of what constituted art, to form new opinions and even to become part of the artwork itself.

Currently, a large proportion of artists work autonomously, and fewer art movements are emerging than during the 20th century. Moreover, many critics continue to regard an absence of technical skill as a lack of artistic sophistication and ability. Because the art of ideas can be more difficult to appraise than art that directly imitates the world, it is often easily dismissed as nothing more than the equivalent of the untutored efforts of children. For so long, appreciating art was simple: the viewer looked at it, recognized and understood it, and marvelled at the skill of the hand that created it. When there is little or no obvious skill involved, or when the materials used are objects similar to those that are discarded as rubbish, viewers' reactions frequently range from hostility and anger to scorn and derision. Condemnation of the audacity of an artist who exhibits an empty room with a light being switched on and off, or who displays a spin painting traditionally made by children, is widespread. However, artists such as Martin Creed, with *Work No. 227: The Lights Going On and Off,* and Damien Hirst, with his spin paintings, have thoughtful and multilayered motives behind their work.

Many of the artists featured in *Why Your Five Year Old Could Not Have Done That* reflect on their own cultures and the societies in which they live. They explore fundamental issues such as society's pluralism,

inherent conflicts between spiritual and civil life, and the effects of consumerism and accountability. The result is not always comfortable, and often reveals unsettling truths or unresolvable contradictions.

The art that has been selected for this book—one hundred works by one hundred artists, produced from the end of the 19th century to the present day—includes such well-known works as *The Scream* by Edvard Munch and *The Snail* by Henri Matisse, along with less familiar works such as *Full-Up* by Arman or *Corner Piece* by Lynda Benglis. As the traditional hierarchies have been pushed aside, many modern artists cannot be classified neatly. However, this book reveals the origins of their individual influences, including prevailing art movements and world or local events, and those whom the artists subsequently inspired. From Conceptualism to New Media Art, from Colour Field to Fluxus, and from Post-painterly Abstraction to Post-Dada, various pertinent art movements are discussed in order to form an overall picture of the development of art.

Organized into five chapters—'Objects/Toys', 'Expressions/Scribbles', 'Provocations/Tantrums', 'Landscapes/Playscapes' and 'People/Monsters'— the featured works of art are enormously varied. In 'Objects/Toys', for example, Gabriel Orozco's *Horses Running Endlessly* could at first be mistaken for a board game, whereas the photomontage by Hannah Höch in 'Expressions/Scribbles' resembles a child's scrapbook but reflects on the situation in Weimar Germany. Notorious works such as Tracey Emin's *My Bed*, Carl Andre's *Uncarved Blocks* and *Vertical Roll* by Joan Jonas are explained in terms of the ideas and objectives behind them, thereby clarifying the intentions of the artists. Each entry discusses artistic approaches and implications, thus drawing attention to the sophistication and often complex endeavours behind the work. Although some of the featured artworks might easily be copied, none could have been devised by a five-year-old child.

GUIDE TO SYMBOLS

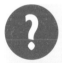
Explains why the artwork could not have been created by a five-year-old child.

Describes the artist's approach, process and technique.

Locates the artwork in its historic and artistic context.

Details the specification and location of the artwork.

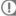

Provides additional incidental information.

Lists examples of similar artworks and their locations.

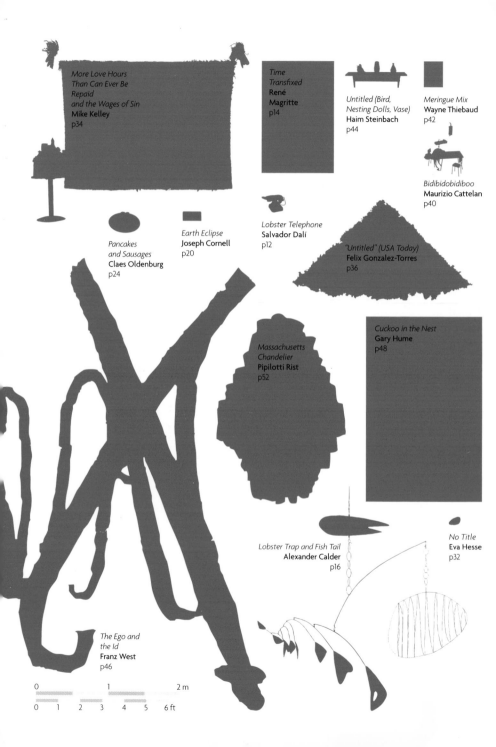

*More Love Hours
Than Can Ever Be
Repaid
and the Wages of Sin*
Mike Kelley
p34

*Time
Transfixed*
**René
Magritte**
p14

*Untitled (Bird,
Nesting Dolls, Vase)*
Haim Steinbach
p44

Meringue Mix
Wayne Thiebaud
p42

Bidibidobidiboo
Maurizio Cattelan
p40

*Pancakes
and Sausages*
Claes Oldenburg
p24

Earth Eclipse
Joseph Cornell
p20

Lobster Telephone
Salvador Dalí
p12

"Untitled" (USA Today)
Felix Gonzalez-Torres
p36

*Massachusetts
Chandelier*
Pipilotti Rist
p52

Cuckoo in the Nest
Gary Hume
p48

No Title
Eva Hesse
p32

Lobster Trap and Fish Tail
Alexander Calder
p16

*The Ego and
the Id*
Franz West
p46

0 1 2 m

0 1 2 3 4 5 6 ft

CHAPTER ONE
OBJECTS / TOYS

The rise of capitalism and commercialism over the last century has frequently inspired artists to express either their disquiet or their approval. Many of the artworks in this chapter were created for that purpose: to reflect on consumerism and industrialism. From Salvador Dalí's *Lobster Telephone* to Dan Flavin's *'Monument' for V. Tatlin*, from Giovanni Anselmo's *Structure That Eats Salad* to Pipilotti Rist's chandelier, the works featured here often call into question the nature of art in society, the effects of materialism and the reactions of viewers.

Although ousted by the Surrealists in 1939, Dalí continued to create surreal works in paint, sculpture, print, film and fashion, and advertising, collaborating with the likes of Elsa Schiaparelli and Alfred Hitchcock. His incessant self-promotion intensified the notion of the artist as genius.

Salvador Dalí (1904–89) invented what he called his 'paranoid-critical' method, based on Freudian theories. To achieve this, he claimed that he induced himself into a hallucinatory state to gain greater access to his unconscious mind. Whatever his method, his resultant creations—with their bizarre associations and optical illusions, such as this plaster lobster telephone handset— were quite astonishing. Deceptively simple, the idea is loaded with symbolism and sexual connotations. Dalí produced five coloured versions and six white varieties. Made for Edward James, the most active collector of Surrealist art in the 1930s, and intended to provoke strong reactions, the telephone was designed so that the lobster's sexual organs would align with the speaker's mouth. The idea came from Dalí's writing about lobsters and telephones in his book of 1936, *The Secret Life of Salvador Dalí*: 'I do not understand why, when I ask for a grilled lobster in a restaurant, I am never served a cooked telephone.' The result is an object that is both teasing and unsettling, reflecting Dalí's flamboyant self-assurance.

LOBSTER TELEPHONE
SALVADOR DALÍ
1936

mixed media, including
steel, plaster, rubber,
resin and paper
18 x 33 x 18 cm
(7⅛ x 13 x 7⅛ in.)
Tate Collection,
London, UK

The best known of all the Surrealists, Dalí forged a colourful path through the 20th-century art world with his recognizable, meticulous, imaginative works and his controversial and unconventional behaviour. He painted with smooth, glossy, oil paint and imperceptible brushstrokes. His three-dimensional works, too, relied on realism to unsettle and provoke.

André Breton, the founder of Surrealism, nicknamed Dalí 'Avida Dollars', which means 'greedy for dollars' and is an anagram of Salvador Dalí. Dalí loved the nickname and used it frequently.

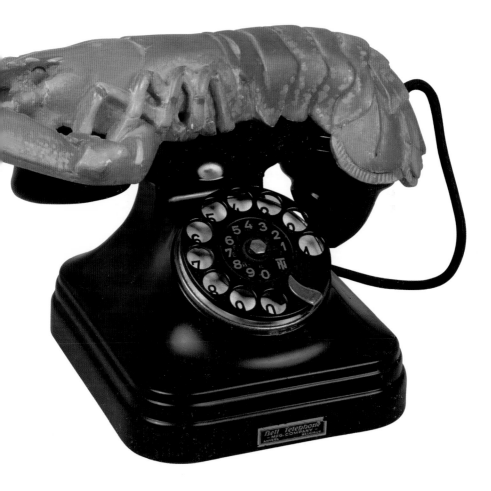

In the early 1930s, Dalí began creating Surrealist objects, believing that they could uncover unconscious secret yearnings in us all. Although a child could have stuck a plastic lobster on a telephone, Dalí's artwork is a witty play on an everyday object and it illustrates his beliefs about the connections between food and sex.

The Memory of the Woman-Child, 1929
Museo Reina Sofía, Madrid, Spain

Soft Construction with Boiled Beans (Premonition of Civil War), 1936
Philadelphia Museum of Art, PA, USA

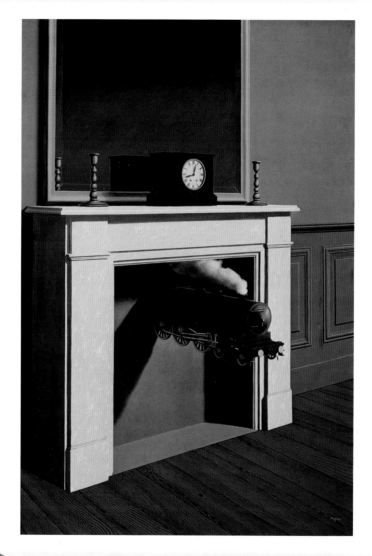

In *Time Transfixed*, using an absurd juxtaposition of objects, Magritte depicts time suspended in a bizarre and improbable situation. Children frequently paint disparate objects together, but without investigating visual riddles or asking viewers to reconsider their preconceptions about familiar objects. Furthermore, no child could possibly reproduce Magritte's meticulous and realistic painting style, which he developed throughout his career as a commercial artist.

TIME TRANSFIXED
RENÉ MAGRITTE
1938

Into the stillness of a sparsely furnished, panelled room, a miniature steam locomotive hurtles out of a fireplace, its smoke floating back up the chimney. A clock and candlestick are reflected in a mirror over the mantelpiece, while another candlestick has no reflection. The original title of this work, *La Durée Poignardée* (literally, *Ongoing Time Stabbed by a Dagger*), was translated into English as *Time Transfixed,* but René Magritte (1898–1967) was dissatisfied with the title. The work was painted for Edward James, a regular patron of the Surrealists, many of whom Magritte had befriended in Paris. Magritte intended the painting to be displayed at the bottom of a staircase at James's home, so that the train would appear to stab guests as they passed, but it never was. Twenty years later, rejecting critics' elaborate interpretations, he explained that the painting was simply exploring enigmas. With its conflicting scales, unexpected juxtapositions and illogical placements, *Time Transfixed* demonstrates Magritte's personal view of the ambiguities and absurdities of existence. It also demonstrates his belief that no matter how realistically an artist might portray something, it could only ever be a representation.

Magritte's highly realistic style, with its precise, hard definitions rather than soft, graduating tonal contrasts, enhanced the effects of his play on reality and illusion. In order to exploit ambiguities, he repeatedly painted many of his motifs, and made Surrealist versions of several well-known paintings, including some by Jacques-Louis David and Edouard Manet. From the 1960s, he inspired younger artists, including Ed Ruscha, Jasper Johns, Jan Verdoodt and Storm Thorgerson, and has been hugely plagiarized in mass media.

oil on canvas
147 x 98.5 cm
(57¾ x 38¾ in.)
Art Institute of Chicago,
IL, USA

In 1924, the poet André Breton published the *Manifesto of Surrealism*. Surrealism was the most influential avant-garde movement of the interwar years, inspired by Freud's psychological research into the unconscious—a part of the human mind where memories and basic instincts are stored. Artists such as Dalí and Magritte produced 'super-real' paintings that synthesized rationality and irrationality.

L'Idée Fixe, 1928
Staatliche Museen Preussischer Kulturbesitz, Nationalgalerie, Berlin, Germany

La Condition Humaine, 1933
National Gallery of Art, Washington, DC, USA

Golconda, 1953
The Menil Collection, Houston, TX, USA

Calder became a leading exponent of Kinetic art, which had been conceived by the Russian Constructivists in 1915. Their influence is evident in his earliest mobiles, but he was also inspired by Dada, Miró's automatism and Mondrian's rhythmic clarity. He declared: 'Art is too static to reflect a world in motion.'

LOBSTER TRAP AND FISH TAIL

ALEXANDER CALDER

1939

Created to hang in a stairwell at the Museum of Modern Art in New York, this is one of the earliest mobiles by Alexander Calder (1898–1976), and it demonstrates the qualities that launched his international reputation. Intended to form biomorphic shapes as it twists and twirls, the mobile simulates the flowing, continuous movement of underwater life. Having trained as a mechanical engineer—later producing paintings, lithographs, toys and household objects—Calder challenged all sculpture's conventions with this work, which responds to the faintest air currents. His ideas developed through his associations with avant-garde artists, including Joan Miró, Fernand Léger, Marcel Duchamp and, in particular, Piet Mondrian, whom he met in 1930. Describing all his mobiles as 'four-dimensional drawings', he aimed to reinterpret the geometrical abstract work of Miró and Mondrian, but, unlike static, two-dimensional paintings, his sculptures generate changing outlines, spaces, shapes and colours as air circulates around them. Although Calder advocated no intricate theory about this work, he intended the unpredictability of pattern and movement that occurred with the finely balanced system to represent the perpetual motion of the universe and the changing physical relationships that take place between all objects.

After visiting Mondrian's studio, Calder declared he would make 'moving Mondrians'. With its few colours and shapes, this work also bears a striking resemblance to a Miró painting. For the first time, art did not merely suggest movement, it instigated it.

painted steel
wire and sheet
aluminium
260 x 290 cm
(102⅛ x 114 in.)
Museum of
Modern Art,
New York, USA

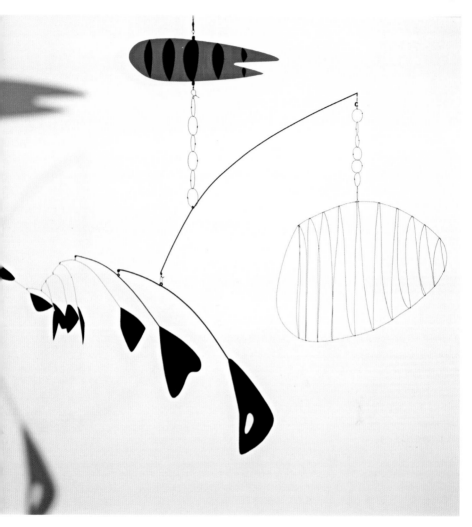

A child could probably make something that resembled this mobile, but Calder's deceptively simple-looking construction was unique, huge, complex and designed with engineered precision. Representing a lobster and a school of fish, the work is meticulously balanced and created specifically to move constantly, producing spontaneous patterns and even sounds to illustrate the random nature of reality.

Mobile, c. 1932
Tate Collection,
London, UK

Mobile (Arc of Petals), 1941
Solomon R.
Guggenheim
Museum, New
York, USA

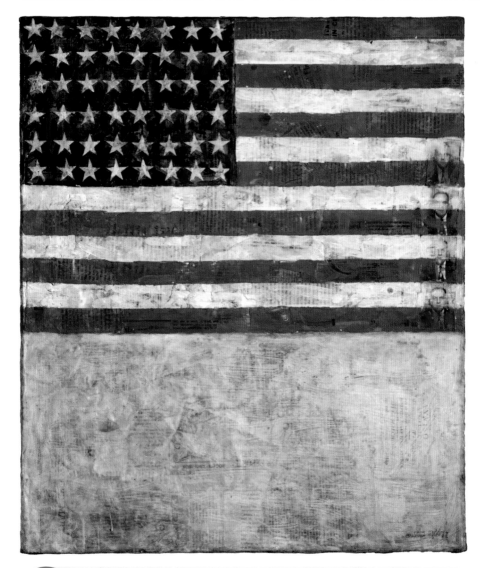

With agitated, textural brushmarks and colour purposefully devoid of tonal contrast, this picture appears to be simple enough for a child to undertake. However, the work is projected as a puzzle posed to viewers, questioning whether aesthetic value is inherent in any particular object, or whether it can only be bestowed by an artist through his or her personal execution and presentation.

FLAG ABOVE WHITE WITH COLLAGE
JASPER JOHNS
1955

Both a painter and a constructor of objects, Jasper Johns (1930–) rejected what he perceived as painterly deception to create art that could be viewed as a reality in itself. He began producing canvases such as *Flag above White with Collage* from the mid-1950s. At the time, several artists were searching for new ideas to succeed the impassioned approach of the Abstract Expressionists. Johns painted this work to combine a serious concern about the craft of painting and the relevance of subject matter. The significance of the painting is in the process itself. Simultaneously light-hearted and challenging, realistic and inventive, straightforward and multifaceted, it presents a paradox. The canvas appears two-dimensional, while brushstroke inflections resemble the methods of masters such as Paul Cézanne. In denying almost all individual assertion and detaching himself from any symbolic connotations, Johns encourages viewers to make up their own minds. The directness of the presentation neutralizes the image (no tonal contrast, a frontal view), while the articulate, painterly treatment creates the epigram intended. In his other works of familiar objects, he poses further riddles: Is this a flag or a copy of one? Is it a work of art? Does it matter? Teasingly thought-provoking and made during the Cold War, this work emerged through Johns's engagement with contemporary artistic debates.

An accomplished painter, printmaker and sculptor, Johns said he 'learnt what an artist was' from Robert Rauschenberg, and was stimulated by the gestural style of Willem de Kooning and by collaborations with composer John Cage and choreographer Merce Cunningham. One of his greatest influences was the philosopher Ludwig Wittgenstein, particularly his concerns with logic and its breakdown.

Johns and Rauschenberg first met in New York City in 1954 when they were both employed to decorate Tiffany's shop window.

encaustic on canvas
57 x 49 cm (22⅜ x 19¼ in.)
Kunstmuseum Basel,
Basel, Switzerland

Three Flags, 1958
Whitney Museum of American Art, New York, USA

Painted Bronze (Ballantine Ale), 1960
Kunstmuseum Basel,
Basel, Switzerland

From the 1950s, Johns, along with Robert Rauschenberg, led US art away from Abstract Expressionism and, with his use of well-known iconography, laid the foundations for Pop art and Minimalism, although he is also often described as a Neo-Dadaist.

EARTH ECLIPSE
JOSEPH CORNELL
c. 1960

Without formal art training, Joseph Cornell (1903–72) became known for his numerous boxed assemblages that reflect his broad interests encompassing the arts, humanities and sciences. *Earth Eclipse* demonstrates the curiosity he felt about what he called 'geographics of the heavens'. Like a museum exhibit, the box contains assorted and carefully placed items and photographs that convey the mysterious and magical aura felt by many during an eclipse. Literal illustration was never Cornell's intent. Instead, the boxes communicate what he called his 'explorations' of poetic connections, revealing meanings, tensions and links between disparate or analogous objects. He described these assemblages as 'poetic theatres', after Victorian miniature theatres, or 'shadow boxes'. In *Earth Eclipse*, he created an environment designed to incite curiosity and contemplation about the physical and spiritual relationships between humankind and nature. His work was sometimes described as a cross between Constructivism and Surrealism, and he particularly admired the Dada and Surrealist artists Marcel Duchamp, Max Ernst and Kurt Schwitters. Like Schwitters, Cornell aimed to create poetry out of commonplace or found materials. Unlike Schwitters, however, he was fascinated not by discarded rubbish but by fragments of once beautiful and often precious objects. In representing the Earth seen from space, *Earth Eclipse* expresses Cornell's belief that artists can transform mundane materials, experiences and ideas into extraordinary and evocative works of art.

wood, glass, steel, plaster, blue sand and photograph
12.5 x 25.5 x 8 cm (5 x 10 x 3⅛ in.)
Israel Museum, Jerusalem, Israel

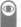

Cornell is recognized as a forerunner and pioneer of assemblage, a term used commonly after the 1950s to describe art that has been created using found objects. Strongly influenced by both the fantasies of Surrealism and the restraint of Constructivism, his small, glass-fronted boxes allow colour, form, texture and light to work together in order to display intangible themes such as memory, fantasy and dreams.

Untitled (Soap Bubble Set), 1936
Wadsworth Atheneum, Hartford, CT, USA

Object (Roses des Vents), 1942–53
Museum of Modern Art, New York, USA

Although children might collect bric-a-brac and photographs in boxes, none would be able to group and display them as Cornell did, balancing light, texture and form specifically to invoke metaphorical ideas or associations. Finding his objects in the bookshops and thrift stores of New York, Cornell carefully selected and arranged everything with great precision in his small, usually glass-fronted wooden boxes, in order to create the correct impact, triggering viewers' thoughts and reminiscences about such things as journeys, time, the planets, fantasies, dreams and peace.

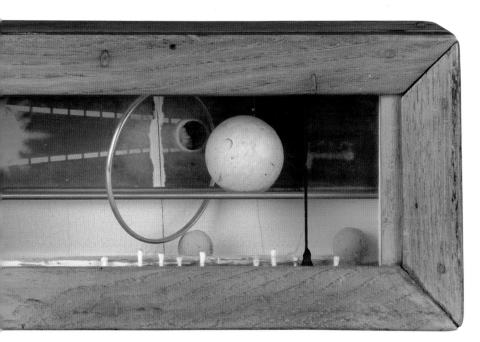

'Beauty should be shared, for it enhances our joys. To explore its mystery is to venture towards the sublime,' said Cornell in describing the boxes he created to inspire viewers to explore their imaginations and spirituality. His lyrical, unexpected arrangements, materials and ideas were often linked to Surrealism, particularly their emphasis on dreams and memories.

From the 1930s to the 1950s, Cornell made short films in which he experimented with sequencing—cutting and juxtaposing images to create innovative collage effects similar to his boxes.

? That destruction can be repackaged as entertainment
is something that often appeals to a childish sense of
humour, as seen in many early slapstick movies and
cartoons. Swiss-born Tinguely considered this when he created
Homage to New York, appreciating that the joke would be almost
universally amusing. However, no child would have created this
work with the same intentions as Tinguely, because he aimed to
satirize the fallibility and unpredictability of machines and our
reliance on them, and to register the indulgent attitude that
society had developed and still maintains towards violence.

ⓘ found objects
8.2 m (27 ft)
Museum of
Modern Art,
New York, USA

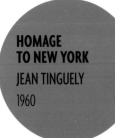

HOMAGE TO NEW YORK
JEAN TINGUELY
1960

'The only thing that remains constant is change,' declared the 17th-century French writer François de la Rochefoucauld. Agreeing with the sentiment, Jean Tinguely (1925–91) began producing objects that involved movement, mainly in humorous and eccentric machines. *Homage to New York* is his best-known work, made in collaboration with the electrical engineer Billy Klüver from recycled scraps of metal found in a rubbish dump. Created to operate in sequence for thirty minutes before self-destructing, it was presented in the sculpture garden of the Museum of Modern Art in New York in March 1960. However, things did not go to plan: it failed to destroy itself, and instead caught fire and had to be brought under control by the fire brigade. Hailed by the press as a 'gadget to end all gadgets', a 'lunatic show' and a 'doomsday machine', the presentation had started well: the work self-ignited, played notes on a piano, spooled out rolls of text, and exploded stink bombs, but then went wrong. It evoked a range of responses from the invited audience. Some saw it as a comment on the threat of nuclear catastrophe; others regarded it as pure entertainment. Tinguely merely proclaimed: 'You cannot expect the world to end the way you want it to.'

Through his explorations of perception and ridicule of technology, Tinguely created bizarre and unpredictable sculptural machines, or Kinetic art, which were officially called 'metamechanics' (artworks that move). Usually involving some sort of mechanism or magnet, his work was never static, so viewers would always see different aspects no matter how often they looked at it. Lively, witty and satirical, he was labelled by a French critic as a 'New Realist', which grouped him with other artists who were not defined by a coherent style, but who incorporated consumer objects into their work and considered notions about the burgeoning, industrialist French consumer society.

In the late 1950s, several films were made in the United States about nuclear bombs. In his machine, Tinguely was remarking on the anaesthetic effect such films were having on the public's perception of violence and destruction. It instigated several ideas by younger artists, particularly Michael Landy, who was inspired by Tinguely's belief in New York's energy and ability to regenerate itself.

Wundermaschine, Meta-Kandinsky 1, 1956
Museum Tinguely, Basel, Switzerland

White Moving Forms on Black Background, 1957
Solomon R. Guggenheim Museum, New York, USA

Meta-Matic No. 17, 1959
Moderna Museet, Stockholm, Sweden

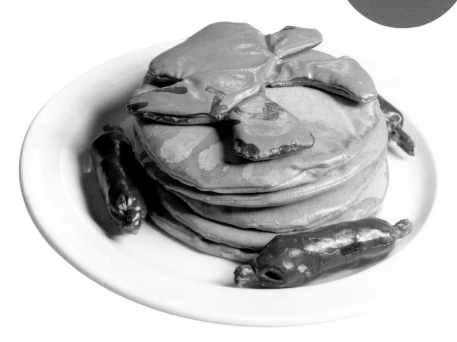

PANCAKES AND SAUSAGES
CLAES OLDENBURG
1962

Since 1962, Oldenburg has investigated issues of mass production, fast food culture and the approbation of mundane objects in developed societies. This soft structure, which alludes to the rise of consumerism, contradicts all accepted rules of traditional sculpture. A child could make a pretend plate of food but would not be able to incorporate the subtle implications or the strands of humour, creativity and reality that are inherent in this piece.

stuffed canvas painted with enamel on china plate
12 cm (4¾ in.) high
28 cm (11 in.) diameter
Private collection

Swedish-American Pop artist Claes Oldenburg (1929–) gained inspiration through exploiting differences between high and mass culture, usually by creating colourful, often oversized and teasing imagery of consumer merchandise. In 1961, a year before he created *Pancakes and Sausages,* he opened 'The Store' in New York's East Side, where he sold plaster replicas of fast foods and junk goods, whose roughly painted surfaces appeared to parody Abstract Expressionism. He used the front section of The Store as a gallery and the back as his studio, saying, 'I like to take a subject and deprive it of its function completely.' Full of humour and irony, *Pancakes and Sausages*, which is made of canvas, stuffed with foam and painted in vivid colours, comments on society's growing reliance on convenience foods and also questions what constitutes a work of art. Oldenburg's main point is that art should be accessible to all. Before becoming an artist, he worked in magazine design and illustration, and gained valuable insights into the expectations of society. Exuberant and irreverent, this 'soft sculpture' dismantles all accepted artistic conventions. It also reflects on US society in particular, while remaining apparently objective in the absence of personal style. Never against consumerism itself and never intimidating, Oldenburg encourages viewers to reconsider high and low culture simultaneously—both the snobbery of the first and the tackiness of the second, as well as the merits and enjoyment of both.

Oldenburg was one of the most original and surprising of the Pop artists. His art reflected a feeling of optimism during the consumer boom of the 1950s and 1960s, which coincided with the globalization of pop music and youth culture. His literally interpreted, highly recognizable and frequently comical works play with contradictions, expectations and paradoxes, confounding viewers with their altered scales or textures and often relaying witty and perceptive observations of consumer society.

Oldenburg made his work out of everyday experiences, which he claimed to find 'perplexing and extraordinary'.

Pop art was partially a reaction against Abstract Expressionism, which many felt had become too introspective and elitist. This work can also be seen as a 20th-century interpretation of Dutch still life paintings, with their detailed and skilful depictions of food. Some years before, Pablo Picasso had laid the foundations of Pop art by incorporating everyday elements into his art.

Floor Cake, 1962
Museum of Modern Art, New York, USA

Soft Toaster, 1964
Allen Art Museum at Oberlin College, OH, USA

Soft Drainpipe, 1967
Tate Collection, London, UK

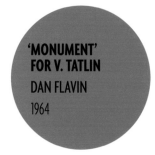

'MONUMENT' FOR V. TATLIN
DAN FLAVIN
1964

The first of thirty-nine 'monuments' that Flavin created in homage to the Russian artist Vladimir Tatlin, this structure reflects the detached and objective approach of Minimalism that emerged in New York in the early 1960s. Flavin's 'light sculptures' follow Minimalist ideals of avoiding personal style and expressiveness, such as metaphorical associations, symbolism and suggestions of spiritual transcendence. Overlapping with Kinetic art, it also picks up on some ideas developed by László Moholy-Nagy, who experimented with artificial light in the first part of the 20th century.

fluorescent lights and metal fixtures
244 x 59 x 11 cm
(95⅞ x 23⅛ x 4⅜ in.)
Museum of Modern Art, New York, USA

Pink out of a Corner (to Jasper Johns), 1963
Museum of Modern Art, New York, USA

Alternate Diagonals of March 2, 1964 (to Don Judd) 2/3, 1964
Dallas Museum of Art, Dallas, TX, USA

By calling his work 'situational', Dan Flavin (1933–96) clarified that he never intended it to be permanent. He also ensured that it was devoid of personal expression. This precise arrangement of fluorescent light fittings was a tribute to Vladimir Tatlin's unrealized tower of 1920, *Monument to the Third International*. Flavin's work, the first of thirty-nine variations assembled between 1964 and 1990, is ironic. Firstly, Tatlin embraced several technological advances in his spiral tower design, whereas Flavin's medium of mass-produced lights in a flat arrangement ignores complexities of form or technology. Secondly, since the fluorescent lighting would eventually burn out, it contrasted with the enduring nature of monuments. Thirdly, the relatively small scale of the staggered composition was in direct contrast to Tatlin's ambitiously large, soaring tower that linked art with technology, supporting Lenin's Plan for Monumental Propaganda. Although the utopian ambitions of the Russian Constructivists were never attained, their art and philosophy fascinated Flavin. Utilizing geometric forms and industrial materials, he gave viewers the chance to broaden their conceptions of what constitutes art by reconsidering traditional elements—line, space, colour, tone, shape and form—as the work appears to dissolve boundaries and alter the physical space it occupies.

Minimalism emerged as a reaction against the 'self-indulgence' of Abstract Expressionism, and marked a renewed interest in Constructivism and Suprematism. In its emphasis of the use of industrial materials over craft techniques, Flavin's work acknowledges the revolutionary ideals of Russia, uniting art and science.

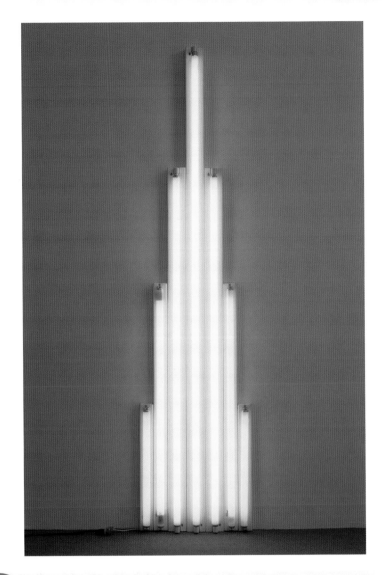

Although children could lean fluorescent lights against a wall, they would not ask viewers to reconsider several things at once, including the function of objects, philosophical ideals first cited in Russia in 1915 and the gallery space itself. By reducing his role from creator to arranger, Flavin was also demonstrating the often disregarded relationships between art, science and engineering.

From 1959 to 1964, Anselmo worked as a painter, but turned to Conceptual art in 1965. By 1968, he had become one of the original members of the emerging art movement Arte Povera, formed by the art critic Germano Celant. Arte Povera artists used diverse, usually mundane materials to break down the constraints of gallery spaces and the outside world. Time is one of Anselmo's constant themes, and in his search for the broadest means of communication he evades one distinguishing style.

crushed lettuce between a large slab of granite and a smaller one, supported by copper wire
71 x 33 x 23 cm (27⅞ x 13 x 9 in.)
Sonnabend Gallery,
New York, USA

Direzione, 1967–70
Walker Art Center,
Minneapolis, MN, USA

Torsione, 1968
Civic Gallery of Modern Art,
Turin, Italy

Untitled, 1986
Royal Museum of Belgium,
Brussels, Belgium

UNTITLED (STRUCTURE THAT EATS SALAD)
GIOVANNI ANSELMO
1968

Along with other Arte Povera artists, Giovanni Anselmo (1934–) challenged the insularity of many official institutions, from governments to galleries. While walking on Stromboli in 1965, he suddenly realized that he was merely a tiny detail in the vast universe. In *Structure That Eats Salad*, he brought these notions together, while expressing the basic principles of energy, gravity, tension and infinity. Fresh lettuce, sawdust and granite irreverently contrasted 'non-art' objects with traditional art materials. Clasped between a large block of granite and a smaller one, the lettuce gradually wilted, causing the smaller block of granite to fall on to a pile of sawdust. While the lettuce is firm, the sculpture is balanced; once it wilts, the tension is lost and the granite slips. The granite alludes to Italy's classical heritage, whereas the change that occurs illustrates Anselmo's interest in metamorphosis within organisms, governments and culture. The copper wire signifies a transfer of energy and power. Trouncing conventional notions of the endurance of art, the work simultaneously contrasts constancy and instability, importance and triviality, attraction and repulsion. Overall, it represents the transience of life, like a modern vanitas.

Anselmo's reaction to the commercialism of Pop art and the emotionally led Abstract Expressionism resulted in him joining the Arte Povera movement, which was perceived by many as the Italian contribution to Conceptual art. Many of his ideas have inspired a range of younger artists, such as Mona Hatoum, Lucia Nogueira, Jo Stockham, Tony Cragg, Cornelia Parker and Jana Sterbak.

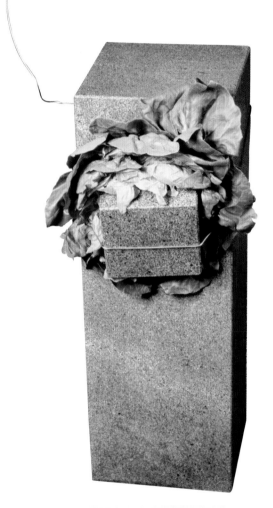

A five-year-old could make a structure like this, but they would not be scrutinizing so many elements at the same time, including the impermanence of substances and life, and natural and manufactured materials. Anselmo was working on many levels as he explored our place in the world, looking at infinity, vulnerability, power, culture and nature, all the time considering how philosophies, science and everyday experiences can be investigated and expressed through art.

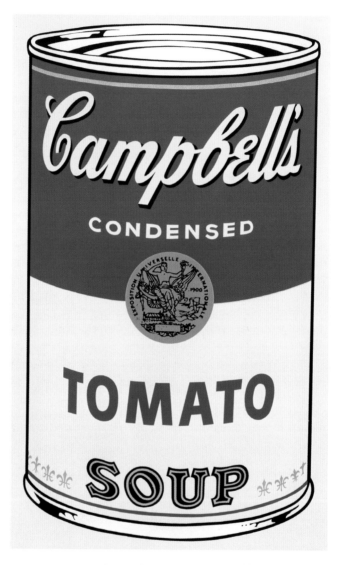

A simple print in bright colours could quite easily have been created by a child; as a straight copy of a familiar, banal and flippant object, it could almost have been made from a painting-by-numbers kit. However, Warhol's achievement with this work was to compel viewers to consider what makes something 'art' and why artworks are so revered. In doing so, he enforced a shift in the role of the artist.

**CAMPBELL'S SOUP
ANDY WARHOL
1968**

In 1962, Andy Warhol (1928–87) exhibited thirty-two screenprints of different varieties of *Campbell's Soup* in New York, deliberately challenging basic assumptions about the function and perception of art and artists in contemporary society. The canvases rested on a shelf, thus resembling a supermarket display. Simultaneously, Warhol was confronting established beliefs about art, consumerism, stereotypes, originality, individuality and recognition in both high and low culture. In addition, by using the commercial process of silkscreen to render the image, he was questioning the notion of the artist as maverick. Extremely familiar to US consumers, soup cans had never before been presented as high art. Tomato was Campbell's best-selling variety, and the label appealed to Warhol for its clarity. It was an exceptionally successful example of conveying information using the minimum of visual means. Warhol once said that one benefit of the consumerist society was the fact that the poor could buy or experience the same things as the rich. A can of Campbell's soup was the same for whoever bought it, and he aimed to achieve something similar in the field of art. The tomato soup had a particular personal association for him, as he explained: 'Because I used to drink it. I used to have the same lunch every day, for twenty years.'

In the 1950s, Warhol was a successful commercial artist who became one of the most well-known and influential figures of the 20th century. By 1960, he was confronting the art world with his skilful, often serialized images of mass-produced goods, celebrities and disasters, based on his understanding of marketing and promotion. Using screenprint and other commercial art-making practices allowed unlimited reproduction. These dehumanized images were the antithesis of traditional fine art in which artists' skills and personalities were integral to their work.

from a portfolio of ten screenprints, synthetic polymer paint on canvas 81 x 48 cm (31⅞ x 18⅞ in.) Whitney Museum of American Art, New York, USA

Marilyn Diptych, 1962
Tate Collection, London, UK

Green Coca Cola Bottles, 1962
Whitney Museum of American Art, New York, USA

Liz, 1964
Cleveland Museum of Art, OH, USA

This Pop art icon is one of the most recognized images from the 20th century. Bold, bright and opposed to academic art, Pop art developed from Dada and in opposition to Abstract Expressionism. Through Warhol's iconography of celebrity and commercialism, the movement became internationally renowned.

From 1966 to her death in 1970 at the age of thirty-four, Hesse produced artworks from unconventional materials, such as latex, fibreglass, string, tape, resin and cheesecloth, in order to attain what she described as 'non-connotive, non-anthropomorphic, non-geometric' forms. Having originally painted in an Abstract Expressionist style, she created these forms as both an amalgamation of and a departure from predominant art trends. She explored techniques traditionally associated with women, including threading, weaving and bandaging.

Hang Up, 1966
Art Institute of Chicago,
IL, USA

Repetition Nineteen III, 1968
Museum of Modern Art,
New York, USA

Resembling a small dish or a cast of an aspect of human anatomy, this delicate object was not made to last. Eva Hesse (1936–70) had a tragic life, involving persecution and conflict, her mother's suicide when Hesse was a child, and her struggle with and early death from cancer. Her work expresses suffering but is never self-indulgent. This piece, which evokes several ideas and none, is intentionally fluid and impossible to define. After fleeing Nazi Germany, Hesse moved to the United States and studied commercial art while also painting in an Abstract Expressionist style. Influenced by Minimalism, she moved on to work in three dimensions and grouped this work in the category of her 'test pieces'—small creations made in papier caché (paper pressed and bound with tape and glue). She wanted her art to be judged without bias in the general discourse of images and not to be cramped by traditional expectations. Hesse worked with materials that she originally found lying on the factory floor that she used as a studio. She never tried to disguise or change their properties but used them to explore ways of evoking a range of organic associations, moods and innuendos. Although she sought to remain detached from each piece, inevitably her personal expression emerged. She also referred to these 'test pieces' as 'nothings', highlighting each work's flimsiness, avoidance of meaning and impermanent nature.

In November 1938, at the age of two, Hesse was put on a train from Hamburg to Holland with her four-year-old sister to escape the anti-Jewish pogrom 'Kristallnacht.'

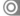

Willem de Kooning was Hesse's childhood idol. She was also inspired by Joseph Beuys and Jean Dubuffet. Her work displays evidence of Pop art, Abstract Expressionism and Minimalism, but she also veers towards Post-Minimalism. Artists influenced by Hesse include Anish Kapoor and Louise Bourgeois.

NO TITLE
EVA HESSE
1969

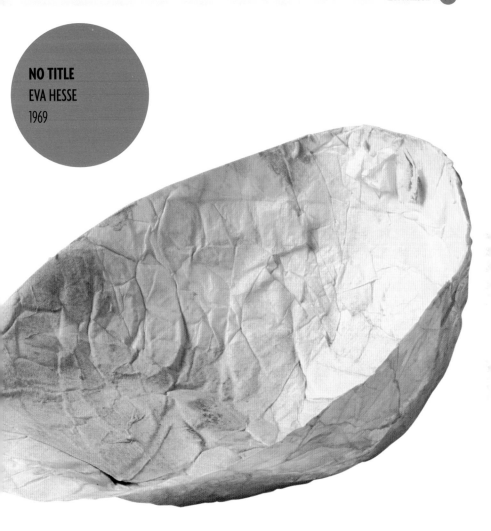

A small, bowl-shaped object made of paper, tape and glue resembles something that a child would make. Hesse did not intend this to be ornamental or even useful; it was purely an object, organic and reminiscent of various things, such as ancient parchment, a mould, skin or a fruit husk. It looks symbolic, but it is not even that, because Hesse sought to express 'non-art', or art devoid of any implications.

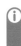

papier caché
15.5 x 15.5 x 8.5 cm
(6⅛ x 6⅛ x 3⅜ in.)
The Estate of Eva Hesse

Although Kelley's art considers the importance of popular culture and challenges established theories of history, art, philosophy, religion and science, it opposes the reductive, analytical elements of Conceptual art. The artist believed that formal artistic conventions were no longer relevant and disassociated himself from traditional art materials and concerns.

MORE LOVE HOURS THAN CAN EVER BE REPAID AND THE WAGES OF SIN
MIKE KELLEY
1987

This collage of handmade objects all sewn together suggests chaos and mess, like a child's bedroom or playroom strewn with toys. However, Mike Kelley (1954–2012) was highlighting the craft, diligence and time involved in each object's manufacture. His main point was that the objects represent a huge amount of love, but love that has been thrust aside and is no longer wanted. He asks viewers to decide: Are these objects still lovable or have they become repulsive? Does the idea of them being discarded make you feel guilty? Does the work make you question the nature of a society that can simply abandon once-loved things? Kelley declared that some teenagers not long out of childhood would find this amusing, while many adults will find it poignant. By adding the title *Wages of Sin*, he endowed the image with melancholic connotations. In order to make the work, he collected and sewed objects together, creating a repetitive image in the style of Pop art. Unlike the work of the Pop artists, who distanced themselves from emotion through mechanical techniques, this collage triggers memories and connections.

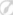

Blending Pop art, Performance art, Arte Povera, Conceptualism and Dada, Kelley's often unsettling work incorporated found objects such as toys, baskets, candles and banners. Although he followed Pablo Picasso and Marcel Duchamp with his use of found objects, rather than focus on the objects themselves he physically altered them to comment on late 20th-century US society.

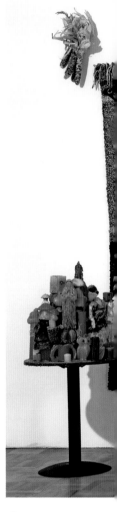

Shock, 1982 Museum of Contemporary Art, Los Angeles, CA, USA

Carnival Time, 1990 Detroit Institute of the Arts, MI, USA

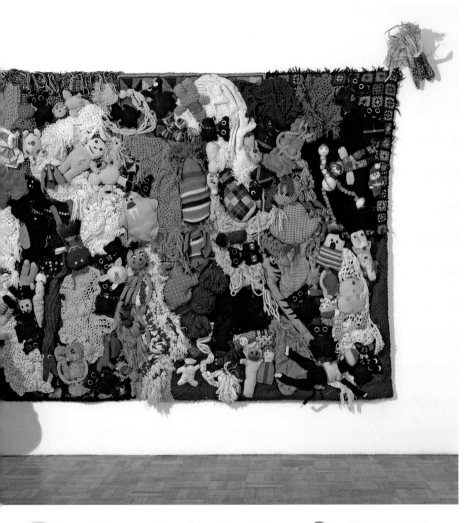

Children often collect soft toys, a few like making collages and some enjoy sewing, but no child would produce a work to examine social conditioning. The toys in this collage were once loved but, as their owners grew up, they were discarded and given to thrift shops, where Kelley found them. He questions motives behind discarding once-loved things.

stuffed fabric toys on canvas with dried corn; wax candles on wood and metal base
228.5 x 303 x 12.5 cm
(89¾ x 119⅛ x 4⅞ in.)
Whitney Museum of American Art, New York, USA

As a direct descendant of Minimalist and Conceptual art, Gonzalez-Torres spent his career investigating everyday objects and situations in the light of viewers' reactions to them. He used readymade objects to challenge the idea of the unique, original art object and created a range of work that allowed for open, individual interpretation. He deliberately instigated a variety of emotional reactions and used a wide range of media, including drawings, sculpture and billboards, as well as unexpected items such as light bulbs, clocks or mirrors.

"UNTITLED" (USA TODAY)
FELIX GONZALEZ-TORRES
1990

Felix Gonzalez-Torres (1957–96) was known for his sensory and often edible works that invited viewers to take part. Personal yet also public, this work consists of a huge mound of sweets that can be installed in various configurations to explore a diversity of ideas and responses. The shiny sweet wrappers are the colours of the US flag, and the work initially inspires childhood memories of innocence and sharing. Gonzalez-Torres aimed for this non-confrontational, light-hearted reaction before uncovering deeper considerations. The first is usually: 'How can this fragile pile of manufactured items, quickly eaten, be art?' Yet surreptitiously and incisively he invoked viewers to reconsider, to contemplate the past, present and future, just as the work reaches the senses of sight, touch and taste. Variable and constantly altering as people take the sweets, the pile is depleted, implying deterioration before death; the instability and change are an allegory for the world. As viewers take the sweets, museum employees replenish the mound, but it is never the same as before. Drawing an indistinct line between artist and viewer, the work makes everyone participants rather than mere onlookers: we all have the opportunity to become involved, to make changes and, ultimately, to affect the equilibrium of society.

sweets, individually wrapped in red, silver and blue cellophane
136 kg (300 lb) ideal weight
Museum of Modern Art, New York, USA

"Untitled" (Double Portrait), 1991
Albright-Knox Art Gallery, Buffalo, New York, USA

"Untitled" (Placebo), 1991
Museum of Modern Art, New York, USA

"Untitled" (Water), 1995
installation

Gonzalez-Torres was inspired by Minimalism and Conceptualism, and his work affected both art and society. Never antagonistic, it explores personal, public and political issues through its sense of nostalgia and poetry. In 2007, he was featured posthumously as the United States' chosen artist at the 52nd Venice Biennale.

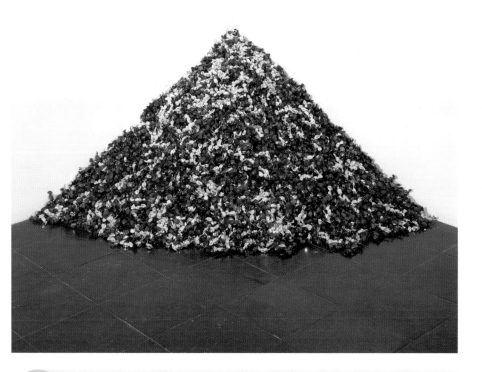

? Although the work comprises items traditionally loved by children, there is nothing childish about the ideas behind *"Untitled" (USA Today)*. Focusing on personal and political beliefs, Gonzalez-Torres was expressing his feelings about gay rights and AIDS, as well as highlighting political volatility. Children could collect and pile up sweets, but they would not be questioning viewers' acceptance of them as art objects nor creating metaphors for sharing, the spread of a virus, instability and inequality.

HORSES RUNNING ENDLESSLY
GABRIEL OROZCO
1995

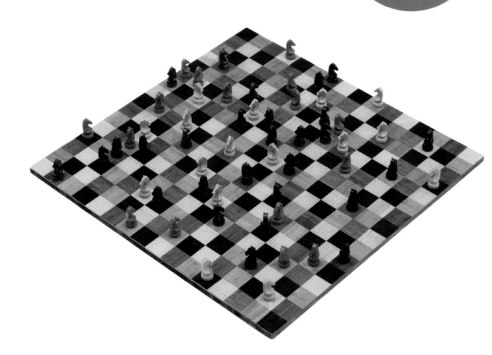

wood
8.5 x 87.5 x 87.5 cm
(3³⁄₈ x 34³⁄₈
x 34³⁄₈ in.)
Museum of
Modern Art,
New York, USA

? Most children would have fun changing and moving the pieces on a massive, four-coloured chessboard and inventing a new game, but they would not use the exercise as a way of creating a visual paradox to represent time without end. In his view that societies are revealed through the games they invent, Orozco presents the board as a landscape and the game as a product of a culture's underlying, preconceived notions of how nature is controlled.

Gabriel Orozco (1962–) uses ordinary, familiar objects in his art to explore attitudes, relationships and expectations that shape our lives and thoughts. This work illustrates instilled beliefs and reactions. Although intentionally infused with humour, *Horses Running Endlessly* is nevertheless thoughtful and reflective. It is just one of Orozco's many disparate works, as he refuses to be labelled or categorized. Incessantly searching for hidden truths in inconsequential or familiar things, he challenges accepted artistic practices, declaring that he does not invent, just reinterprets. This chessboard comprises four colours rather than the standard two, and instead of being eight squares by eight, it is sixteen by sixteen, making 256 squares in total. In place of the usual thirty-two chess pieces—kings, queens, rooks, bishops, knights and pawns—all the players are knights. In this invented game, the knights can play on for ever, turning through space infinitely, unchecked by other pieces. With no king to capture, the conventional goal of the game of chess has been discarded, leaving unbounded possibilities. Orozco explained that his changes transformed a regular and recognizably structured chessboard into an open landscape, and his knights became freely running horses. He was always fascinated by the power and flexibility of the knight, in the way that it is able to move between squares unlike any other chess piece, and is the only player on the board that is allowed to jump over others.

Renowned for his diversity and lack of affiliation to any one movement, Orozco constantly experiments with and alters found objects in order to comment on society. Mainly three-dimensional, his work poses new ways of reconsidering assumptions, beliefs and habits. Spending most of his time between Mexico City, New York and Paris, he prefers not to remain in any one place for the same reasons that he does not make one type of art.

Orozco's *Empty Shoebox* is often put on the floor of his exhibitions. Reactions to it vary enormously. It has even been thrown away by an over-zealous cleaner.

With a heavy sprinkling of wit, Orozco's art incorporates the recycling of found materials embraced by the Arte Povera movement; Earth art's exploration of sites beyond galleries; and his body in Performance art. He acknowledges inspiration from predecessors such as Bruce Nauman, Eva Hesse, Piet Mondrian, Constantin Brancusi, Piero Manzoni, Robert Smithson and the Russian Constructivists.

Maria, Maria, Maria, 1992
Museum of Modern Art, New York, USA

Yielding Stone, 1992
Artist's collection

Empty Shoebox, 1993
Museum of Modern Art, New York, USA

Ballena, 2006
José Vasconcelos Library, Mexico City, Mexico

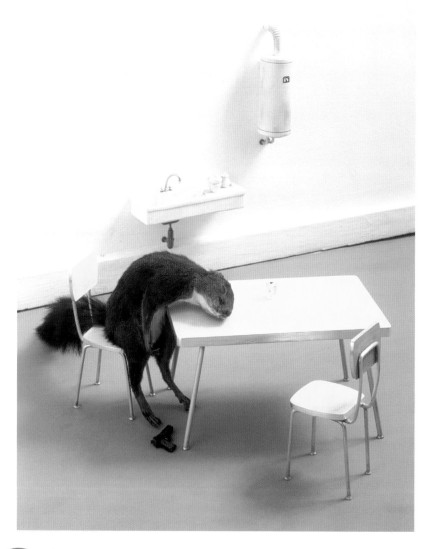

It is possible that a young child could make a squirrel, perhaps out of felt, and even create a playful setting for it. Such a task is relatively straightforward. However, on close examination, it is clear that this is a real, stuffed squirrel, and that the artist is using his mordant sense of humour to provoke viewers, to ridicule the art world and to express a contemplation of mortality.

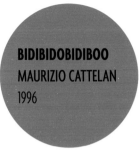

BIDIBIDOBIDIBOO
MAURIZIO CATTELAN
1996

The US-based Italian artist Maurizio Cattelan (1960–) is well known for his ironic sense of humour and often shocking works. Frequently and controversially mocking aspects of our cultural and social lives—in this work he used a taxidermic animal to express his feelings about life and death—he aims to call attention to the pretentiousness of the art world, ridiculing what he perceives as its innate silliness and artificiality. *Bidibidobidiboo* is one of several anthropomorphic animal scenes that Cattelan has made to deride aspects of society. In this work, the dead squirrel has apparently committed suicide in a kitchen using a tiny handgun that lies nearby. By mocking the self-promotion and self-importance practised by so many artists, Cattelan suggests that everything is not always as it seems and that much of the art world is contrived. No less important is the work's childlike openness, through which the fragility of life is expressed. The work is a combination of contradictions and suggestions as it merges art with entertainment, wit with outrage, and subversion with diversion. Overall, Cattelan intended the installation to remind viewers that laughter can help relieve the pain of tragic circumstances or can lighten the revelation of uncomfortable truths.

Originally a furniture maker, Catellan creates art that borders on the absurd and, at times, the distasteful, as he explores issues such as power, authority and, particularly, death in sculpture, installations and performances. In 1995, he began creating artworks that featured stuffed animals. Four years later he started making life-size wax figures of people and placed them in surreal surroundings.

In 1999, Cattelan created *La Nona Ora*, a life-size sculpture of Pope John Paul II being killed by a meteorite.

stuffed squirrel, ceramic, formica, wood, paint and steel installation

Working Is a Bad Job, 1993
Venice Biennale, Venice, Italy

Errotin, le Vrai Lapin, 1995
Performance art

La Nona Ora, 1999
Private collection

In his criticism of contemporary cultural issues, Cattelan is usually classed as a Conceptualist and an installation artist. He also sets himself up as art's joker. Inspired predominantly by Andy Warhol, he often makes ironic references to other artists, especially his Italian predecessors, and blends ideas from Dada, Minimalism and Pop art.

Thiebaud's bold, colourful cakes, milkshakes, lollipops, hotdogs, pies, deli counters and other fast foods are all presented in his customary uniform, clear-cut manner: unambiguous yet expressive and painterly. Although often classed as a Pop artist, Thiebaud has always denied being one, declaring that he paints his subjects because they remind him of his childhood and of the things he loves about the United States, not because he is trying to change attitudes or make statements about consumerism.

Thiebaud believed that by concentrating closely on an object when painting it, 'there is no point at which you stop learning things from it'.

MERINGUE MIX
WAYNE THIEBAUD
1999

Pies, Pies, Pies, 1961
Crocker Art Museum,
Sacramento, CA, USA

Confections, 1962
Byron Meyer,
San Francisco, CA, USA

Three Machines, 1963
De Young Museum,
San Francisco, CA, USA

As a teenager, Wayne Thiebaud (1920–) worked in the animation department of Walt Disney Studios. Later, he was an art director for a pharmaceutical company and eventually became involved with the Abstract Expressionists. By that time, Pop art was emerging. Based on the commercialism and mass media he was familiar with, Pop art was an appraisal of the new consumer society that was emerging after World War II, intended to be as disposable as mass-produced goods. Although Thiebaud's paintings appeared to assume the responsibility for Pop art in California, he always claimed that he was never the West Coast's answer to Andy Warhol—he regards Warhol's work as too flat and mechanical, while his own aim has always been to create spatial tensions between objects that appeal to him. In *Meringue Mix*, his painterly, thick and textural brushmarks describe the slices of pie that he has arranged close to the front of the picture plane, at equal distances from each other, creating a rhythmical sequence across a neutral ground. *Meringue Mix* is painted not from life, but from memory. As Thiebaud said: 'Most of the objects are fragments of actual experience. For instance, I would really think of the bakery counter, of the way the counter was lit, where the pies were placed.'

Significantly, Thiebaud always paints prepared items as an evolution of Marcel Duchamp's 'readymades', although specifically pertaining to the food world. However, his impasto, vivid colours and emotional allusions also reflect the expressiveness of Willem de Kooning and Franz Kline, as well as Pop artists such as Jasper Johns and Robert Rauschenberg.

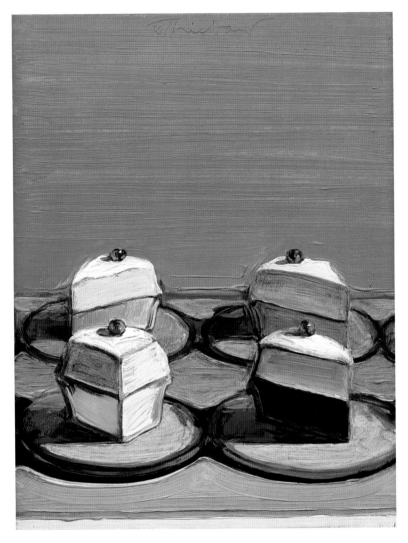

Although most children would take pleasure in painting their favourite foods, few could create effective tonal contrasts and perspective, artfully designed to appear simple. The uniform pattern of the meringues creates the impression of a print—a technique that derives from Thiebaud's experience as a cartoonist and commercial designer.

oil on panel
34.5 x 26.5 cm
(13½ x 10⅜ in.)
Private
collection

UNTITLED (BIRD, NESTING DOLLS, VASE)
HAIM STEINBACH
2006

Since the 1970s, Haim Steinbach (1944–) has created art inspired by consumerism and our fascination with objects, in particular the complexities of both individuality and conformity, and how external factors affect personal choices. By arranging mass-produced objects on shelves, he creates tensions between anonymity and desire. His displays of banal objects vary but also incorporate fixed elements: the interior angles are all 90, 50 and 40 degrees. The size and colour of each work always relate to the objects too, as would occur inside a home. This work features an orange bird, nesting dolls and a vase. Individually and collectively, the works evoke varying meanings for different viewers. Each piece is created to encourage viewers to consider how people choose and impose hierarchies on objects around them. For example, a vase might be displayed prominently or shut away in a cupboard. Why people choose objects, where they put them, and the importance—or unimportance—they accord them are all part of Steinbach's investigation of ambivalence and an inherent 'language' of choice and placement. Another aspect of his explorations of worth and inconsequence is finding objects in second-hand shops and sales.

MDF shelf, ceramic bird, wooden nesting dolls, Korean ceramic vase
30 x 84 x 27 cm
(11¾ x 33 x 10⅝ in.)
Artist's collection

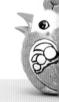

Believing that individual choices are often simply reworked and previously seen ideas, Steinbach creates his *Shelf Works* to imitate different art styles, from the simplicity of Pop art or Minimalism to the more expressive Rococo or Baroque. He has been linked with various art movements, including Dada, Pop art, Minimalism and Simulationism. His work overlaps with each of these but is also totally unique and individual.

Ultra Red #2, 1986
Solomon R. Guggenheim Museum, New York, USA

*Untitled
(Locks, Friar, Sister)*, 1987
Tate Collection, London, UK

Black Lagoon, 2010
Hammer Museum,
Los Angeles, CA, USA

? Each of the objects on this shelf could have been chosen and placed there by a five-year-old, but a child could not select and position each item to evoke the subtle questions they pose about meanings inherent in our culture, particularly how the things people choose to surround themselves with constitute a form of language or dialect that is both personal and social. Exploring the psychological, aesthetic and cultural elements of objects, Steinbach redefines perceptions of objects in art and draws comparisons with art in museums and the objects people own and display in their homes.

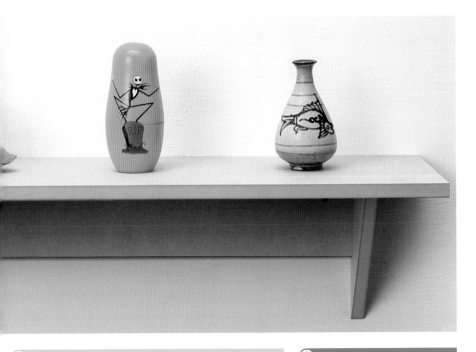

Steinbach has been creating art using manufactured, commonplace objects in pertinent juxtapositions since the 1970s. By focusing on the selection, colour and placement of these objects, he explores aspects of society that are rarely considered. His use of readymades in this way descends directly from Pablo Picasso and Marcel Duchamp. Steinbach emphasizes his objects' original functions as consumer icons.

Originally inspired by Paul Cézanne and Surrealism, Steinbach soon became linked with Simulationism, a theory that questions whether we can distinguish between actual reality and the perception of reality.

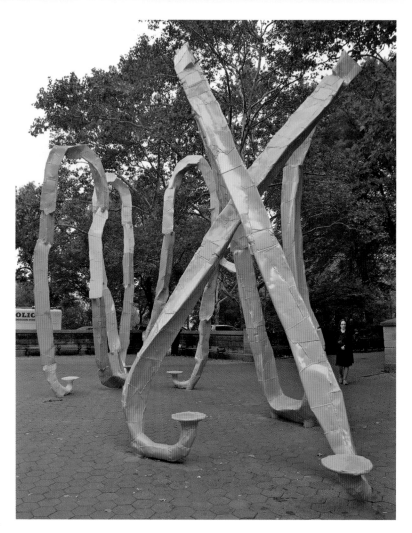

? Although this sculpture is made of metal, a child could make something similar out of paper or modelling clay. Most children would like to play around it, attracted by its tall, colourful, looping forms that resemble giant streamers. West created this artwork for interaction, much like a child's playground, but it originated from the writings and theories of the psychoanalyst Sigmund Freud.

aluminium, steel, lacquer
pink: 599.5 cm
(19½ ft) high;
multicoloured:
625 cm
(20½ ft) high
Private collection

**THE EGO AND THE ID
FRANZ WEST
2008**

The Ego and the Id looks like something from a child's playground. With its two separate, brightly coloured abstract forms that soar high into the air, it loops up and down, forming stools at the bottom. Viewers are enticed to interact with the work, by either sitting on the stools or playing around the longer, undulating elements. Franz West (1947–) insists that the artwork is not complete until viewers interconnect with it. His aim has always been to create art that inspires genial environments, where viewers are as much a part of the work as the work itself. The pink, yellow, green, orange and blue piece was created to contrast starkly with either urban or rural surroundings, specifically for West's first US retrospective exhibition in 2009. The idea developed from a paper written by Sigmund Freud in 1923 on the ego's battle with three forces: the id, the super-ego and the outside world. West felt a connection with Freud, as they were both born in Vienna. He created this work to pose a puzzle he frequently ponders: what use can be found for sculpture? His point extended into the location: when exhibited, the work was in Central Park, New York, far from a museum and in an open, recreational space, surrounded by distant city buildings. The dichotomy appealed to his intention of creating sociable environments out of unexpected alignments and comparisons.

With his Austrian heritage, West followed the Vienna Secessionists by exploring organic shapes and forms. From his first important works of the mid-1970s, the Adaptives—small amorphous objects designed as sculpture to be observed and as toys to be played with—to his biomorphic sculpture and installations, West's art is often integrated with performance. All his works are abstract and ambiguous, made to be handled or interacted with, yet with no clearly intended purpose.

In making his work interactive, West attempts to create functional art. He often makes—and encourages viewers to use—sculptured sofas, in direct allusion to Freud's couch.

West was inspired by Freud's theories on psychoanalysis, and the philosophies of Ludwig Wittgenstein and the Viennese Actionists, who rejected the idea of art objects and encouraged viewers' participation through actions. Subsequently, West has influenced artists such as Martin Kippenberger and Mike Kelley.

Untitled, 1991
Museum of Contemporary Art, Los Angeles, CA, USA

Lemur Head, 1994
Hirshhorn Museum and Sculpture Garden, Washington, DC, USA

Clamp, 1995
Kröller-Müller Museum, Otterlo, Netherlands

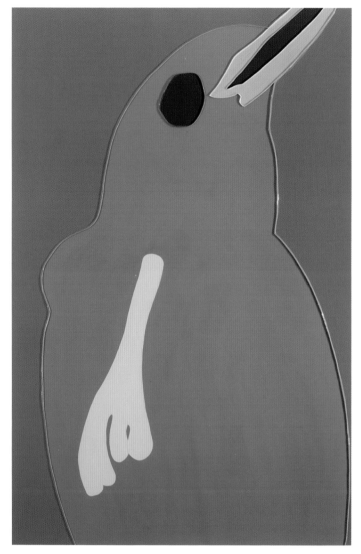

This dramatically simplified image of a bird can be compared readily to the flat, uncomplicated style of children's paintings. From the late 1990s, Hume deliberately produced a range of imagery associated with childhood, utilizing his favoured restricted palette and severely reduced forms. However, the apparent innocence of each image is often used to obscure underlying connotations.

CUCKOO IN THE NEST
GARY HUME
2009

After the phenomenal success of his Door Paintings, which he produced during the early 1990s, Gary Hume (1962–) continued to paint large, abbreviated forms in household gloss paint, in which he developed themes that included women, flowers and animals. *Cuckoo in the Nest* is one of a number of paintings of birds and other creatures that resemble children's illustrations. The smooth, slick gloss paint precluded Hume from having to make any attempt at portraying depth or tone, which allowed him to focus on areas that mattered to him—structure, surface and colour—and to explore both literal and metaphorical interpretations. In contrast to oil on canvas, the use of gloss paint on aluminium separates the work from traditional painting, while in a physical sense it reflects viewers, thus bringing them into the painting itself and creating a sense of artistic detachment and objectivity. The work is also intended to be perceived as an object in its own right. Maintaining the large scale that he used in his Door Paintings and featuring just five colours, Hume's abridged image conveys a baby bird with a large round eye and pink beak, apparently waiting to be fed. At the same time, the bright and colourful figurative representation is suggestive of a less naive idea, that of female anatomy.

Originally inspired by artists including Andy Warhol, Patrick Caulfield, Joseph Beuys and Michael Craig-Martin, Hume emerged in the 1990s as one of the leading figures of the group that became known as the Young British Artists (YBAs). Since then, he has continued to explore his unique adaptations of Minimalism, Conceptualism and Pop art.

Hume begins his paintings by tracing a found image on to acetate and projecting it on to a wall. After simplifying the image, he transfers it on to a sheet of aluminium and fixes draught excluder to the contours. Then, with the aluminium laid flat, he paints each section using commercial, ready-mixed paint. When the paint is dry, he cuts away the draught excluder.

This work features in the book *Art for Baby*, published in 2011, with eleven other images by acclaimed contemporary artists.

gloss paint on aluminium
244 x 161.5 cm (95⅞ x 63½ in.)
White Cube, London, UK

Garden Painting No. 3 (Rabbit), 1996
Kunstmuseum Wolfsburg, Wolfsburg, Germany

Snowman, 1996
Museum of Modern Art, New York, USA

Water Painting, 1999
Tate Collection, London, UK

Perry's classically formed, brightly decorated vases depict unsettling and often shocking figurative themes. He works with ceramics because he says it is an innocent, secondary art form without 'any big pretensions'. Using strong autobiographical elements, he often features his alter ego, Claire, and his imaginary teddy, Alan Measles, on his pots, which he creates employing the traditional method of coiling. On the surfaces he uses various techniques, including glazing, incision, embossing and the application of photographic transfers. He also works in printmaking, drawing and embroidery.

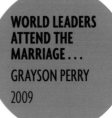

WORLD LEADERS ATTEND THE MARRIAGE...

GRAYSON PERRY

2009

World Leaders Attend the Marriage of Alan Measles and Claire Perry is a meticulously crafted, shimmering pot based on a classical design, embellished with two images that recur in the work of Grayson Perry (1960–): his fantasy hero teddy bear, Alan Measles, and his female alter ego, Claire. Perry felt that Alan Measles was his guardian and protector during the most vulnerable period of his life, whereas 'Claire' was the name he took when dressing in feminine clothing. Once he had made the pot, Perry used transfers and glazes to build up the surface narrative, describing the wedding of Alan and Claire. In attendance are Barack Obama, Gordon Brown and Nicolas Sarkozy. The ceremony exemplifies various difficulties that Perry experienced growing up as a transvestite, while the imagery helped him to resolve the masculine and feminine aspects of his personality and his reliance on his imaginary teddy. He uses ceramics to explore complex, psychological dilemmas. He maintains that pottery is perceived as lowly in relation to fine art and therefore can be used as a base for bold and often confrontational statements. He has said: 'No matter how brash a statement I make, on a pot it will always have certain humility . . . the shape has to be classical invisible: then you've got a base that people can understand.'

glazed ceramic
52 x 32 cm (20³⁄₈ x 12⁵⁄₈ in.)
Private collection

Aspects of Myself, 2001
Tate Collection, London, UK

Over the Rainbow, 2001
Saatchi Collection, London, UK

Taste and Democracy, 2004
The Burger Collection,
Hong Kong

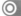

Perry's critical observations about society and his own life are expressed through a diversity of forms and designs inspired by the past. These include some of the methods and models of ancient Greek and Roman ceramics, the colours and patterns of Malaysian batik fabrics, Chinese scroll patterns and European folk art.

The cartoonlike teddy bear and fairy story-style illustrations on this gracefully proportioned vase are deceptively innocent-looking, belying their more disturbing significance. Children could decorate a pot with images of teddies and figures in fancy costumes at a wedding, but they would not incorporate the levels and layers of art history, politics and underlying personal traumas that are seen in Perry's work.

Since the 1980s, Rist has produced installations created from fusions of performance, sculpture, music and film, exploring uncomfortable topics. In particular, she considers boundaries that are made individually and collectively in society. Issues she exposes include questions about gender, the body, and relationships between individuals and within groups. Using colourful, witty and often vividly lit imagery, she explores unexpected or surreal elements of contemporary life, expressing it through vibrant colour, speed and sound.

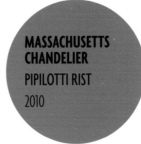

MASSACHUSETTS CHANDELIER
PIPILOTTI RIST
2010

Tiers of coloured underpants hang from a circular frame, luminous in a darkened gallery, like washing drying on a rotary line. Warm light emanates from within, while outside light is projected on the work as flowers, grass and sky. Suspended from the ceiling, *Massachusetts Chandelier* is made up of underpants collected from the artist and her friends and family, and displayed, glowing and translucent, affecting perceptions. Intentionally exuberant, animated and humorous, the work was created to encourage viewers to consider issues relating to gender, sexuality and the human body. The Swiss artist Pipilotti Rist (1962–) created the installation to radiate with soft colour and to transmit a sense of happiness and serenity. However, she insists that, although the work is purposely uncomplicated and straightforward, it is not childlike. She claims to have turned these everyday materials into something beautiful. But beneath the apparent light-heartedness of the work she is also considering feminist or taboo issues. She says: 'This part of the body is very sacred, the site of our entrance into the world, the centre of sexual pleasure and the location of the exits of the body's garbage.' The unreal evocations that the work projects contrast with the more concrete issues that she is illustrating.

two light projections on tiers of underpants, one light bulb
250 x 167.5 cm (98¼ x 65⅞ in.)
Luhring Augustine Gallery, New York, USA

Atmosphere and Instinct, 1998
Solomon R. Guggenheim Museum, New York, USA

Himalaya's Sister's Living Room, 2000
Solomon R. Guggenheim Museum, New York, USA

Homo Sapiens Sapiens, 2005
San Stae Church, Venice, Italy

Inspired by a variety of sources, including MTV, feminism and the feminist group Guerrilla Girls, Joseph Beuys, Nam June Paik, video art, Surrealism and Conceptualism, Rist's work has been exhibited in unusual places, including New York's Times Square and the Venetian Baroque church of San Stae, thus spreading her ideas to an even broader audience.

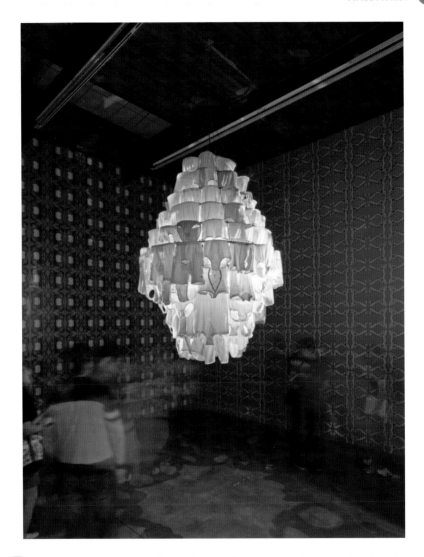

A huge chandelier made of coloured underpants: many children would thoroughly enjoy making something similar, and it could be achieved quite easily with wire, underwear and a light bulb. Rist wanted to make this installation as fun and absurd as a child would make it, but her reasons went much deeper. For example, she chose underpants because they are coverings for parts of the anatomy that are particularly important in terms of birth, privacy and sexuality.

Hirondelle Amour
Joan Miró
p62

*The Marriage of Reason
and Squalor II*
Frank Stella
p74

Untitled
Mark Rothko
p80

Onement I
Barnett Newman
p66

The Dog
**Alberto
Giacometti**
p72

*Work No. 227: The Lights
Going On and Off*
Martin Creed
p94

24 Hour Psycho
Douglas Gordon
p88

*Beautiful, Pop,
Spinning Ice Creamy,
Whirling, Expanding
Painting*
Damien Hirst
p92

Samuel Beckett
Maggi Hambling
p96

One: Number 31
Jackson Pollock
p70

*Head
(Biomorphic
Abstraction)*
Hans Arp
p60

Tree of life
John Hoyland
p90

0 1 2 m

0 1 2 3 4 5 6 ft

Improvisation 21A
Wassily Kandinsky
p56

Untitled (Grey)
Gerhard Richter
p78

Cut with the Kitchen Knife through the Last Weimar Beer Belly Cultural Epoch in Germany
Hannah Höch
p58

Corner Piece
Lynda Benglis
p82

Trademarks
Vito Acconci
p86

Room with Chair
Howard Hodgkin
p84

Chief
Franz Kline
p68

Painting
Wols
p64

In the Beginning Was the Image
Asger Jorn
p76

CHAPTER TWO
EXPRESSIONS / SCRIBBLES

Often self-referential, philosophical or reflective, the artworks in this chapter are primarily abstract or semi-abstract, free and expressive. Forthright gestures such as the biomorphic head by Hans Arp, *Onement 1* by Barnett Newman and John Hoyland's *Tree of Life* variously illustrate ambiguities, turmoil, movement, insights and humour, giving shape to new ideas and discarding established notions about pictorial space and colour values. Conceptualism is apparent in many of the works, from Gerhard Richter's loops and swirls of grey paint to Howard Hodgkin's *Room with Chair* and Douglas Gordon's twenty-four-hour film, which introduce new vocabularies and create new boundaries for art.

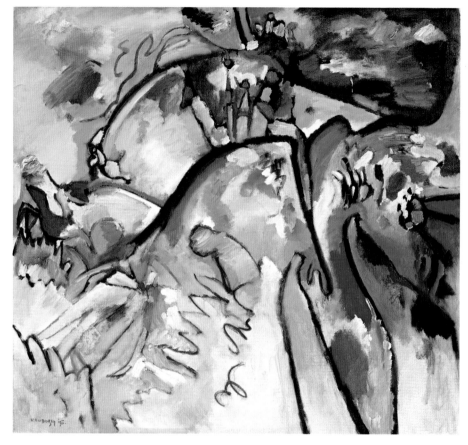

Kandinsky is one of several artists who would have been pleased by the assumption that a five-year-old had painted this work. His intention was to produce art that inspired the feelings of wonder and discovery experienced by children, both in his creations and in the viewer's contemplation of them. But his work also contains countless intellectual, mystical and spiritual implications that allude to various complex issues, including intrinsic emotions and tensions that can be expressed through colour, line and form.

oil on canvas
96 x 105 cm (37¾ x 41¼ in.)
Städtische Galerie im
Lenbachhaus, Munich,
Germany

Church in Murnau, 1910
Städtische Galerie im
Lenbachhaus, Munich,
Germany

Cossacks, 1910–11
Tate Collection, London, UK

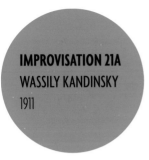

IMPROVISATION 21A
WASSILY KANDINSKY
1911

Using colour and line, Wassily Kandinsky (1866–1944) explored diversities between matter and spirit. This painting is one of his many *Improvisations*, which express his intuitive perceptions, distinguished by a simple numbering system. The undulating lines represent the landscape of Murnau in the southern Bavarian Alps where he was living at the time of painting. In also alluding to his skills as a musician and his spiritual and philosophical beliefs, particularly the spiritually based philosophy known as theosophy, *Improvisation 21a* is not a tangible narrative. The concept of creating musical equivalents through line and colour emerged from the artist's synaesthesia, which meant that he 'saw' colour when he heard sounds or read words. Kandinsky also associated colour with spirituality. In the year he painted this work, he wrote his first major theoretical text, *On the Spiritual in Art, and Painting in Particular*, which explored connections between theosophical thought and form and colour in painting. Painted three years before the outbreak of World War I, *Improvisation 21a* evokes sensations of a world on the brink of destruction. The patches of colour and black lines eliminate any reliance on linear perspective and reinforce the idea of upheaval, with society on the verge of collapse.

A pioneer of abstract art and a master of colour and composition, Kandinsky sought to remove the constraints of traditional representation in a bid to uncover pure articulacy through paint. He was one of the first artists to consciously create an impression of movement without depicting moving objects. Believing that art should be as liberated as music and not restricted to simply imitating the world around us, in 1909 he began to produce non-representational paintings. He divided these into three categories: *Impressions*, which were inspired by nature; *Improvisations*, which were spontaneous reactions of his own inner self; and *Compositions*, which included several layers of meaning.

Between 1910 and 1920, Munich became one of the main meeting places for members of the artistic avant-garde. Kandinsky lived there from 1896 to 1914 and was perceived as the inspiration behind the Expressionist movement. In 1911, he founded Der Blaue Reiter with Franz Marc, an artists' group that emphasized the expression of spiritual values.

In 1922, Kandinsky returned to Germany from Moscow, where he remained until 1933. He taught at the Bauhaus, teaching and analyzing the spiritual, mystical and scientific elements of colour.

Höch was part of a group of Dadaists living in Berlin that included Raoul Hausmann and John Heartfield, who pioneered photomontage. Photomontage developed from Cubist collages and became recognized as a particular technique of the Berlin Dadaists. Their constructions exemplified all Dadaists' rejection of traditional artists' creative roles, and Höch and her contemporaries described themselves as engineers more than artists.

Despite Dada's progressive stance, Höch struggled to be taken seriously by her male counterparts.

photomontage, collage, mixed media
114 x 90 cm (44¾ x 35⅜ in.)
Staatliche Museen zu Berlin, Berlin, Germany

Equilibre (Balance), 1925
Institut für Auslandsbeziehungen, Stuttgart, Germany

Indian Dancer, 1930
Museum of Modern Art, New York, USA

CUT WITH THE KITCHEN KNIFE... HANNAH HÖCH
1919–20

The full title of this work is *Cut with the Kitchen Knife through the Last Weimar Beer Belly Cultural Epoch in Germany (Schnitt mit dem Küchenmesser durch die letzte Weimarer Bierbauchkulturepoche Deutschlands)*, and it derides the political breakdown of Weimar Germany in 1919. Combining contemporary images from newspapers and magazines, Hannah Höch (1889–1978) illustrated the internal strife that occurred between groups of people, cutting through the tensions she was so aware of. In the lower right-hand corner is a small self-portrait pasted above a map that indicates the countries that had given women the vote at that time. Surrounding her are fellow Dadaists George Grosz, Raoul Hausmann, John Heartfield (in the bath) and the writer Theodore Däubler (on top of a baby's body). Above is Kaiser Wilhelm; the head of General Hindenberg on the body of a dancer; and the German Minister of Defence, Gustav Noske. On the left-hand side are Albert Einstein, saying: 'He-he, young man, Dada is not an art trend'; the president of the Weimar Republic; a declaration: 'Vote for Dada!'; and the assassinated Communist Party leader, Karl Leibnecht, saying: 'Join Dada!' The image intentionally undermines the collective values that led to World War I.

Although it was rarely acknowledged, Höch's influence on contemporary and younger artists was significant. Aware of Germany's social and political problems, her position as a female artist within a male-dominated art movement and expectations of women, she made bold statements in her work. For instance, the kitchen knife in the title of this artwork refers to assumptions about the role of women.

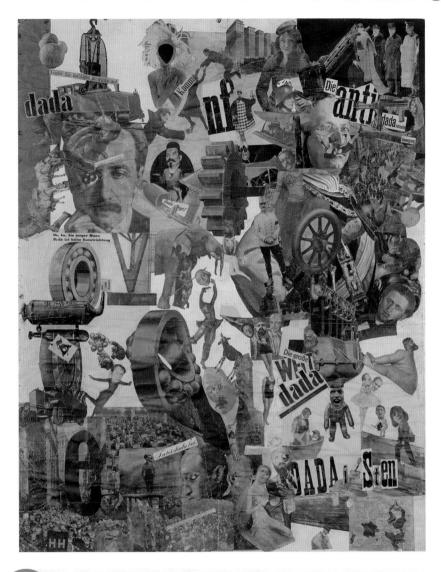

Overcrowded and seemingly nonsensical, this montage looks as if a child has haphazardly stuck down fragments of photographs on to a sheet of paper. However, Höch was consciously commenting on World War I, sexism, and social and political tensions within Germany. Primarily, the piece represents the political chaos in Berlin at the time and the significant problems that developed at the end of the war.

As one of the founder members of the Dada movement, Hans (or Jean) Arp challenged expectations of art and experimented with various methods and styles. He often reduced and simplified natural forms. His biomorphic abstractions were his most organic forms and shapes, which although appearing ambiguous are still recognizable. He worked in a variety of media, including paint, wood, marble, bronze and collage, aiming to capture and express energy and the essence of nature, and to liberate art from the constraints that were imposed by society.

HEAD (BIOMORPHIC ABSTRACTION)
HANS ARP
1929

A poet as well as an artist, Hans Arp (1886–1966) began producing abstract sculptures from 1910. He joined the Dadaists in Zürich in 1916, determined to undermine the social and political values that had allowed World War I to happen. He began producing collages, reliefs, paintings, drawings and sculpture that echoed his poetry, expressing flowing, imaginary ideas based on nature. Biomorphism was first discussed at around this time, and *Head (Biomorphic Abstraction)* reflects the concept. The form of the work appears natural and reminiscent of elements seen in nature. Having previously worked in a Cubist style, Arp developed his curvilinear, sinuous approach almost in opposition to Cubism, out of his need to express both ambiguity and humour in the light of world events. The roughly discernible face also serves to mock the established practice of the wealthy having their likeness portrayed—in making the work almost nonsensical, he was lampooning the arrogance of wanting to display one's own portrait. Aware of the horrors that had taken place during the war, by the time Arp produced this, he was working spontaneously, almost unconsciously, allowing shapes to form by chance in his hands and the resulting image to be left without modification or detail.

painted wood relief
67 x 56.5 cm (26⅜ x 22¼ in.)
Private collection

Untitled (Collage with Squares Arranged according to the Laws of Chance), 1916–17
Museum of Modern Art, New York, USA

Head and Shell, c. 1933
Peggy Guggenheim Collection, Venice, Italy

Pistil, 1950
La Fondation Arp, Paris, France

Significantly involved with several avant-garde art movements in the early 20th century, Arp was especially inspired by Wassily Kandinsky. As well as being a Dadaist, he was a prominent member of Abstraction-Création, a loose association of artists who embraced all kinds of non-figurative art. His work inspired many others, particularly Joan Miró.

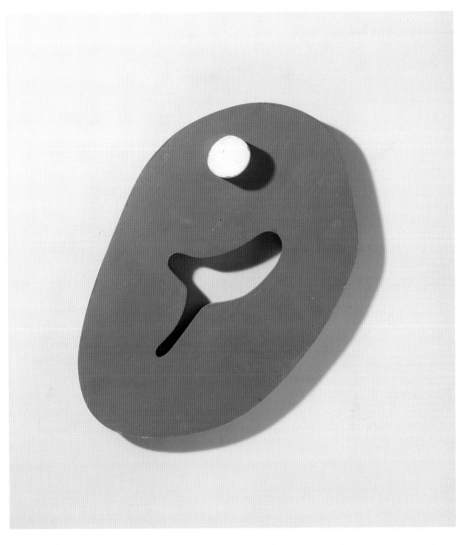

Any child could cut shapes out of different materials and make them vaguely resemble a face, and the overall appearance of this artwork is childlike and facile. Not wanting to create a complex, detailed or realistic image, Arp made the face look like a primitive mask or a non-descript blob, satirizing conventional art and those who perpetuated it. In exploring automatism, he aimed to represent an idea, because he believed that only through abstraction could the underlying reality be achieved.

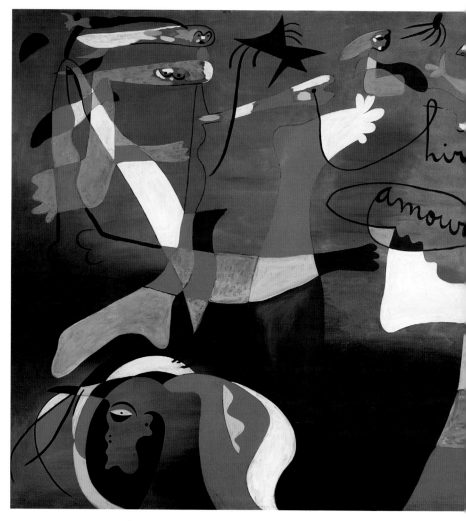

Several lines that resemble a child's doodle have been swirled over an unevenly painted ground. Lines and shapes are vaguely familiar: feet, hands, birds and even a face and some cats can be discerned. The ambiguities in the image are deliberate, unlike a child's arbitrary scribble. They represent Miró's inner feelings, what he called the 'sparks of the soul'.

The Tilled Field, 1923–24
Solomon R. Guggenheim
Museum, New York, USA

Carnival of Harlequin, 1924–25
Albright-Knox Art
Gallery, Buffalo, NY, USA

In 1924, Miró refused to sign the Surrealist Manifesto. In 1931, he explained why: 'I've been labelled a Surrealist. But what I want to do above anything else is maintain my total, absolute, rigorous independence.' His influence on subsequent art was huge, however, particularly on the Abstract Expressionists and graphic design.

HIRONDELLE AMOUR
JOAN MIRÓ
1933–34

The title of this brilliantly coloured work translates as *Swallow Love*, and it was the design for one of four wall tapestries. At the time, Joan Miró (1893–1983) had only recently returned to painting after creating collages and works based on Dutch paintings. The image is a combination of chance and careful planning: its black calligraphic lines and flat planes of bold colour are suggestive of vaguely recognizable, biomorphic forms, yet the work was created predominantly through automatism, or unconscious drawing. Miró said: 'Rather than setting out to paint something, I begin painting and as I paint, the picture begins to assert itself . . . The first stage is free, unconscious,' but he added that, 'The second stage is carefully calculated.' Years later, he said that his automatism was led by hunger-fuelled hallucinations: 'In 1925, I was drawing almost entirely from hallucinations. Hunger was a great source of these.' Inspired by Dadaism and Surrealism, he often referred to his work as 'anti-painting' or 'a revolt against a state of mind and traditional painting techniques'. Miró was the first artist to use automatism and, in doing so, created a totally new language of art.

oil on canvas
199.5 x 247.5 cm
(78⅜ x 97¼ in.)
Museum of
Modern Art,
New York, USA

Miró poured, flicked and spread paint on to unevenly primed canvases. Over this, he painted lines and shapes he had planned in preparatory studies. His most predominant technique was what the Surrealists described as 'pure psychic automatism', or free association. Painting from the subconscious, the artist used automatism to access creativity from the unconscious mind.

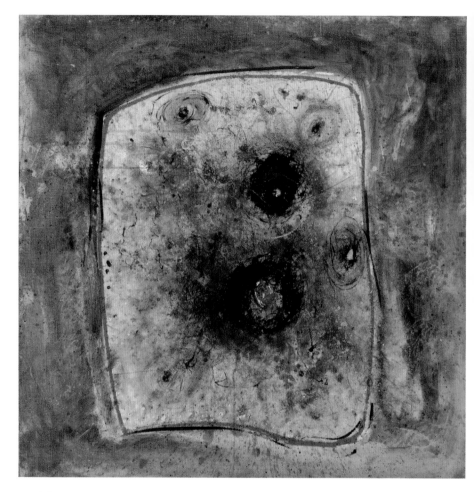

? This painting seems to be the type of random arrangement that a five-year-old might come up with. However, it emerged from the mind of an intellectual, a person who used painting as an expression of his many concerns and as a vehicle for self-revelation. Wols, who was born in Berlin in 1913, was disgusted by the Nazis and what they had done during World War II, and this painting exposes his anxieties about the world.

A talented photographer, Wols was also an accomplished violinist and a student of zoology, geology, botany and ethnology. He never regarded painting as a profession and disliked dealers and exhibitions.

**PAINTING
WOLS
1946–47**

Although Wols (1913–51) painted this work as an elaborate, automatist doodle, he based the image loosely on a mouldy slice of bread. The sad irony is that, in his poverty, he probably also ate the bread. This practice of eating stale food was the ultimate cause of his untimely death, five years after this painting was produced. Working spontaneously to express the angst he felt about the state of the world after World War II, Wols—a pseudonym of Wolfgang Schulze—began producing paintings while he was interned in France as a German citizen for the first fourteen months of the war. Previously, he had studied at the Bauhaus and had earned a living as a photographer in Paris during the 1930s. It is believed that Wols, hungry and an alcoholic, produced most of his paintings while he was in a hallucinatory state. This painting is deliberately rendered with a childlike naivety to convey his emotions. His experiences—fleeing from Germany as an army deserter, his internment in France at the start of the war, the German occupation while he was living there and his alcoholism—all served to increase his depression. This painting expresses that inner turmoil and despair, whether you know anything or nothing of Wols's life.

Inspired by the writings of the Chinese Daoist philosopher Laozi, Wols also wrote poetry to express his own philosophies. Although he had worked in ink and watercolour since 1939 and produced a number of animated and expressive book illustrations, he did not begin painting in oils until 1946, making this one of his first oil paintings. With an informal, gestural and spontaneous style, he applied paint in impasto layers, often dripping it directly on to the canvas or scratching into it, to create a work that seems to explode with his emotions.

oil on canvas
81 x 81 cm (31⅞ x 31⅞ in.)
Museum of Modern Art,
New York, USA

Wols, born Alfred Otto Wolfgang Schulze, was particularly influenced by his friends Paul Klee, Otto Dix and George Grosz, and later László Moholy-Nagy at the Bauhaus. On moving to Paris, he met many artists associated with Surrealism, including Amédée Ozenfant, Fernand Léger and Hans Arp, and became linked to two predominantly French Expressionist painting movements: Tachisme and L'Art Informel.

Gouache #16, 1940–41
Museum of Modern Art,
New York, USA

Stringed Instrument, 1942
Museum of Modern Art,
New York, USA

Untitled, 1944–45
Tate Collection, London, UK

Newman painted rich Indian red uniformly across a canvas. He then stuck a strip of masking tape down the centre and applied light cadmium red with a palette knife on the masking tape without removing it. Sketchy and uneven, the paint and masking tape were an experiment that became a revelation, inspiring Newman to produce similar paintings in which he explored how lines simultaneously divide and unite space.

ONEMENT I
BARNETT NEWMAN
1948

The post-World War II years were difficult. Barnett Newman (1905–70) was not alone in believing that traditional standards of art were no longer appropriate, that something new was needed to help lift society's depression. Recognizing the primal urge of humans to create, he reconsidered primitive art, as had artists before him, which had been driven by the same creative inclinations. Yet rather than follow the gestural and often emotionally motivated abstract art of his peers, Newman painted this intense maroon pigment, leaving the strip of masking tape in place and painting over it with patchy orange-red paint to contradict classical standards of beauty, invoke emotions and divide as well as unite the composition. Although his outcomes differed, Newman shared the Abstract Expressionists' interests in myth and the instinctive approach of primitive artists. His masking tape line, which he later called a zip, became a symbol he used to stimulate and inspire. Deceptively simple, *Onement I* is nevertheless challenging, questioning both spirit and matter. Despite its modest size, Newman proclaimed it to be his artistic breakthrough, in which he discovered a new method of enthusing viewers physically and emotionally, rather than creating conventional divisions within a picture.

Newman taught art in schools, but never passed his drawing exams to become a fully qualified teacher.

oil on canvas and oil on masking tape on canvas
69 x 41 cm (27⅛ x 16⅛ in.)
Museum of Modern Art, New York, USA

Vir Heroicus Sublimis, 1950–51
Museum of Modern Art, New York, USA

Adam, 1951–52
Tate Collection, London, UK

Newman's highly intellectualized approach to art attempted to reach viewers' inner feelings. Through his admiration of Suprematism and Neo-Plasticism, and his fascination with primitive art, he sought to uncover mystical notions. His work was described as an exploration into the metaphysical, which helped to inspire Minimalism and Colour Field painting.

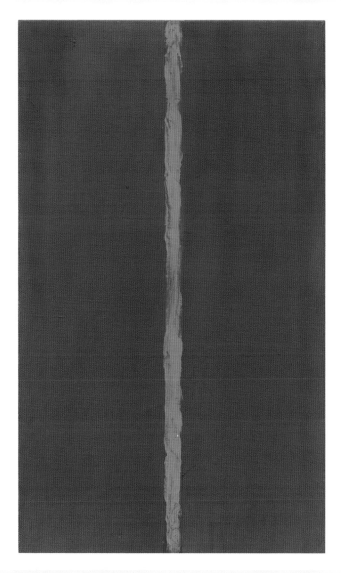

A strip of masking tape is stuck vertically down the centre of a painted canvas and another colour painted thickly over it. Any child could do that, but none would do so in order to make statements about the modern world needing new and powerful kinds of art—art that expresses and invokes intuition and aspirations. Newman stressed that his work embodied meaning beyond the colour, composition and texture.

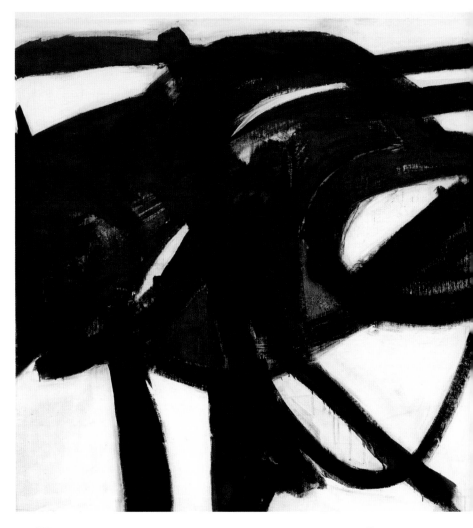

The big, sloppy strokes of paint and the brooding tone in this picture initially appear to resemble something that a child might create. Indeed, some critics blamed Franz Kline for laying down a simple format that could be easily repeated. However, a child could not compress the multitudes of subtle allusions, the suggestions of images and the feel of determination and speed that Kline succeeds in bringing to *Chief*.

oil on canvas
148 x 187 cm
(58⅛ x 73½ in.)
Museum of
Modern Art,
New York, USA

Kline began developing his expressive, calligraphic style of painting from about 1950, which linked him to the Abstract Expressionists. This US art movement of the 1940s to 1970s relied on artists' instincts and emotions, and included painters such as Willem de Kooning, Jackson Pollock and Mark Rothko.

CHIEF
FRANZ KLINE
1950

The title refers to a locomotive that Franz Kline (1910–62) was fond of as a child, and one can sense it in the momentum of the strange black form that bounds towards the viewer. Many of Kline's paintings in his signature black-and-white palette evoke landscapes—the industrial and rural setting of Pennsylvania, where he was raised, or the cityscapes of New York, where he found success. Some critics have also noticed echoes of the artist's drawings of his wife, Elizabeth. She suffered increasingly from mental illness as the years passed, and Kline would portray her sitting in a rocking chair, her peacefulness belying the turmoil in her mind. However, the artist was always reluctant to talk of hidden images and meanings in his pictures; the forthright abstract gestures alone were meant to suffice. It was this insistence on abstraction, as well as the architectonic simplicity of Kline's forms, that recommended him to Minimalists such as Carl Andre and Dan Flavin. Ultimately, the genius of *Chief* lies in its ambiguity, in the fact that the viewer needs to know nothing of Kline's biography to sense that the picture speaks of the artist's inner turmoil, giving ominous shape to troubles bearing down on him at speed.

Kline's black-and-white abstractions have been compared to New York's cityscapes, the Pennsylvania landscape and oriental calligraphy. He originally painted with a fluent, realist style but, after meeting de Kooning, developed his personal, gestural and animated approach in an effort to energize viewers with his powerful symbolic expressions.

Painting Number 2, 1954
Museum of Modern Art,
New York, USA

Blueberry Eyes, 1959–60
Smithsonian Institution,
Washington, DC, USA

Meryon, 1960–61
Tate Collection,
London, UK

ONE: NUMBER 31
JACKSON POLLOCK
1950

Fraught with energy, tension and drama, *One: Number 31* is one of the largest paintings that Jackson Pollock (1912–56) made using the 'drip' technique, as it became known. It is one of three huge works that he produced in swift succession during the late summer of 1950. The dense, interlaced mesh of layers was created with spattered, flicked, dripped and poured paint, applied with sticks and stiffened brushes. Deliberately avoiding any pictorial representation, Pollock was exploring both Surrealist automatism and Jungian psychoanalysis, believing that his liberated paint application came directly from his inner self, which, in turn, was connected to larger forces in the universe. In this way, natural life forces, anxieties and concerns about the modern world were expressed concurrently. Although not actually depicting his era, he was nonetheless expressing its essence through his dynamic gestures. Despite the appearance of improvisation, Pollock asserted that he ultimately maintained control of his work: 'When I am in my painting, I'm not aware of what I'm doing. It is only after a sort of "get acquainted" period that I see what I have been about.' With no focal point or any obvious repetition or pattern, the work can nevertheless be seen to have a fundamental structure.

oil and enamel paint on canvas
269.5 x 531 cm
(107⅞ x 208⅝ in.)
Museum of Modern Art, New York, USA

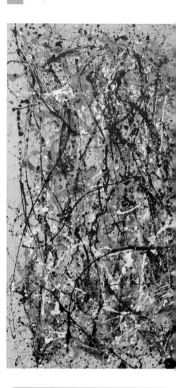

⊚

Pollock's methods of evoking the rhythmic energy of nature emerged from his interest in primitive cultures, particularly the Native American Navajo, and the work of Pablo Picasso, Joan Miró and the Surrealists, and of the Mexican muralists David Alfaro Siqueiros and José Clemente Orozco. His development of Action Painting flouted the traditions of easel painting.

①

Pollock believed that the canvas should express the artist's emotions. His images were not painted; they happened. He said: 'The painting has a life of its own. I only let it come through.'

Since he first produced paintings using his 'drip' technique, with infantile-looking splashes and squiggles, Pollock's work has been compared to the scribbles of young children. In 1950, he declared: 'New arts need new techniques. The modern artist cannot express this age; the airplane, the atom bomb, the radio, in the old forms of the Renaissance or of any other past culture.' So although this work might initially appear to be a childish scrawl, it actually conveys the preoccupations of the time.

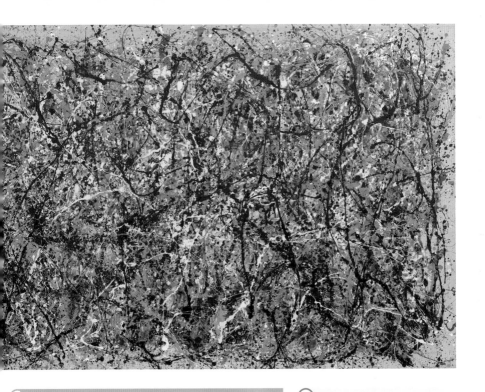

Pollock's fascinations included primitive art, myths, automatism and Jung's philosophies. His pouring, dripping and flinging of industrial paint on to large unstretched, unprimed canvases on the floor was radical and overturned traditional notions of painting. As he worked, he walked around or on his canvases, applying paint in a rhythmic, almost ritualistic manner.

Eyes in the Heat, 1946
Peggy Guggenheim Collection,
Venice, Italy

Number 1, Lavender Mist, 1950
National Gallery of Art,
Washington, DC, USA

Convergence, 1952
Albright-Knox Art Gallery,
Buffalo, NY, USA

This is a Saluki, an Egyptian hunting dog and probably the oldest breed in the world. In 1965, Alberto Giacometti (1901–66) recalled the origin of the work, simply titled *The Dog* (*Le Chien*): 'One day I was walking along the Rue de Vanves in the rain, close to the walls of the buildings, feeling a little sad perhaps and I felt like a dog just then. So I made that sculpture. The sad muzzle has a likeness to the Saluki.' About five years before he produced this, Giacometti had determined to depict figures as he actually experienced them, from his viewpoint: to fuse reality with representation and not to aim for superficial, photographic likenesses. In 1951, along with this sculpture, he also created sculptures of two other kinds of animal: two horses and a cat. These were his first sculptures of animals. His extreme characterization of the dog was regarded by some as a humorous caricature and by others as a metaphor for the human condition in post-war Europe. Almost certainly emblematic, the dog and its downtrodden stance also represent Giacometti's perception of the struggle of artists for recognition. He never again featured animals in his sculptures, but this lone work follows the attenuated, seemingly weightless style of his human figures. The distant, emaciated animal personifies depression and need, while the hidden depths of its personality are overshadowed by its hunger. In 1957, the novelist and playwright Jean Genet described the work in an essay: 'He prowls and sniffs, muzzle level with the ground. He is gaunt.'

bronze
46 x 99 x 15 cm
(18⅛ x 38⅞ x 5⅞ in.)
Kunsthaus, Zurich,
Switzerland

THE DOG
ALBERTO GIACOMETTI
1951

After World War II, many people were re-evaluating the meaning of existence. Existentialism, the belief that our lives are shaped by our own choices, became popular. Jean-Paul Sartre described Giacometti as an Existentialist, but the artist insisted that, although his ideas may have parallels in the philosophy, he merely rendered his observations.

Three Men Walking II, 1949
Metropolitan Museum of Art,
New York, USA

Man Falling, 1950
Kunsthaus, Zurich, Switzerland

The Cat, 1954
Metropolitan Museum of Art,
New York, USA

? At a glance, you might think that a child could have made this, but not even the roughness of the finish can conceal the artist's technical proficiency and sophistication. Giacometti's lean and textured structure conveys the basic form and fur of the animal as it lopes along. It expresses the artist's direct observations and his emotional response to the subject, together with his inner perceptions that developed. This is the way he imagined the dog should look.

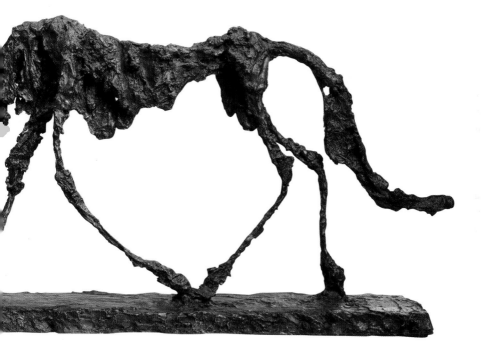

After experimentation with Cubism and primitive art, Giacometti had a Surrealist phase, which he later abandoned. But the explorations shaped his output. Following the sketchy, linear methods he employed in drawing and painting, he worked quickly in plaster, building up a palpable sense of a physical presence.

Giacometti said that he sculpted not forms but 'the shadow that is cast' by figures, in an attempt to capture their overall impression, or 'spirit'.

Stella was not opposed to Abstract Expressionism but simply endeavoured to move in a different direction. 'Post-painterly Abstraction' and 'Hard-Edge Painting' were terms used in the late 1950s and early 1960s to describe his work and that of others who also preferred detachment over emotion. The direction that their painting took helped to activate Minimalism.

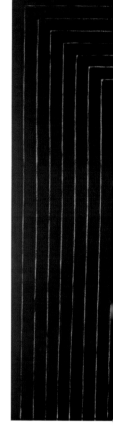

THE MARRIAGE OF REASON AND SQUALOR II

FRANK STELLA

1959

This painting by Frank Stella (1936–) was a move away from the emotive subjectivity of Abstract Expressionism, the dominant art movement of the time. Later known as one of Stella's 'Black Pinstripe' canvases, it appears to be painted in two equal halves, each side containing twelve stripes of black enamel paint radiating from a central vertical line. Stella was inspired by Jasper Johns, particularly his flag paintings and his theory that the canvas and paint should be viewed as a whole object, independent of what was represented. Despite the subordinated content, Stella's freehand brushstrokes allowed for a certain amount of individuality, including occasional drips and irregularities, indicating that he did not entirely reject the act of painting. When he exhibited the work in 1959 with four similar paintings, its controlled austerity was so far removed from the exaggerated surfaces of Abstract Expressionism that it sparked a heated debate. In defence of his approach, he said: 'Painting is a flat surface with paint on it—nothing more. It is a physical object, rather than a metaphor for something else. What you see is what you see.'

enamel
on canvas
230.5 x 337 cm
(90⅝ x 132½ in.)
Museum of
Modern Art,
New York, USA

Challenging the concept of painting that had remained since the Renaissance, Stella promoted the idea of artists as labourers. To emphasize this, he used commercial enamel paint, a housepainter's brush and a palette knife for this work. He painted rhythmically, without any mechanical assistance, with the result that natural irregularities appeared.

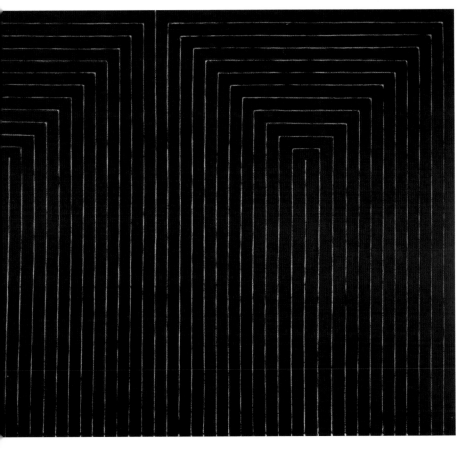

A large canvas, painted black with pin-width parallel lines of the canvas showing through in a geometrical pattern, may seem simple enough to create. Even though a five-year-old would have trouble keeping the fine lines regular, this piece could be replicated by a child. However, Stella was making a topical and philosophical statement, challenging Abstract Expressionism's gestural domination and rejecting metaphorical associations, symbolism or suggestions of spirituality that so many other artists sought to express. He wanted viewers to appreciate the canvas as an object in itself. As he said, he aimed to 'eliminate illusionistic space'.

Six Mile Bottom, 1960
Tate Collection, London, UK

Harran II, 1967
Solomon R. Guggenheim Museum, New York, USA

Agbatana II, 1968
Musée d'Art et d'Industrie, St Etienne, France

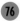

The raw, free and spontaneous application of paint in this work seems as if it could have been produced by a child, and the approach does indeed derive from the liberating simplicity of children's paintings. However, Jorn's fascination with colourful and expressive childlike imagery was a way of liberating his work from what he saw as repressive bourgeois conventions and the manifestation of 'Pataphysics, an obscure, irrational philosophy to which he adhered.

acrylic and oil on canvas
200 x 300 cm (78⅝ x 117⅝ in.)
Private collection

Disturbed Grief, 1957
Stedelijk Museum, Amsterdam,
Netherlands

The Timid Proud One, 1957
Tate Collection, London, UK

IN THE BEGINNING WAS THE IMAGE
ASGER JORN
1965

In the Beginning Was the Image exposes the philosophical beliefs of Asger Jorn (1914–73), which were based on 'Pataphysics (with a single opening quotation mark), invented by the French playwright Alfred Jarry. While the Surrealists and their followers found 'Pataphysics amusing, Jorn took it seriously, because the associated disorder and confusion corresponded to his many, often conflicting, theories. Here, viewers are presented with an image of the 'Pataphysical world. The multicoloured, vaguely discernible images are intentionally mysterious, and no single interpretation is correct: whatever anyone can see is acceptable. Each face or feature that Jorn originally painted was deliberately disfigured by him before it took on a distinct form. Moreover, the imposing scale, along with his use of a familiar line from the Bible, 'In the beginning was the Word', implies the work's importance. Although he once said: 'I use the titles in a very slapdash way,' he carefully selected them to complement his work and to an extent aimed to guide viewers' interpretations. Also apparent here is his fascination with his Nordic heritage and his early interest in Wassily Kandinsky and Fernand Léger, his former teacher.

Jorn worked in numerous disciplines, including painting, sculpture, ceramics, collage and writing. Aiming to liberate preconceptions, every gestural brushstroke was simply a reaction to the last as he aimed to delve beneath superficiality.

In 1948, in a Parisian cafe, Jorn, Christian Dotremont, Joseph Noiret, Constant Nieuwenhuys, Corneille and Karel Appel—artists from Copenhagen, Brussels and Amsterdam—formed CoBrA, named after the first letters of the cities. Their art movement was to be inspired predominantly by children's art, primitive art forms and the work of Paul Klee and Joan Miró. In 1951, although its popularity had increased, the CoBrA movement was officially disbanded.

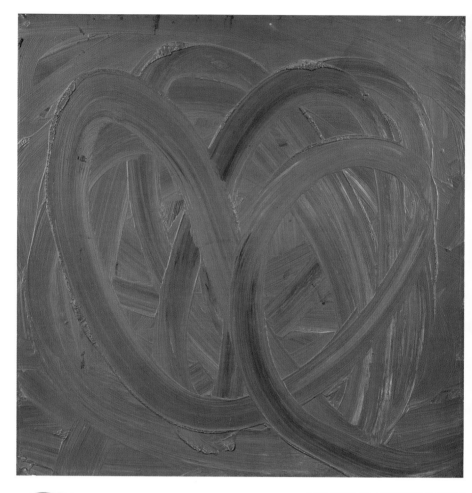

The loops and swirls of paint on this grey canvas are simple enough for a child to create as an exercise, but when Richter produced it he was already established as a skilful painter. This work is part of a series: the colour chosen for its neutrality, the style for its expressiveness. It was created to investigate feelings of loss and hopelessness, and express hidden truths that Richter believes are exposed in painting by chance.

Richter's formative years had a huge effect on his development. His father and uncle were involved with the Nazi movement, and, from 1946, the East German communist regime imposed strict rules on art.

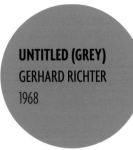

UNTITLED (GREY)
GERHARD RICHTER
1968

In 1969, Gerhard Richter (1932–) began to produce a group of abstract, grey paintings that were simply made up of textures, created by various methods of paint application. He had escaped to West Germany just before the completion of the Berlin Wall in 1961, where he discovered a world beyond the realist images that had been insisted upon in East Germany by the post-war Soviet government. Inspired by the energy and liberation he saw in abstract paintings, he began producing works like this in an uninhibited manner, to explore his inner feelings. He used various materials to attain chance details and textures, blurring, scraping and swirling paint freely. He said: 'Grey. It makes no statement whatever; it evokes neither feelings nor associations: it is really neither visible nor invisible. Its inconspicuousness gives it the capacity to mediate, to make visible, in a positively illusionistic way, like a photograph. It has the capacity that no other colour has, to make "nothing" visible.' Years later, he gave additional underlying reasons for these works: 'Grey monochrome paintings [were] the only way for me to paint concentration camps. It is impossible to paint the misery of life, except maybe in grey, to cover it.'

Richter was inspired by Abstract Expressionism, Pop art, Fluxus and Dada, and by the work of Jackson Pollock, Lucio Fontana, Joseph Beuys, Georg Baselitz and Andy Warhol. For years, the effects of growing up in Germany during the Holocaust profoundly influenced him too. He has inspired artists including Christopher Wool and Ellsworth Kelly, as well as the Minimalist and Conceptualist movements.

After moving to Düsseldorf in West Germany in 1961, Richter began projecting and tracing photographic images directly on to his canvases, and blurring them in order to force viewers to consider the painting processes rather than the subject matter itself. In his series of grey paintings, he applied layers of paint thickly, smearing and moving it with brushes, rollers or window-cleaning tools. The resulting unplanned textures and marks appeared as spontaneous, formless and gestural illusions, so that the paintings did not convey one set meaning.

oil on canvas
50 x 50 cm (19⅝ x 19⅝ in.)
Artist's collection

Grey, 1974
Tate Collection, London, UK

256 Colours, 1974
Kunstmuseum, Bonn, Germany

Self-Portrait, 1996
Museum of Modern Art, New York, USA

UNTITLED
MARK ROTHKO
1968

Although he did not allude to underlying meanings or narratives, Rothko did explore the effects of colour and form on the psyche. His colours are intense, with subtle gradations, and induce almost religious feelings of meditation in viewers who contemplate his paintings. To increase their impact as part of the world rather than separate objects, they are always frameless.

Rothko declared that Henri Matisse's *Red Studio*, bought by MoMA in 1949, inspired most of his later works.

oil on paper mounted
on masonite
99 x 63.5 cm (38⅞ x 25 in.)
Private collection

No. 10, 1950
Museum of Modern Art,
New York, USA

*No. 9 (Dark over Light Earth/
Violet and Yellow in Rose)*, 1954
Museum of Contemporary Art,
Los Angeles, CA, USA

Red on Maroon, 1959
Tate Collection, London, UK

Early in his career, Mark Rothko (1903–70) worked through a variety of styles, including Expressionism and Surrealism, but by 1950 he had arrived at his ideal style, exploring 'the simple expression of the complex thought'. Working on huge canvases, he created paintings usually comprising two or three soft-edged rectangles of luminous colour against a coloured or monochrome background. This work is painted with broad brushes and sweeps of yellow, with a dry brush used to create the brighter yellow shapes over the top. He explored a wide range of colours and tones in order to evoke different moods and atmospheric effects, which varied from calming to uplifting to fortifying. In dispensing with all representational connotations, he concentrated on the mechanical and pictorial properties of painting, including colour, light, line, shape, space, proportion and scale. Literally saturating each canvas with colour, his work became known as Colour Field Painting, although he rejected the term. He claimed that his painting expressed the 'full gravity of religious yearnings and the angst of the human condition'. He added: 'I'm not interested in the relationship of colour or form or anything else. I'm interested only in expressing basic human emotions: tragedy, ecstasy, doom and so on.'

Along with Barnett Newman and Clyfford Still, Rothko was one of the leading exponents of an area of Abstract Expressionism that was less concerned with the action of painting and more interested in the investigation and application of colour. He was largely self-taught as an artist, and his thinly applied colour inspired many others.

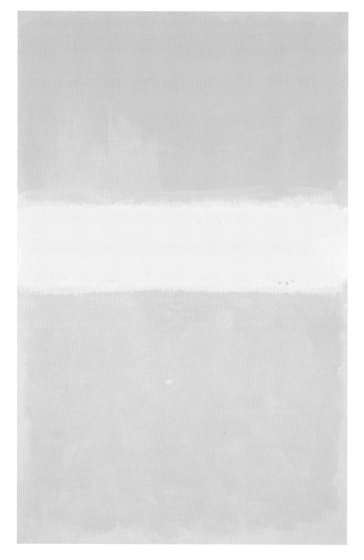

When Rothko said that artistic expression was drawn from 'the spontaneity, simplicity and directness of children', he was not implying that a child could do what he did. At first glance, the simple painted shapes (which he called 'multiforms') might suggest otherwise, yet Rothko's compositions and thinly layered colours were planned deliberately to induce powerful, even spiritual feelings in viewers.

? What child would not enjoy pouring liquid latex on a floor and watching the bright colours swirl together? It is an exercise that would delight most. However, in *Corner Piece* Benglis was highlighting several prevalent creative ideas and art movements, including Minimalism, Pop art, Abstract Expressionism and feminism. Irreverence, respect, irony and humour are all expressed as she strove to expand the boundaries of art.

In the late 1960s and 1970s, Benglis worked in a loft studio in New York, creating floor pieces and wax paintings. Few of these paintings remain, because she burnt many of them to heat her studio.

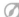

CORNER PIECE
LYNDA BENGLIS
1969

The inspiration for this piece was the medley of ideas that had been evolving across the United States as Lynda Benglis (1941–) was growing up. By 1969, the dominant art styles were Minimalism, Abstract Expressionism and Pop art; Benglis mixed the low art materials of Pop with the gestural movements of Abstract Expressionism, contrasting them with the ordered, static shapes of Minimalism. In this dynamic and confrontational work, she also deviated from traditional perceptions of the female as passive and acquiescent, affirming her position as a feminist. While Minimalists used detached processes, industrial materials and simplified forms, Benglis leant towards the energetic, demonstrative approach of the Abstract Expressionists. Fascinated by the properties and behaviour of latex, as well as by viewers' reactions and the idea of working in a controlled manner with a relatively uncontrollable substance, she aimed to demystify the act of creation and to evoke tension between her process and the finished object. The unstructured streams of colour were created in a method similar to Pollock's Action Paintings, and the multicoloured swirls that emerged in the mass became a record of that procedure: a biomorphic form abounding in abstract allusions.

Benglis avoided the conventions and restraints of realistic representation, customary painting practices and traditional materials to create flowing and energetic forms that propel art into everyday life. Emphasizing the act of making, as well as the final forms of her work, her method of pouring and mingling coloured streams of latex derived from Pollock's dripping, throwing and swirling painting procedure. This concept also assimilated with another emerging artistic phenomenon that became known as Performance art.

poured pigmented latex
270.5 x 269 cm (106¼ x 105¾ in.)
Hirshhorn Museum and Sculpture Garden, Washington, DC, USA

Fallen Painting, 1968
Albright-Knox Art Gallery, Buffalo, NY, USA

Zita, 1972
Museum of Art, Rhode Island School of Design, RI, USA

Modern Art Number 1, 1970–74
Museum of Modern Art, New York, USA

Fascinated by Jackson Pollock, Helen Frankenthaler, Barnett Newman and Andy Warhol, Benglis developed a unique artistic approach. As a result, she has been associated with feminist art and Post-Minimalism, which uses Minimalist concepts combined with human participation, placing emphasis on organic form and gesture. She has inspired many younger artists, including Matthew Barney and Polly Apfelbaum.

ROOM WITH CHAIR
HOWARD HODGKIN
1969

By blending representational elements and personal reflections with an Abstract Expressionist approach, Hodgkin creates bright, semi-abstract paintings and prints, which evoke themes such as sexuality, loss and memory. Vividly coloured paint in thick streaks and blobs and translucent washes render conversations, encounters and other experiences through vaguely recognizable imagery. In the 1970s, he moved from painting predominantly geometric shapes to more fluid, lyrical patterns, inducing moods and sensations in colours often inspired by his many travels, particularly to India. Despite an appearance of spontaneity, his layered technique is carefully planned and executed.

Renowned for his powerful use of colour, Howard Hodgkin (1932–) produces both figurative and abstract work, which he describes as 'representational pictures of emotional situations'. This piece was created at the end of his 'geometric' phase, when he was moving towards softer, more variable applications of paint, and his smooth, flowing lines of colour were replaced with more expressive, shorter splodges and smudges. The image remains indefinable, indicative of a chair in a space, yet not an actual interior scene. The flat colours and shapes suggest a location, a memory, autobiographical details and an intimate reflection of human behaviour and custom, but nothing tangible. Hodgkin claims that his work protects and preserves aspects of the memory, anchoring its elusiveness and stimulating viewers' own memories and experiences. Concurrently, he intended this painting to be an evocative representation of an environment and a transient moment depicted in a style reminiscent of the Indian miniatures he admired. Viewers are invited to consider whether they are looking at an objective pattern of colour and shape; into a room containing carpet, chair, skirting board and brightly painted wall; or symbolic representations of human presence and habits.

Red Bermudas, 1978–80
Museum of Modern Art,
New York, USA

Rain, 1984–89
Tate Collection, London, UK

Memories, 1997–99
National Galleries of Scotland,
Edinburgh, UK

Hodgkin's work features aspects of Pop art, such as bright, abbreviated elements, and more emotive Abstract Expressionist techniques. After the 1970s, as his painting became looser, it was often compared to the intimate and exuberant works of Pierre Bonnard, Edouard Vuillard and Henri Matisse. Other diverse influences include Georges Seurat, Pablo Picasso, Willem de Kooning and Mark Rothko.

oil on wood
66 x 74 cm
(26 x 29⅛ in.)
Private
collection

Hodgkin works predominantly from his memory and imagination and therefore requires few props. His paintings are usually fairly small in scale and focus on the fleeting nature of life, which is ironic because many of them take him years to complete.

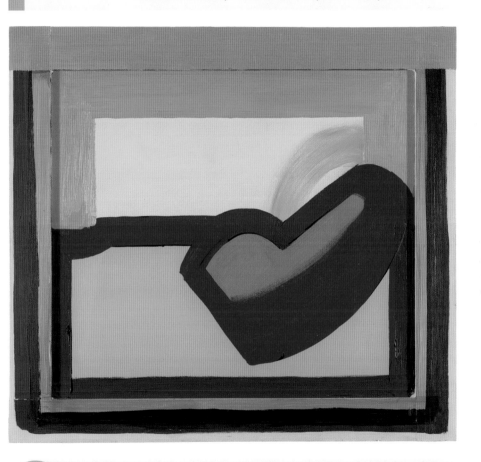

Flat, bold colours applied with palpable brushmarks convey an unsophisticated style often seen in children's paintings, but this is part of Hodgkin's objective: to inspire recollections, feelings and sensations rather than solid ideas. The animated marks and naive style deliberately evoke direct and unpredictable responses, which detailed, lifelike imagery would not express with such strength and immediacy.

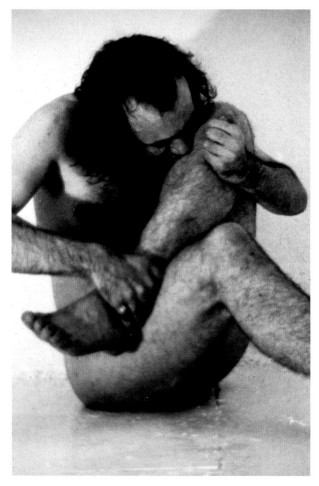

Although children might fling off their clothes and even bite themselves, they could not consider the multifaceted ideas that Acconci has contemplated, inspired by life experience. In the photographs, Acconci explores the commercial practice of branding through trademarks in our over-supplied consumerist world, while at the same time criticizing traditions of art and the established and obdurate way in which art is presented.

black-and-white
photographs
35.5 x 193 cm
(14 x 75⅞ in.)
Blanton Museum of Art,
Austin, TX, USA

**TRADEMARKS
VITO ACCONCI
1970**

Crossing boundaries of personal space, social taboos and privacy, performances by Vito Acconci (1940–) feature unsettling and often repugnant personal acts. At the same time, his work is also articulate and playful as he challenges attitudes towards art within society. In this work, he used his body to explore both superficial and deeper connotations of everyday life. Sitting naked in an empty gallery space, he twisted his body into contorted poses and bit his legs, arms and shoulders, creating impressions of his own teeth on his skin. He then applied printer's ink to the bites and made prints of them. Multiple messages are implied, including a reference to Jackson Pollock, who was perceived as a powerful and masculine figure in control of his large, physical paintings. By using printing ink, Acconci conveys a love of language. Additionally, as the title *Trademarks* proclaims, he was investigating society's reliance on branding and how commercial goods are valued by their trademark, while well-known figures, such as celebrities and politicians, are also categorized and judged in similar ways. Unlike many of his works, *Trademarks* was not performed in front of a live audience. Instead, a series of the photographs was printed in the US art magazine *Avalanche* in 1972.

Acconci initially devoted himself to a career as a writer, but by 1969 he was producing installations and enacting performances, specifically addressing the relationships between artist and audience. This led him to expose elements of his own privacy or to invade the personal space of others. In his performances, which he records with photographs and film, he explores how we function in society, including our attitudes towards art. All his work is infused with a sense of humour.

Having started out as a poet and writer in New York, Acconci says a chance encounter with a painting by Jasper Johns in the late 1960s changed his career.

Influenced by both Fluxus and Dada, Acconci crosses boundaries between Conceptual art, Body and Process art, Performance art, film, video and installation. For this diversity, he is often branded a Post-Minimalist and, like other Post-Minimalists, he engages predominantly with social issues and less frequently with specific art-related concerns.

Conversions, 1971
Museum of Contemporary Art, Barcelona, Spain

Under-History Lessons, 1976
Museum of Contemporary Art, Los Angeles, CA, USA

20 Foot Ladder for Any Size Wall, 1979–80
Museum of Modern Art, New York, USA

**24 HOUR PSYCHO
DOUGLAS GORDON
1993**

Douglas Gordon (1966–) began interceding with Alfred Hitchcock's masterpiece more than thirty years after it was made, reducing it from a flowing 109-minute film, full of projected tension, to a series of stills, making viewers look again at the images in terms of camera angles, editing and time, rather than considering the story or the characters. The slowing down of the film distorts the flow of images, thus deconstructing the process, removing its original objective and reducing it to its most basic essentials—changing the familiar to the unfamiliar. Part of Gordon's investigation was to explore how he could alter, expand and distance viewers' expectations, understanding and experience of moving pictures in general, which was why he used such a well-known and classical work. He insists that his piece is not merely a work of appropriation or a simple abduction, and explains that he created it to make audiences reconsider the original film. He maintains that skill and technical ability are not part of his rationale: he was not competing with Hitchcock's expertise but using it as a conduit. The extended replication of the film was created to stimulate recognition, memories, considerations of authorship and authenticity, and questions about perception and meaning. The focus was never on film-making, nor subject matter, but on the medium itself. Above all, it was about viewers' own interpretations.

black-and-white video,
24-hour running time

Gordon explores ideas through photography, video, film, text, sound and installation. Most of his work is concerned with media, communication technologies and representation, and it can be seen to have built on Pop art ideas and, in particular, Conceptualism.

*Confessions of a
Justified Sinner*, 1995
Cartier Foundation,
Paris, France

Monster, 1996–97
Honolulu Academy of Arts,
Waikiki, Hawaii, USA

Little technical ability was required to adapt and decelerate Hitchcock's 1960 film *Psycho*, so it is conceivable that a child could have done this. Yet by decreasing the speed of the well-known film, Gordon was considering how it was originally constructed and the responses of viewers to the altered version rather than the content of the film itself or his methods of making the video.

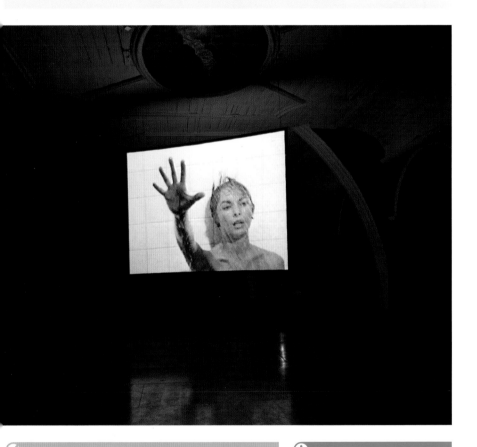

Gordon often reworks well-known films and other material from the public domain, slowing them down, cutting and repeating elements, rewinding, dissolving and generally re-presenting them. He maintains that his working process develops from his memories.

In order to further examine themes such as trust, guilt and confession, Gordon also creates tattoos, both on himself and on others.

By 1960, Hoyland had begun to produce his first fully non-representational paintings, using bands of colour to explore visual effects, such as illusions of progression and recession. He often squeezed paint on to his supports directly from the tubes, and his thick, impasto textures and lines were confident, boldly coloured and sinuous, with free, fluid brushmarks, in an attempt to make ideas and technique inseparable. From the late 1960s, he also transferred many similar methods to screenprints, lithographs and, later, etchings and monotypes.

acrylic on canvas
66 x 51 cm (26 x 20 in.)
Private collection

Downland, 1978
Courtauld Gallery,
London, UK

North Sound, 1979
Tate Collection,
London, UK

Memory Mirror, 1981
Fitzwilliam Museum,
Cambridge, UK

TREE OF LIFE
JOHN HOYLAND
1994

Tree of Life was a title John Hoyland (1934–2011) used for several paintings that each explored a simple concept to express more complex ideas. Applied with brushes and a palette knife, the jewel-like colours of this work reflect the tropical countries he visited, especially Jamaica. In the painting, he investigated, as had many artists before him, the continuation and source of life, and the fruitfulness and abundance of nature, along with various established and traditional myths about the tree of life. With these symbolic and legendary connections, *Tree of Life* also represents the abstract elements of love, wisdom, rebirth, strength, redemption, friendship, bounty and encouragement. Hoyland was delighted to take an accepted and ancient icon for his own modern explorations and interpretation. The expressive force of this painting derives from the intensity of colour and the power of the abstract forms. Unlike the Abstract Expressionists, Hoyland was reluctant to impart his own feelings into his work, but with his gestural and positive approach he applied the paint in energetic, expressive lines and splodges of vibrant colour. This powerful style suggests ideas to individual viewers rather than representing the artist's personal feelings.

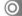

In New York in 1964, Hoyland met Helen Frankenthaler, Barnett Newman, Kenneth Noland and the critic Clement Greenberg, who showed him work by Hans Hofmann and Morris Louis. He was inspired by them all, and especially by Colour Field painting and Post-painterly Abstraction. His friends Robert Motherwell and Anthony Caro also influenced him.

Most children paint what they think they know rather than what they actually see. This work looks as though a young child could have painted it, depicting an idea rather than reality, and creating a symbol of a tree. However, in *Tree of Life* Hoyland was expressing Abstract Expressionist ideas, examining the properties of his paint and showing feelings without emotion, while also exploring perception and illusion.

By pushing boundaries and presenting completely new concepts, Hirst changed perceptions of contemporary art. Never reliant on technical skill, he has always focused on underlying meanings rather than conventional considerations of art. His work is diverse, often shocking and usually driven by powerful messages. Openly declaring himself to be a brand, he began the series of spin paintings by placing large canvases on a centrifuge and pouring cans of household gloss paint on to the surface. As the canvases spin, the colours splatter outwardly in random shapes and colours.

household gloss on canvas
183 cm (72 in.) diameter
Private collection

BEAUTIFUL, POP, SPINNING ICE CREAMY, WHIRLING, EXPANDING PAINTING
DAMIEN HIRST
1995

One of the most important artists of the late 20th and early 21st centuries, Damien Hirst (1965–) transformed the direction that art was taking and rocketed to fame in the 1990s with some of his most provocative works, which notoriously featured dead animals suspended in formaldehyde. Like many recent artists, he insists that the idea is more important than the actual piece. As he said: 'The hand of the artist isn't important—you're trying to communicate an idea.' The central themes behind this spin painting are similar to many of his other concepts: a re-examination of how we live and our mortality, including the vulnerability of existence and why we make certain choices, many of which are uncomfortable, thoughtless or disingenuous. Characterized by their wit, energy and forcefulness, these spin paintings emphasized a renewed interest in the practical processes of making and of craft techniques, highlighting arbitrary and expressive forces. Hirst found it amusing that people constantly questioned which way up the spin paintings should be, so he now displays them all on a revolving mechanism—just as there are many options in life, so he illustrates that there are infinite possibilities in these works. As he says, 'I hope it makes people think about things that they take for granted . . . I want to make them question.'

Hirst claims that if people were to attend art exhibitions as frequently as they watch films and advertisements, they would understand art more.

Following traditions started by Salvador Dalí and Andy Warhol, Hirst embarked on entrepreneurial self-promotion, which helped to establish his fame. In 1988, while still an art student, he organized a groundbreaking exhibition in London, which prompted the label Young British Artists, or YBAs.

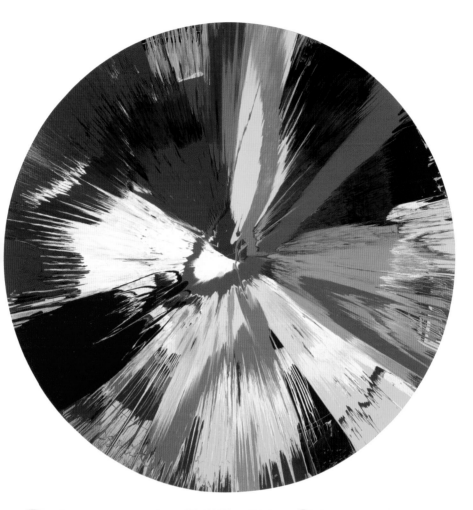

Inspired by a painting technique that he saw as a child on the BBC's *Blue Peter* programme, Hirst began experimenting with spin paintings in 1992. A child could do this, but Hirst was examining the choices of ironies, pretences, falsehoods and desires that we face as we navigate through life. To compound the idea of chance, most of Hirst's spin paintings were produced by assistants.

Forms Without Life, 1991
Tate Collection, London, UK

Away from the Flock, 1994
Tate Collection, London, UK

Controlled Substance Key Painting, 1994
Tate Collection, London, UK

Every few seconds, lights go on and off in an empty room. A child could switch lights on and off, but Creed was exploring society's ingrained expectations of art and intentionally provoking reactions of disbelief, anger, surprise and comedy. Following a long line of Conceptual artists who reinterpreted Duchamp's readymades, Creed timed the lights specifically so that viewers had time to walk into the room and look around before it went dark again.

WORK NO. 227: THE LIGHTS GOING ON AND OFF
MARTIN CREED
2000

There was a furore in the British press after this installation won the Turner Prize in 2001. At five-second intervals, lights are turned on and off in a bare-walled gallery. Affronted journalists complained that an empty room in an art gallery should not win any accolades, which was the artist's point. By controlling visibility conditions, Martin Creed (1968–) directed viewers' attention to walls that normally act as the background for art objects. Rather than a support for artwork, the gallery became a medium itself and forced viewers to consider meanings, purposes and established attitudes towards art in museums. *Work No. 227* can also be perceived as a universal metaphor for life: birth (lights on) and death (lights off). Creed was building on notions that began with the Dadaists and continued with Surrealism, Pop art and then Conceptualism. By making the gallery the actual work, *Work No. 227: The Lights Going On and Off* is a witty twist on both Minimalism and Conceptualism, and also disparages the arrogance of much contemporary art. In order to eliminate any further claims of pretentiousness, each of Creed's diverse artworks is categorized by a number, and all exploit materials with little commercial value, thus intentionally challenging the profligate culture in which we live.

By confronting artistic traditions, viewers' sense of space and their expectations of a gallery experience, Creed's work emerges from Minimalism, Conceptualism, Performance and Installation art. It is usually classed as Post-Conceptualism because, as he states, it is up to viewers, not artists, to decide what a work is about.

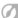

A central theme of Creed's work is the nature of art, and he uses non-traditional art materials, which generally have no significant value, as well as a large dose of humour. Although this theme is the preoccupation of a great deal of modern art, Creed explores it in non-conformist, droll and sometimes unsettling ways.

Creed numbers all his works—disregarding their size or importance—and then follows each number with a title that simply describes what the work is.

electrical timer
(5 seconds on; 5 seconds off)
dimensions variable
Museum of Modern Art,
New York, USA

Work No. 143, The Whole World + The Work = The Whole World, 2000
installation

Work No. 220, Don't Worry, 2000
installation

Work No. 790, Everything Is Going to Be Alright, 2007
installation

At first glance, you might think that a child had gone crazy here, flinging paint on to an adult's drawing, but Maggi Hambling's method of working is deliberate and calculated. Swirls and layered strands of colour convey the complex temperament of her sitter. Intentionally building up the surface of the portrait, she has implied the ambivalent nature of the avant-garde Irish writer.

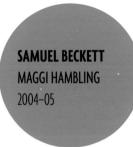

SAMUEL BECKETT
MAGGI HAMBLING
2004–05

Maggi Hambling (1945–) defines the features of the Irish poet and playwright Samuel Beckett with expressive, broken lines and vivid colours. She treats the surface of his skin in much the same way as she would paint the sea: it wildly and organically spreads like a mesh across the composition. Painted fifteen years after Beckett had died, the portrait forcefully captures his intense character and the close understanding and empathy between artist and subject. Because the canvas is filled almost entirely with Beckett's face, the image is thrust forward, creating a confrontational intimacy. Viewers feel that they are in the man's presence. Luminous marks appear to pulsate with life and energy. Hambling worked from earlier drawings that she had made from life, additionally gathering her memories and perceptions of the poet to create an image that reaches beyond conventional realism. A personality trait shared by Hambling and Beckett was that of treating death with wit and ingenuity, rather than with the usual sadness and solemnity. Her approach to the painting is audacious and determined as she considers her subject matter. She perceives his strengths and weaknesses and conveys his dark humour, working across the portrait with rapidly applied scribbles of colour.

Hambling's reputation became established mainly through her vivid portraits. With dynamic brushstrokes and a fluid manner, she conveys her subjects' fleeting emotions and underlying personalities in a blend of control and automatism. Although she paints many portraits in her sitters' last months, or even after they have died, she insists that life forces, not death, compel her to paint.

Hambling drew her mother in her coffin, declaring that it seemed 'the most natural thing to do'.

oil on canvas
122 x 91.5 cm (48 x 36 in.)
Private collection

With an intrinsic curiosity and fascination for exposing deep-rooted elements, both in portraits and landscapes, Hambling has an animated and expressive style that cannot be categorized. It has been inspired by artists as varied as Alberto Giacometti, Paul Klee, L. S. Lowry, Francis Bacon and Andy Warhol, as well as the coast near her home in Suffolk, England.

Max Wall and his Image, 1981
Tate Collection, London, UK

Shop Window, Red Light District, Barcelona, 1985
Fundação Calouste Gulbenkian, Lisbon, Portugal

George Melly, 1998
National Portrait Gallery, London, UK

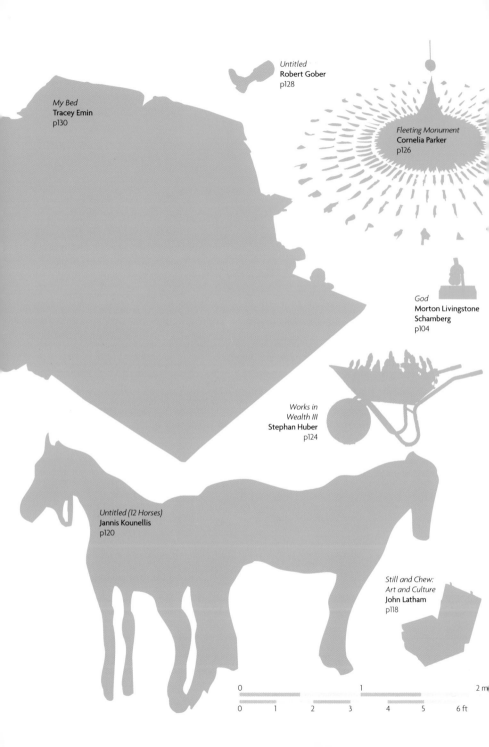

Untitled
Robert Gober
p128

My Bed
Tracey Emin
p130

Fleeting Monument
Cornelia Parker
p126

God
**Morton Livingstone
Schamberg**
p104

*Works in
Wealth III*
Stephan Huber
p124

Untitled (12 Horses)
Jannis Kounellis
p120

*Still and Chew:
Art and Culture*
John Latham
p118

0 1 2 mi

0 1 2 3 4 5 6 ft

CHAPTER THREE
PROVOCATIONS /
TANTRUMS

In 1917 when Marcel Duchamp
exhibited *Fountain*, his upside-down
urinal, he instantly rendered obsolete
craft skills that had been a necessary
mark of quality in art for centuries. He
was the cause of much scandal among
critics and the public, as he ultimately
eliminated sentiment, self-importance,
good taste and cultural traditions from
art. Many of the artworks contained in
this chapter follow his lead and exploit
new visual technologies and original
ways of thinking. For example, Morton
Livingstone Schamberg's *God* and *Still
and Chew: Art and Culture* by John
Latham, which both use readymade
objects, and Gavin Turk's bronze bin
bag all dissolve distinctions between
acceptability and absurdity.

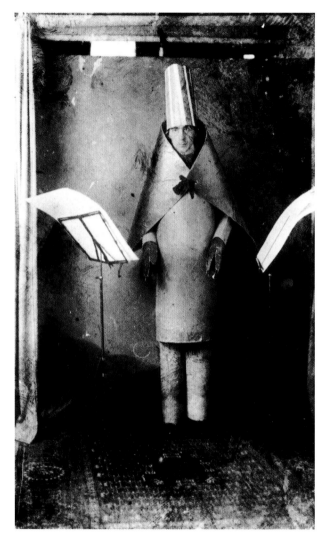

This homemade costume created out of coloured cardboard would look more appropriate on a child, and it is certainly something that many would love to make and wear. On a grown man, however, it looks quite absurd, which was Ball's intention. The silly costume—and nonsense poem that Ball recited while wearing it—was part of a performance that he staged in reaction to World War I and all its horrors, which were annihilating all previously established principles and beliefs.

MAGICAL BISHOP COSTUME
HUGO BALL
1916

In 1916, Hugo Ball (1886–1927) opened a nightclub in Zurich, which he called the Cabaret Voltaire, as one of the manifestations of Dada ideas. The club was used for artistic and political purposes and was pivotal in the development and promotion of the Dada movement. Wearing this bizarre and cumbersome costume, he appeared on stage in the club. In his diary entry, he described the outfit: 'My legs were covered by a sort of bright blue cardboard column that made part of my body look like an obelisk. Over this, I was wearing an enormous gold cardboard collar lined with scarlet paper, attached around my neck so as to allow me to flap it like a pair of wings by raising and lowering my elbows. The costume was topped off with a magician's hat, a very tall, blue-and-white striped cylinder.' Standing in the costume, he recited the first of his 'sound poems', which were nonsense words that came out as strange noises. That evening, he recorded his impression of the event: 'A pale, bewildered face in my Cubist mask, that half-frightened, half-curious face of a ten-year-old boy, trembling and hanging avidly on the priest's words in the requiems and high masses in his home parish. Then the electric lights went out, as I had ordered, and bathed in sweat, I was lowered off the stage like a magic bishop.'

◎ Ball chose to use satire to illustrate the Dadaists' abhorrence of World War I. With no set style or leader, Dada aimed to obliterate traditional values, particularly in art. The work they produced relied on chance, absurdity and experimentation rather than skill. Even the name Dada has multiple meanings. It eventually formed the basis of Surrealism.

Ball left Germany for neutral Switzerland during World War I, where he co-founded the Dada movement. He and others questioned every aspect of civilized life. Principally a writer, he wrote the Dada manifesto and a journal. He said: 'For us, art is not an end in itself . . . but . . . an opportunity for the true perception and criticism of the times we live in.'

Ball's intention was 'to remind the world that there are people of independent minds—beyond war and nationalism—who live for different ideals.'

ⓘ gelatin silver print
71.5 x 40 cm (28⅛ x 15¾ in.)
Fondation Arp, Clamart, France

Bicycle Wheel, Marcel Duchamp, original 1913
Centre Georges Pompidou, Paris, France

Dada Movement, Francis Picabia, 1919
Museum of Modern Art, New York, USA

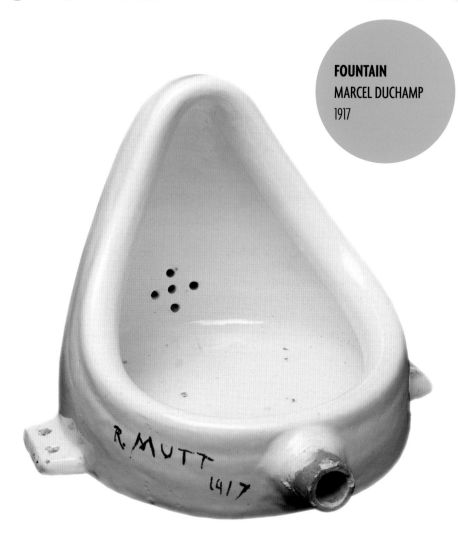

FOUNTAIN
MARCEL DUCHAMP
1917

Few works of art are so easily accused of infantile humour as Marcel Duchamp's *Fountain*. Perhaps only a childish mind could devise such a joke at the expense of the adult art world. However, no novice could have judged the right moment to intervene or chosen the best means to scandalize the public. *Fountain* is a feat of ideas, and that is why the presentation of such a found object stands beyond the reach of children. Single-handedly, this work revolutionized art almost beyond compare.

This most famous provocation of the art world began when the Frenchman Marcel Duchamp (1887–1968) bought a standard urinal from a New York hardware store. Duchamp had previously been a Cubist painter, but in around 1913 he started to abandon painting in favour of readymades—ordinary objects that, with little or no transformation, he nominated as art and attempted to exhibit in spaces where art was expected to be viewed. He signed this particular readymade with a pseudonym, R. Mutt, gave it the title *Fountain* and submitted it for the annual exhibition of the American Society of Independent Artists. By rights, it should have been accepted: Duchamp had surreptitiously obtained membership of the society for his 'Richard Mutt', and all members were allowed to submit work to the exhibition. But *Fountain* was rejected on grounds of indecency and plagiarism (this ugly object was the work of a plumber, it was said, not of an artist). Nevertheless, with one simple but outrageous act, Duchamp proved that the modern artist is not sovereign, and that institutions such as museums also do much to determine what is art. Duchamp posed other questions about art, among them, what are the characteristics and conditions that define an object as a work of art? Should art appeal primarily to the eye (not primarily to the mind), and should it involve some transformation of materials or can a pre-made object be considered for its merits?

Duchamp began his career as a conventional painter but in 1913, inspired by Cubism and Futurism, and influenced by time-lapse photography, he exhibited *Nude Descending a Staircase*. It caused a scandal in the art world. Realizing that, during World War I, abstract ideas were more significant than ever, Duchamp began exploring the idea of 'readymades'. For this, he selected a diverse range of mass-produced, everyday objects and presented them as art, challenging traditional concepts of aesthetics, originality and taste.

found ceramic urinal
36 x 48 x 61 cm
(14⅛ x 18⅞ x 24 in.)
8 casts in museums worldwide

Along with Pablo Picasso, Duchamp was the most influential artist of the 20th century. Inspired by Paul Cézanne, Francis Picabia, Futurism and Cubism, he, and especially *Fountain*, immediately influenced countless other artists, such as Morton Schamberg, Richard Hamilton, Jasper Johns, Jeff Koons, Sherrie Levine and Damien Hirst. Duchamp's legacy continues. This work in particular marked a defining moment, transforming the direction of art over the next century.

The pseudonym inscribed on the urinal, 'R. Mutt 1917', has been interpreted by some as 'Readymade once was, 1917'.

Bottle Rack, 1914 Philadelphia Museum of Art, PA, USA

Comb, 1916 Philadelphia Museum of Art, PA, USA

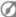

From 1904, Schamberg made several trips to Europe and became inspired by a number of contemporary artists working there. Perceiving machines as objects that could both enrich and depersonalize lives, he explored and interpreted modern technology through paintings that emphasized line and form. As well as being an artist, he was an accomplished photographer and architect, and he used photography extensively to inform his works.

wood mitre box,
cast-iron plumbing trap
c. 1917
height: 31.5 cm (12⅜ in.); base:
7.5 x 12 x 29.5 cm (3 x 4¾ x 11⅝ in.)
Philadelphia Museum of Art,
PA, USA

GOD

MORTON LIVINGSTONE SCHAMBERG

c. 1917

In 1900, the writer Henry Adams compared the dynamo engine with the Virgin Mary, suggesting it as an alternative icon for the modern age, and in 1930, the poet Hart Crane called the Brooklyn Bridge 'the Altar of a new God'. Between these events, Morton Livingstone Schamberg (1881–1918) and Elsa von Freytag-Loringhoven, a poet, shoplifter and collector of junk, presented this inverted household drainpipe on a wooden box, offering a flippant tribute to machines. They called it *God*. Schamberg and Freytag-Loringhoven were Dadaists, who used satire and impudence to mock traditional artistic conventions. The work echoes Marcel Duchamp's *Fountain* (1917), which was exhibited in the same year, partly for the irreverent placing of a banal object as a work of art and partly for its plumbing connections. Although traditionally it has been attributed to Schamberg, recent scholarship suggests that the piece may have been created by von Freytag-Loringhoven, while Schamberg helped with the concept and photographed it. The work's message combines the abhorrence that they felt about World War I and the idea that machines and technology were taking the place of religion.

Schamberg faced antagonism when he returned to the United States and tried out ideas inspired by the art he had seen in Europe, particularly Cubism and Dadaism. *God* was his only three-dimensional work; his main focus was painting.

Schamberg was a pioneer of modernism in the United States, but his career was cut short when he died aged forty-six. Influenced by a diversity of artists and art movements, including Paul Cézanne, Pablo Picasso, Marcel Duchamp, William Merritt Chase, his friend Charles Sheeler, and Cubism, Fauvism and Futurism, Schamberg is classed as a Dadaist as well as an important precursor of Precisionism, a US avant-garde movement that exploited pure form.

? Any child could find a piece of pipe and stick it on a box, but this work has to be taken in context. It was made during World War I by a US pacifist, who worked away from the avant-garde artists of New York and Paris, and whose intention was to question the implications of art during and after such a devastating conflict and how society could have allowed it to happen.

Untitled, c. 1916
Metropolitan Museum
of Art, New York, USA

Painting IV (Mechanical Abstraction), 1916
Philadelphia Museum
of Art, PA, USA

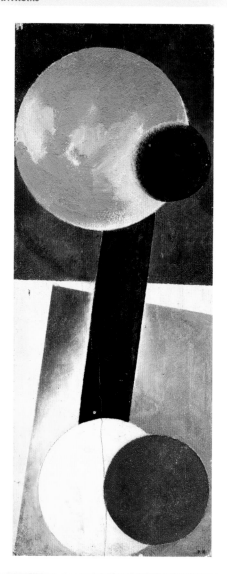

? The abstract geometric shapes painted roughly with flat colour appear to be something a child could produce, but this painting was a reflection of the Russian situation at the time—one year after the Revolution and the year in which World War I ended. Among other like-minded artists, Rodchenko sought to simplify forms into fundamental shapes in an effort to make sense of the changing world.

ABSTRACT COMPOSITION
ALEXANDER RODCHENKO
1918

This painting is intended to reflect the modern world of 1918. Alexander Rodchenko (1891–1956) was a Russian avant-garde artist and a pivotal figure within the Constructivist movement. Inspired by Vladimir Tatlin and Kasimir Malevich's Suprematism, he believed that art could help motivate the social transformations he deemed necessary for his country. Russian Constructivism was in support of the Revolution and was based on the idea that art should reflect the forms and processes of modern technology to help create an ordered, forward-thinking society. Rodchenko believed that new values in everything would help to create an improved future for all, and that art, as well as keeping up with new technological ideas, should also support the changes that were occurring in Russian politics and society. He felt an innate disappointment with the existing world, its outdated systems and unfair hierarchies, and determined to help shape the new age he perceived for Russia. This painting expresses his views through subdued green, blue, orange and black circular and rectangular shapes, which seem to move on the canvas. It does not represent anything concrete, but suggests machinery at work. Overall, it is more about social ideals than about art.

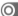

Inspired by Cubism, Art Nouveau, Futurism and, particularly, Malevich and Tatlin, Rodchenko was convinced that art could aid the Revolution. With Wassily Kandinsky, he became involved in government reforms of art collections and education. He also influenced Minimalism and Conceptual art and artists, including Ad Reinhardt, Robert Motherwell and Mark Rothko.

Rodchenko's style changed quite rapidly from his early Art Nouveau designs and impressionistic paintings to abstract works such as this painting, made with rulers and compasses. Although influenced by Suprematism, he did not share Malevich's mystical leanings, declaring that his art was scientific and non-objective. A Bolshevik, he was committed to the Revolution and soon abandoned fine art, instead designing everything from advertising to book covers, to reach even more people. Later he went back to experimenting with an array of media, from painting and sculpture to graphic design and photography.

oil on canvas
53 x 21 cm (20¾ x 8¼ in.)
Russian State Museum,
St Petersburg, Russia

Non-Objective Painting No. 80 (Black on Black), 1918
Museum of Modern Art,
New York, USA

Spatial Construction No. 12, c. 1920
Museum of Modern Art,
New York, USA

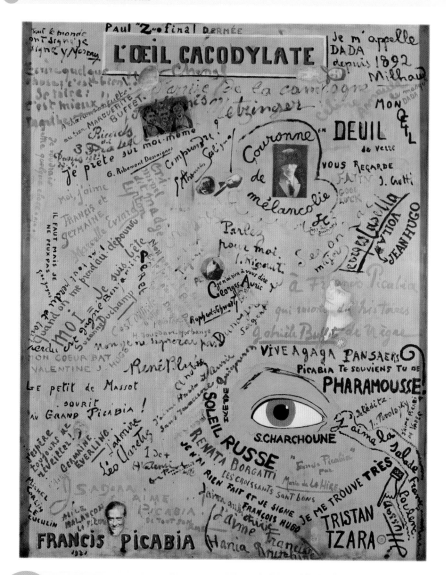

More than fifty friends contributed to this work, adding their own scribbles, collage, photomontage and irreverent phrases randomly across the canvas. It seems to be the type of artwork that children would make with their own friends, but while they might simply write, doodle or stick things on a large surface, Picabia was posing radical questions about attitudes towards artistic processes.

THE CACODYLIC EYE
FRANCIS PICABIA
1921

In the spring of 1921, Francis Picabia (1879–1953) underwent an eye operation that required treatment with sodium cacodylate. While recovering, he drew a large eye at the bottom of a canvas and called it *The Cacodylic Eye (L'Oeil Cacodylate)*. Friends visiting his studio over the following months were invited to inscribe their signatures on the canvas, rather like a 'get well' card for a colleague. The signatures by artists, writers and musicians, plus bits of collage and photomontage, surround the cartoon-style eye. With fifty-six haphazardly written signatures, many accompanied by flippant comments such as: 'Fatty, good luck'; 'I did nothing but sign'; 'I like salad'; 'I should, but I cannot'; 'Russian sun'; 'Croissants are good'; and 'I love Francis and Germaine', the work demonstrates the importance the Dadaists conferred on group dynamics, as well as the satirical nature of the movement. Marcel Duchamp signed with his new pseudonym, Rrose Sélavy, which sounds like *Eros c'est la vie*, translated as 'Eros (love), that's life'. When there was no more space left, Picabia decided the work was finished. Manifestly sardonic, the canvas parodies traditional art, which was the intention; Picabia was determined to challenge attitudes about fine art that were at the time regarded as irrefutable.

Universally accepted as an important influence on subsequent generations, Picabia abandoned working in a consistent or identifiable style once he had joined the Dada group of artists, writers and musicians in 1918. His close friendship with Marcel Duchamp, along with his intellectual irreverence, abundance of ideas and idealistic anarchism, made him one of the major figures of Dadaism. Picabia was impossible to classify because his work was so diverse, and he soon tired of Dadaism, complaining in 1921 that Dada was no longer revolutionary.

oil with photomontage and collage on canvas
148.5 x 117.5 cm (58⅝ x 46⅛ in.)
Centre Georges Pompidou, Paris, France

Dada materialized as an 'anti-art' movement between 1916 and 1922, in protest against the senseless atrocities of World War I and the traditional values that had allowed it to happen. Dada artists conducted an unrestrained assault on the conventions of art, aiming to undermine all that previously had been considered sacrosanct.

Machine Turn Quickly, 1916–18
National Gallery of Art, Washington, DC, USA

The Fig-Leaf, 1922
Tate Collection, London, UK

The Handsome Pork-Butcher,
c. 1924–26 and c. 1929–35
Tate Collection, London, UK

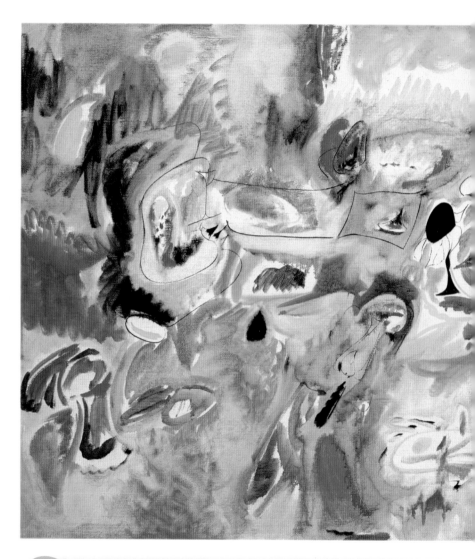

? If this were made up of random colours and shapes, it would be possible to believe that a young child had painted it. However, Gorky created it after he had spent years developing his style, which resulted in a unique combination of Cubism, Surrealism and Expressionism, and drew on his own inner traumas that developed from his experiences of persecution and being a survivor of the Armenian genocide in 1915.

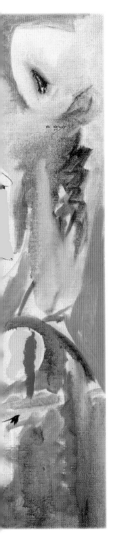

YEAR AFTER YEAR

ARSHILE GORKY

1947

The art of Arshile Gorky (*c.* 1902–48) was never devoid of his emotional scars—he fled Turkish persecution in Armenia and witnessed his mother die from starvation. Living in the United States for most of his adult life, he experienced the Depression and World War II from a US perspective. Through books, magazines and galleries, he became familiar with avant-garde European art, particularly the work of Paul Cézanne, Pablo Picasso and Joan Miró, insisting that an artist can mature only after a period of apprenticeship. Gorky soon merged various art styles with automatism, introduced to him by Surrealist friends, and his work evolved as a new, unique pictorial language. *Year after Year*, with its fluid, nebulous shapes and translucent, brilliant colours, enigmatically alludes to his childhood, especially the gardens, orchards and wheat fields of Armenia, with additional direct observations from nature. The biomorphic shapes can be vaguely recognized as living things, but they are intended to generalize the landscape, collectively evoking all our memories.

◎ Gorky's contribution to modern art should never be underrated. His friendship with André Breton affected him strongly, as did the encouragements of Roberto Matta and Stuart Davis. *Year after Year* developed from his 'apprenticeship' with Cézanne, Wassily Kandinsky and Picasso, and Gorky generally is acknowledged as the founder of Abstract Expressionism.

ℹ️ oil on canvas
86.5 x 104 cm
(34 x 40⅞ in.)
Private
collection

Gorky believed that the juxtaposition of colours could denote space, rendering conventional perspective superfluous. Synthesizing Surrealism and Impressionism with Cubism and his own individual concepts, he rapidly developed the style for which he became famous.

👁 *The Artist and his Mother*, *c.* 1926–36
Whitney Museum of American Art, New York, USA

Waterfall, 1943
Tate Collection, London, UK

Armand Fernandez Arman, known only as Arman, was determined to create new artistic effects. By the late 1950s, he had moved away from traditional painting and sculpture in favour of adapting manufactured and found materials to express his purposes. For a while in the mid-1960s, he used paint again, but only to parody Abstract Expressionism. Mostly, he used rubbish, persistently and wittily, as a deliberate acknowledgement of the waste generated by the consumer society.

FULL-UP

ARMAN

1960

Arman (1928–2005) used rubbish to illustrate the materialistic, throwaway culture that had developed since World War II. 'Full-Up', or 'Le Plein', was actually an entire exhibition that took up the whole of a small gallery, the Iris Clert, in Paris. Using junk that he had collected from the surrounding streets, Arman crammed the gallery with as much of it as he could, with the result that the exhibition could be viewed only from outside the front window. This sardine tin formed the container for the exhibition invitation, as can be seen by the words 'Arman—"Full-Up"—Iris Clert' printed on it. To a certain extent, the exhibition was intended to counter his friend Yves Klein's previous exhibition, 'The Void', at the same gallery, which contained nothing but an empty glass display case. 'Full-Up' questioned how people's opinions change and why items previously considered essential become undesirable. It also alluded to the huge problem caused by the amount of rubbish that society generates and its harmful impact on the environment. The banality of the sardine tin is purposefully humorous, but it also reveals controversies about value and worth, mass production, and high and low art.

promotional sardine tin filled with rubbish and exhibition invitation
10.5 x 6 x 3 cm
(4⅛ x 2⅜ x 1⅛ in.)
Museum of Modern Art, New York, USA

Arman's work grew out of his obsession with collecting things. He had developed this during his childhood, undoubtedly influenced by his father who sold furniture and ornaments, and his grandmother who was a compulsive hoarder.

Arman was against Art Informel and Abstract Expressionism. In 1960, following both Kurt Schwitters's and Marcel Duchamp's ideas, he became a founding member of Nouveau Réalisme. This movement aimed to bring life and art closer together, and formed a link between European and US trends in Pop art. With his concerns and stimulating creations, Arman is often also classed as both a Conceptual and an Environmental artist.

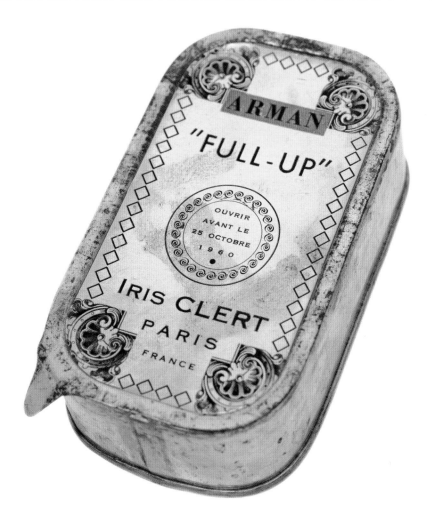

While most five-year-olds could easily collect rubbish from the street and pile it up until it filled a small room—and even make a new label for an old tin—they would not select the objects specifically. Arman created his installation to raise questions about how things are treasured or discarded, and aspects of human behaviour both in public and in private.

Condition of Woman I, 1960
Tate Collection, London, UK

Chopin's Waterloo, 1962
Centre Georges Pompidou,
Paris, France

The Attila of the Violins, 1968
Stedelijk Museum, Amsterdam,
Netherlands

In his *White Manifesto* of 1946, Fontana stated: 'Matter, colour and sound in motion are the phenomena whose simultaneous development makes up the new art.' Slashing surfaces was his way of exploring these themes, particularly movement, time and infinity. Although the cuts may seem spontaneous, they were in fact carefully planned. He often lined the backs of his canvases with black gauze to create an illusion of depth.

When Fontana first began to use his new cutting method, he said he was 'happy to go to the grave after such a discovery'.

SPATIAL CONCEPT 'WAITING'
LUCIO FONTANA
1960

canvas
93 x 73 cm (36½ x 28¾ in.)
Tate Collection, London, UK

Spatial Concept, 1949
Galleria Nazionale d'Arte Moderna, Rome, Italy

Spatial Concept, Expectations, 1959
Solomon R. Guggenheim Museum, New York, USA

Before the outbreak of World War II, Lucio Fontana (1899–1968) experimented with several painting styles, but after 1945 he began developing his idea of 'Spatialism', or 'Spazialismo'. This was based on the principle that, as machine technology was speeding up everything, artists should create similar energy and dynamism. He aimed to penetrate the flat surfaces of paintings that had been established for centuries and, in 1959, he began to cut his canvases to integrate real rather than imagined space and depth. In this work, the slash appears to burst from within, evoking a lively but somewhat violent impression. On the suggestion that his slashes might seem aggressive, Fontana claimed, 'I have constructed, not destroyed.' At its simplest, the work echoes Abstract Expressionist brushwork, but it also presents what the artist described as 'an infinite dimension'. Calling his work 'an art for the Space Age', he sought to go beyond the artistic legacy of his Renaissance forebears. The slash was not intended to decorate or to represent anything from the real world, but to transcend space and generate a feeling of infinity.

In 1949, Fontana devised the term 'concetto spaziale', or 'spatial concept', to describe the work he was producing. He called this particular slashing style 'tagli', or 'cuts'. Ultimately inspired by Futurism, he was nevertheless against the movement's glorification of war, but admired its exploitation of technology and movement. In questioning the traditions of Western art, his work also prefigured later developments such as Environmental art, Performance art and, particularly, Arte Povera.

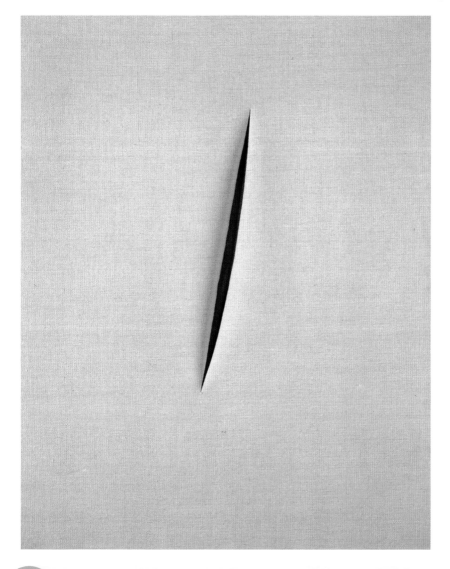

The slash of a knife across a canvas looks easily achievable, and Fontana never said it was a difficult technique. However, a child would not do it for the same reasons as Fontana. With one decisive slash, he aimed to explore underlying notions of space and infinity, as well as the limitations of art and its ultimately perishable nature. He said: 'Artworks cannot last forever . . . where man ends, infinity begins.'

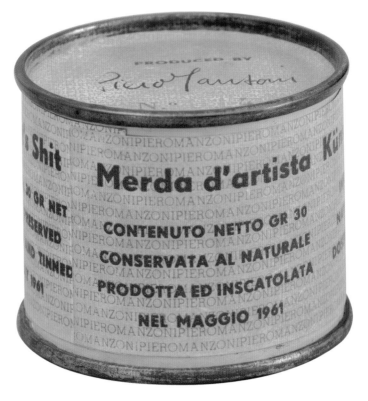

No technical skill was necessary to produce this work—any five-year-old child could have deposited their own excrement in a tin, or pretended to. Manzoni, however, was making several points that few children would be able to appreciate. The work parodies inflated values of art and also exploits consumerism, particularly the developing preoccupation with packaging and possessions. Meanwhile, the contents of the tin represent the ultimate use of waste as an art material.

ARTIST'S SHIT
PIERO MANZONI
1961

In 1961, Piero Manzoni (1933–63) canned, sealed and exhibited ninety cans of what he described as 'Artist's Shit', implying that his own excrement was inside each can. On every tin, he attached a label that described its contents in four languages: Italian, English, French and German. The labels read: 'Artist's Shit, contents 30 gr net, freshly preserved, produced and tinned in May 1961.' Manzoni signed and numbered every can and displayed them in a gallery, pricing each at the equivalent of its weight in gold—at the contemporary rate. The work was a joke and satirized the art market, the cult of the artist as genius, consumerism and the waste people generate. The artist was also offering a new mass-produced item with new packaging (which he made using brown paper or newspaper and string, sealed with red wax and a metal seal bearing his name). At the time packaging was being exploited by Pop artists, and Manzoni's decision to price his excrement so highly made clear reference to the tradition of art having become a glorified commodity. He was emphasizing the idea that anything bearing an artist's signature became valuable, regardless of its content. The lingering uncertainty about whether the cans actually contain Manzoni's faeces remains, because if opened they would lose their value.

A self-taught artist, Manzoni questioned artists' aims and methods. He started his career painting abstract works, such as his *Achromes* series, which began as colourless surfaces impregnated with plaster, and soon incorporated further materials, such as polystyrene. By the late 1950s, he was using more unusual materials to express ideas. In 1958, for example, he wrote his signature on living people and issued them with certificates of authenticity—a declaration that anything signed by an artist might become an expensive work of art.

tin can with unidentified contents, paper wrapping
5 x 6.5 cm (2 x 2½ in.) diameter
Museum of Modern Art, New York, USA

Although classed as a Conceptual artist, Manzoni prefigured Conceptual art and Arte Povera, which emerged fully in the late 1960s. He was influenced profoundly by Yves Klein's monochromatic paintings of the late 1950s and Nouveau Réalisme with which Klein was associated, as well as Marcel Duchamp's readymades and his *Fountain* (1917) in particular.

Achrome, 1958
Solomon R. Guggenheim Museum, New York, USA

Artist's Breath, 1960
Tate Collection, London, UK

Line, 1000 Metres Long, 1961
Museum of Modern Art, New York, USA

With no particular artistic affiliation, Latham worked in a variety of media, including painting, performance, book art, Conceptual art and film. He expounded several highly original viewpoints, aiming to connect art and science more closely. He collaborated with other artists and scientists, often shattering conventional systems of thought. From creating art with spray paint to burning, cutting up and painting books, he challenged and shocked viewers about thought processes, habits of belief and acceptance.

leather case containing a book, letters, photocopies and labelled vials filled with powders and liquids
8 x 28 x 25.5 cm
(3⅛ x 11 x 10 in.)
Museum of Modern Art, New York, USA

Man Caught Up with a Yellow Object, 1954
Tate Collection, London, UK

Derelict Land Art: Five Sisters, 1976
Tate Collection, London, UK

John Latham (1921–2006) had many provocative theories about beliefs, time and structures, which he frequently expounded. This work aimed to promote—and destroy—further beliefs, specifically on art theory of the 1960s, on the perceived inviolability of books and on the demise of art. The demise, he believed, reached an all-time low in 1951 when Robert Rauschenberg displayed an unmarked canvas as art. In 1966, Latham borrowed a copy of Clement Greenberg's *Art and Culture* from the library of Saint Martin's School of Art, where he was employed as a part-time lecturer. Books in general symbolize learning, knowledge and culture, and Greenberg's book was considered the definitive guide on art at the time. At a party, Latham invited students to chew pages from the book, then he dissolved the masticated pulp in acid. The process took several months, during which time the library sent Latham several letters demanding the book's return. Eventually, he handed in a labelled flacon of the distilled 'essence' of Greenberg—and lost his job. Displayed in a leather case, the vials and library correspondence became this artwork.

In 1966, Latham co-founded the Artists' Placement Group with his wife Barbara Steveni and others, to involve artists in local government and industry. Later, he profoundly influenced Conceptual and Performance art, in which ideas take precedence over traditional artistic concerns. He was also involved with the international group Fluxus, which aimed to blend different materials and disciplines in art.

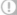

In London and New York in the 1960s, Latham took part in two gatherings, both called Destruction in Art Symposium (DIAS), where he burnt 'Skoob Towers', or piles of books. (Skoob is 'books' written backwards.)

? Children might chew bits of paper, put them in glass jars and pour liquid on them. They might also put their filled vials in a case for safe keeping; however, it is extremely unlikely that they would be making any preconceived statements about art. For Latham, it was pertinent that the bits of paper came from a renowned book on art theory, and Latham's point was that, although books are a source of knowledge, he believed this particular book to be narrow-minded and misleading.

Influenced by artists including Lucio Fontana, Jackson Pollock and Franz Kline, Kounellis integrates life and politics with art. By 1967 he had joined the Arte Povera movement, which broke with artistic conventions and exploited humble, everyday materials.

UNTITLED (12 HORSES)
JANNIS KOUNELLIS
1969

In a solo exhibition in Rome in 1969, Jannis Kounellis (1936–) exhibited twelve live horses. His inspiration had come from a phrase used by André Breton in the magazine *Le Surrealisme au Service de la Revolution (Surrealism in the Service of the Revolution)* produced in the early 1930s. Breton's article discussed the impossibility of the Tartars taking their horses to drink at the fountains of Versailles. When Kounellis exhibited the horses, he made a multilayered declaration. Firstly, in a privately owned gallery there were economic and social implications about exhibiting non-saleable art. Secondly, the size, power and strength of horses can be daunting. Thirdly, the horses' smells, noises and bodily functions changed the neutrality of the gallery space. Finally, horses have many associations, from their importance to humanity throughout history to their extensive representation in art. The subjective and dynamic concept resolutely rejected conventional, marketable art.

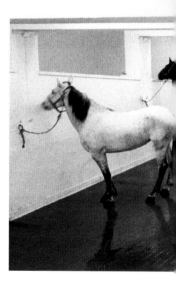

In his investigation of shared and individual values, Kounellis uses a variety of unexpected materials, such as cotton, coffee, wood, stones and live animals, as well as a mixture of approaches, to illustrate the fragmentation of society and language.

Before abandoning traditional painting to create sculptures and installations with diverse materials, Kounellis often painted large stencilled letters, arrows and road markings. This was his way of investigating the subconscious structure of urban civilizations and how they perceive themselves.

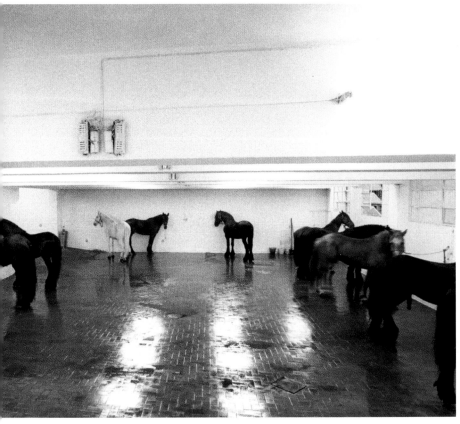

Kounellis tethered twelve horses for several days in L'Attico Gallery in Rome and ensured that the environment was as close to their own stabling conditions as possible. While a child could lead and tether horses, the installation represented a great deal more than the act alone. Kounellis was preoccupied with the idea of creating art that could not be sold. He chose horses to illustrate this because of their links with art history, particularly with classical or equestrian sculpture and history paintings, and to refer to the degeneration of modern culture and impermanence.

live horses
installation
dimensions variable

Untitled, 1969
Centre Georges Pompidou,
Paris, France

Untitled, 1987
Solomon R. Guggenheim
Museum, New York, USA

Untitled (Coffee), 1989–91
Tate Collection, London, UK

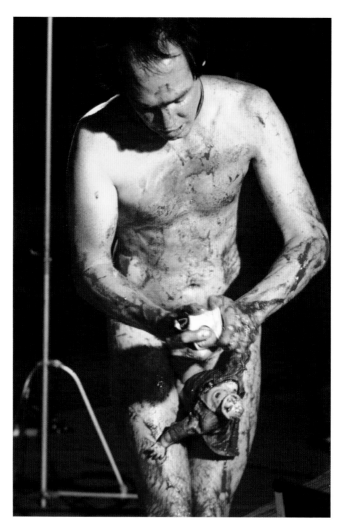

Although McCarthy claimed that his ideas developed from the children's TV programmes that he watched while growing up in Utah, his work, which parodies the often brutal and carnal factors inherent in contemporary culture, could not be produced by a child. The ideas may be infantile but, underneath his often sordid or shocking performances, there are messages about the physicality of artistic processes and the exploitation and distortion of many facets of contemporary society, such as sex, food, violence, film, and art itself. These messages emerge from his training in film, video and art.

CLASS FOOL
PAUL McCARTHY
1976

Deliberately messy and frequently distasteful, Paul McCarthy (1945–) nevertheless intends much of his work to amuse. He has always sought to break the limitations of painting by using the body as a creative tool, and his work is usually a commentary on the anaesthetic effect of the mass media on society's capacity to be shocked. In *Class Fool*, he replaced paint with ketchup and bodily fluids, and canvas with his own naked body. His use of ketchup is a parody of the simulation of blood in films. By purposefully opposing social conventions, the work tested the emotional limits of both McCarthy as the performer and his viewers. The performance took place in a classroom of the University of California, San Diego. The artist spattered the walls with ketchup and then, naked, threw himself violently around the room until he was dazed and injured. He then vomited several times and inserted a Barbie doll into his anus. The performance, which ended when the audience could no longer stand to watch his degradation and self-humiliation, established many elements that have become common features of his work, including bodily fluids, ketchup and Barbie dolls. Relishing the exposure of unpleasantness and what he perceives as unpalatable truths of human existence, McCarthy used *Class Fool* to shock people into re-evaluating their lives and attitudes.

McCarthy's performances, installations, videos, experimental sculptural forms and graphic works all combine to express his concerns about the sanitation and exploitation of violence and conflict through the mass media. By using painting more as an act than to produce a final object, he is directly following in the footsteps of Abstract Expressionism.

performance, video, photographs
University of California, San Diego, CA, USA

Caribbean Pirates, in collaboration with Damon McCarthy, 2001–05
installation

Blockhead, 2003
installation

Inside Her Ordeal, 2009
installation

McCarthy's work has evolved directly from his experiences and memories. When he was an art student, Abstract Expressionism, Minimalism, Pop art, Conceptual art and Performance art were predominant movements, and he integrates and interprets them all in his own work.

Working in obscurity for about thirty years, McCarthy achieved prominence in the 1990s, when many younger artists cited him as a major influence on their work.

**WORKS IN
WEALTH III
STEPHAN HUBER**
1983–96

The striking and diverse artworks by Stephan Huber (1952–) create immediate emotional and evocative impact, conveying pertinent statements, usually about contemporary society and ways of thinking. This work—a wheelbarrow filled with a chandelier—is heavy with symbolic references intended to stimulate viewers' imaginations, dependent on their individual experiences, attitudes, memories and associations. The two objects were chosen carefully, for their simplicity and familiarity, and especially for their universal connotations. The wheelbarrow signifies diligence and endeavour; the chandelier, wealth and luxury. Both these concepts are important elements in contemporary capitalist society. Huber created the piece specifically for the Contemporary Art Wing of the Hamburger Kunsthalle, a large and well-lit space that highlighted the small-scale of the artwork. In homage to Marcel Duchamp, the work communicated particularly with late 20th-century audiences, with its topical references to contemporary politics and culture. Juxtaposing coherent symbols of manual labour and of affluence and comfort, the work is a metaphor for capitalism, in which supposedly one (wealth) can be achieved with plenty of the other (hard work).

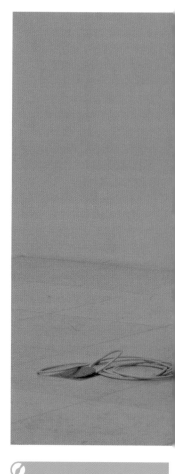

In addition to his large installations and smaller works in public spaces, Huber creates graphic works, films and performance projects. His use of readymades descends directly from the early 20th century, and Duchamp and the artist-architect Antoni Gaudí. Huber uses readymades to draw attention to important issues in a light-hearted way. With his pointed juxtapositions, he is often classified as a Conceptual artist.

Works in Wealth III is only one of Huber's ways of creating a direct narrative with viewers. Often including autobiographical, political, social or literary references, the unusual perspectives of his work are sometimes puzzling but never threatening.

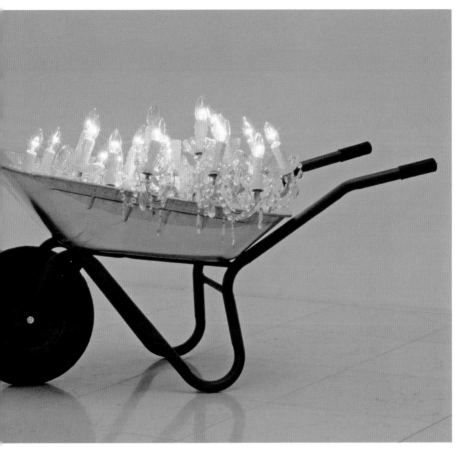

A shiny wheelbarrow piled high with an even shinier chandelier is something that any child could put together with a little effort. However, the fact that the work is situated in a gallery space indicates that the artist was exhibiting it for meaningful reasons not immediately apparent. Indeed, produced in the 1980s and 1990s, it symbolizes the public's attitude towards capitalism, which decisively triumphed over communism at the time but was also perceived as exploitative by many.

wheelbarrow and chandelier
80 x 130 x 68 cm
(31½ x 51⅛ x 26¾ in.)
Hamburger Kunsthalle,
Hamburg, Germany

Ich Liebe Dich, 1983
Städtische Galerie im Lenbachhaus
München, Munich, Germany

Shining, 2004
Museum Moderner Kunst Stiftung
Ludwig, Vienna, Austria

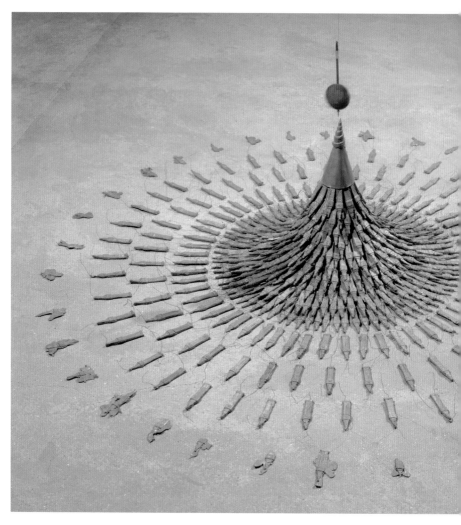

While this work might seem too precise for a young child to have made, it could be mistaken for a child's plaything—perhaps some found objects that have been turned into a toy. Yet the sculptor and installation artist Cornelia Parker created this work specifically to examine the physical properties of objects and space, and to investigate the power of scale and its potential to create and change meanings.

lead, wire and brass pendulum
76 x 214 x 214 cm (29⅞ x 84⅛ x 84⅛ in.)
shown in Norwich Castle, Norfolk, England, in 2006

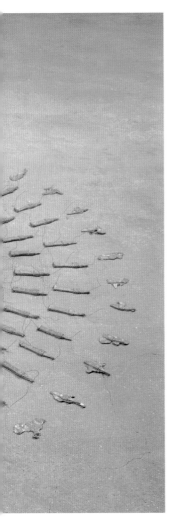

Classed in the 1990s as a Young British Artist, or YBA, Parker is now more often labelled an installation artist. In redefining objects and spaces with humour and irony, she acknowledges Marcel Duchamp's influence. In 1997, she was nominated for the Turner Prize, and was awarded an OBE in 2010.

FLEETING MONUMENT
CORNELIA PARKER
1985

In order to examine the power of scale and its potential to create and alter meaning, Cornelia Parker (1956–) arranged small but familiar-looking objects—heavy with historical associations—in an unexpected format, prompting a reconsideration of established assumptions. *Fleeting Monument* consists of Big Ben souvenirs beneath a brass pendulum, arranged as if the pieces have been scattered in various directions. The circular composition and pendulum, with its regular and rhythmical motion, appear to suspend time, which highlights Parker's fascination with nature, particularly its fragility and the transience of existence. It conjures reminiscences of a sun dial. Parker says she wants her art to suggest a different meaning for everyone: 'You make an open-ended proposition and the audience completes it somehow. That's what you hope an artwork to be—a constantly living thing.'

Thirty Pieces of Silver, 1988–89
installation

*Cold Dark Matter:
An Exploded View*, 1991
Tate Collection, London, UK

Brontëan Abstracts, 2006
installation

In her installations, Parker often destroys, reconstructs or changes objects, altering how familiar items are perceived. Most of her work is temporary. In transforming explosive energy into flowing expressions, she addresses fears about unpredictability and the influence of mass media on society's attitudes.

Children could easily shape a lump of wax to create the impression of part of a man's leg, dress it in clothing that they had cut up to fit and then lean it against a wall. Most children would find this extremely humorous. This was one of the sentiments that Robert Gober intended when he made this painstakingly crafted work, which would be beyond the skills of most children—and, indeed, most adults. He also aimed to unsettle viewers with its tremendous realism. The apparent simplicity of the piece explores several complex themes about isolation, mortality, victimization and vulnerability.

This life-size and lifelike work was created from a bleached beeswax cast of Gober's lower leg. With the wax still warm, he implanted individual human hairs from a wig, then clothed the leg in a trouser, sock and a worn-in shoe. Attention to detail has always been of paramount importance to him in his art.

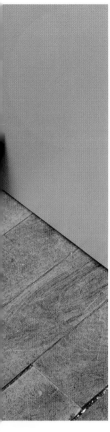

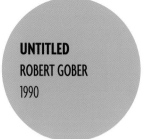

UNTITLED
ROBERT GOBER
1990

Through using strange combinations or distorted juxtapositions, Robert Gober (1954–) creates disconcerting objects that frequently resemble the work of the Surrealists. *Untitled* poses far more questions than it answers, such as: What is the leg doing here? Where did it come from? Where is the rest of the body? What has happened? Although viewers are aware that the leg is not real, it appears uncomfortably exposed and vulnerable. The work is worryingly ambiguous and the artist's attention to detail makes the subject matter appear simultaneously fascinating and repulsive. The triteness of the clothing and the exposed white, hairy skin suggest that the leg belongs (or belonged) to someone ordinary. Like René Magritte, Gober was fascinated with mundane and fragmented or displaced objects, and this makes the work seem all the more unsettling. Both a craftsman and a Conceptual artist, Gober confronts viewers with the sorrows and separations that we all have to face in life, but this work is also somewhat perplexing, evoking unexpected or irrational reactions. It echoes a true story that Gober relates: 'My mother used to entertain me as a child with tales from the operating room where she worked as a nurse . . . Her first operation was the amputation of a leg. The doctor turned and handed the leg to her and she didn't know what to do.'

beeswax, wood,
leather, cotton and hair
29 x 20 x 51 cm
(11⅜ x 7⅞ x 20 in.)
Israel Museum,
Jerusalem, Israel

Inverted Sink, 1985
Albright-Knox Art Gallery,
Buffalo, NY, USA

Cigar, 1991
Museum of Contemporary Art,
Los Angeles, CA, USA

Clearly influenced by Surrealism, especially Magritte and the ways in which he challenged perceptions with incongruous visual metaphors, Gober aims to confer in a similar way new meanings on familiar things. Calling everyday objects into question, he challenges viewers to reconsider elements of life through a unique mix of Surrealism, Conceptualism and Minimalism. While discussing what inspires him, he says: 'You look back and you see all these different influences: dreams, people you've known, things you've read.'

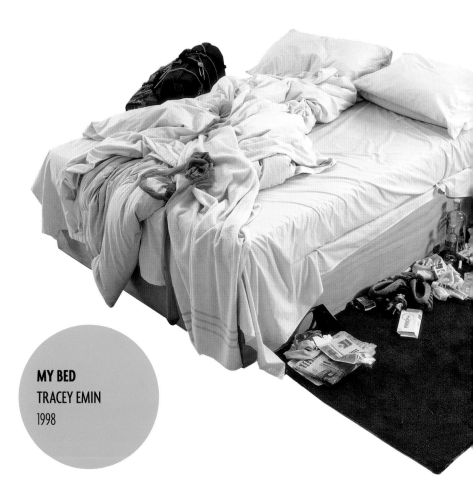

MY BED
TRACEY EMIN
1998

mattress, linen,
pillows, objects
79 x 211 x 234 cm
(31 x 83 x 92 in.)
Saatchi
Collection,
London, UK

Children may often leave their beds unmade and their
rooms in a mess, but a close look at this installation
reveals that the bed and strewn items belong to an
adult. When it was first displayed jottings, appliqué, videos and
photographs were placed on the surrounding walls, all combining
to express personal trauma as well as anxieties and powerlessness.

Through the use of unusual media, including traditional female crafts such as blanket-making, appliqué and drawing, as well as found objects, Emin's art is autobiographical and contradicts society's expectations of women's art and artists. She communicates her most intimate experiences, often through uncomfortable examinations of existence.

Although this is a double bed, the work is lonely and self-conscious. The bed was supposedly left in this state after Tracey Emin (1963–) had stayed in it for several days while suffering from depression. The detritus around the bed includes empty vodka bottles, cigarette ends, stained sheets, dirty underwear and tights, condoms, Polaroids and a fluffy white toy. Combined with misspelt scribbles, dramatic declarations on textiles, photographs and videos of Emin's apartment in London, the original installation intentionally confuses life and art, posing questions such as whether this is a confession, an exploration of inner feelings or an exaggerated expression of the disparities and dilemmas of the world. Hotly debated since it was shortlisted for the Turner Prize in 1999, *My Bed* represents a side of life that many would not wish to confront. Yet everything in the installation was carefully planned with nothing left to chance. As Emin has said: 'Everything I do is edited, considered and its final production very much calculated.' Wherever it is exhibited, the work always inspires ambivalent and often contradictory responses.

*Everyone I Have
Ever Slept With*, 1995
Saatchi Collection, London, UK
(destroyed by fire in 2004)

I've Got It All, 2000
Saatchi Collection, London, UK

In 1997, the exhibition 'Sensation' was held in London, Berlin and New York. It featured Damien Hirst, Cornelia Parker and Tracey Emin, among others. Labelled the Young British Artists (YBAs), they all experimented with unexpected concepts, materials and processes.

BAG
GAVIN TURK
2000

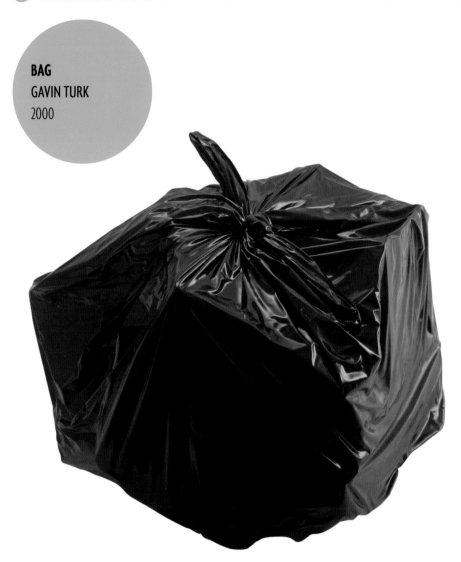

? This is not what it looks like. It is not a bin bag, but a painted bronze cast of one. If it was an actual bag full of rubbish, then a child could have created it by simply tying it up when it was full. Instead, it is a sculpture made of classical materials, intended to remind viewers of their wasteful, consumerist lives, as well as highlighting concepts of ownership, creativity and worth.

Particularly in Western society, large black plastic bags are traditionally filled with discarded items, objects that are no longer needed and considered to be rubbish, such as those found and used by the artists Tony Cragg and Joseph Cornell, for example. Filled rubbish bags, therefore, can be seen to represent our wasteful consumerist society and lack of care for the environment, as well as individual changing loyalties. This painted bronze is intended to project an illusion of reality, to fool the eye and evoke recollections of the *trompe l'oeil* paintings that were so admired in historic art movements, particularly during the Baroque period. Gavin Turk (1967–) believes that our culture is identified and defined both by what people throw away and by what they display in museums, and he is fascinated by how people measure worth and value. This work—a classical bronze sculpture masquerading as a bag of rubbish—fuses all these thoughts and at the same time mocks the seriousness of galleries. Turk also considered the ways in which people relate to familiar objects and why some are respected while others are scorned. Indeed, one of Turk's main preoccupations is why some works of art are conferred iconic status and others are overlooked. This work appears so recognizable and banal that most people walk straight past it when it is displayed, not realizing that it is an exhibit and a work of art. Turk made several variations of *Bag* and exhibited them in different gallery environments. Mostly, each was received with irreverence and contempt, which was what the artist expected.

Turk acknowledges his debt to many artists, including Marcel Duchamp, Andy Warhol, Yves Klein and Joseph Beuys. He was classed as one of the YBAs (Young British Artist) in 1997, and his work has been extremely influential to other artists, particularly for its reintroduction of technical skill.

Ambiguities and self-absorption permeate much of Turk's precise and skilful work. He frequently features himself and recognizable elements from the world in general or iconic artworks. His sculpture, drawings and assemblages investigate various themes, from the artist's role to myths surrounding creativity, mortality, artistic conventions and popular culture, for example.

Turk's art is political and provocative, as he comments entertainingly on cultural change and social attitudes.

painted bronze
42 x 53 x 50 cm
(16½ x 18¾ x 19¾ in.)

Gavin Turk Right Hand and Forearm, 1992
Tate Collection, London, UK

Camouflage (Self-Portrait), 1996
Hull Museums Collections, Yorkshire, UK

Che Guevara, 1999
Saatchi Gallery, London, UK

Sunflower Seeds
Ai Weiwei
p176

Winding Towers
Bernd and Hilla Becher
p150

Counter-Composition of Dissonances, XVI
Theo van Doesburg
p140

Concorde Grid
Wolfgang Tillmans
p170

Equivalent
Alfred Stieglitz
p144

Goin' Fishin'
Arthur Dove
p142

Untitled (8) I
Jim Dine
p154

Concrete Cabin
Peter Doig
p168

Map of Broken Glass (Atlantis)
Robert Smithson
p152

The Factory
Maurice Utrillo
p138

Geneva Circle Two
Richard Long
p164

New Stones, Newton's Tones
Tony Cragg
p158

Footsteps
Christian Marclay
p166

Crack is Wack
Keith Haring
p162

Uncarved Blocks
Carl Andre
p156

Yard
Allan Kaprow
p148

| 0 | | 1 | | 2 | | 3 m |
| 0 | 2 | 4 | 6 | 8 | | 10 ft |

CHAPTER FOUR
LANDSCAPES /
PLAYSCAPES

From wall frescoes in ancient Rome to
6th-century Chinese watercolours and
17th-century Dutch painting, landscape
has always been a popular genre. It
continued to be fashionable into the
20th century, yet the works in this
chapter move decidedly away from the
familiar elements of the genre as many
artists declined to create observational
depictions of the real world. They
challenged the traditional display of
art and sought to move art away from
'high' culture and into 'low' culture.
In this chapter, innovative art such as
Allan Kaprow's first 'Happening', *Yard*,
Robert Smithson's *Map of Broken Glass
(Atlantis)* and Tony Cragg's coloured
arrangement *New Stones, Newton's
Tones* demonstrates ways in which
artists have presented new ideas based
on old themes, thus aiming for greater
accessibility and assimilation.

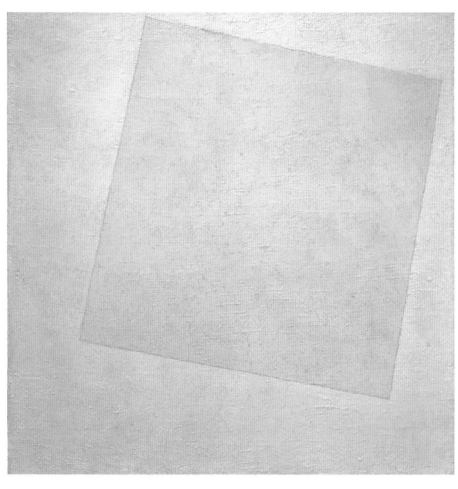

A child could certainly have painted this simple square canvas, although perhaps not as neatly, first with a coat of white paint, then with a cooler shade of white for the smaller square tilted at an angle. However, timing is everything, and Malevich was one of the first artists to break away completely from any attempt at representing the visible world. He used white to emphasize application and technique, and also to annihilate any notion of traditional subject matter.

oil on canvas
79.5 x 79.5 cm
(31¼ x 31¼ in.)
Museum of
Modern Art,
New York, USA

SUPREMATIST COMPOSITION: WHITE ON WHITE

KASIMIR MALEVICH

1918

This is one of the most radical and groundbreaking artworks of the 20th century, and one of the first paintings made without reference to external reality. The small square seems to float on the larger white square (the painted canvas). Clearly painted by hand, the small square is not precisely symmetrical, and its outlines are inaccurately ruled, revealing—along with variations of paint texture—some subjectivity about the process of painting. Kasimir Malevich (1878–1935) developed Suprematism in 1915 as a universal language, to free viewers' interpretations of the material world and enable them to interpret art more subjectively. He described Suprematism as 'the supremacy of pure feeling or perception in the pictorial arts', which had 'nothing in common with nature'. Having decided that white was the ultimate colour, because it contains the full spectrum and is the colour of infinity, he used it to emphasize his abandonment of figurative representations and illusions of depth, to cleanse art and to make way for a new, hopeful world through pure geometric shapes and flat, monochrome backgrounds. Depictions of the real world were unnecessary. This canvas was painted a year after the Russian Revolution, when Malevich had also relinquished descriptive titles in favour of abstract ones.

Reeling from the effects of World War I and the Russian Revolution, Malevich began to feel that Cubism and Futurism, the leading artistic movements of the time, were too restrictive and that art needed a total change in this altered world. Also fascinated by space–time physics and the notion of the fourth dimension, which had been introduced in the 1880s, he determined to develop a style of painting that did not represent anything that could be said to imitate life.

In eradicating all references to reality, Malevich changed the evolution of art. He said: 'Colour is the essence of painting, which the subject always killed.'

Influenced by Cubism, Futurism and primitive art, Malevich's Suprematism was a unique philosophy of painting in which he acknowledged Plato and Immanuel Kant. His ideas were crucial in the development of abstract art, inspiring many other artists, including Natalia Goncharova, El Lissitzky, Alexander Rodchenko, Paul Klee and Ad Reinhardt.

Black Square, 1915
State Russian Museum,
St Petersburg, Russia

Suprematist Composition: Aeroplane Flying, 1915
Museum of Modern Art,
New York, USA

Suprematist Painting, 1916
Stedelijk Museum,
Amsterdam, Netherlands

tu maître Armand Parent,
Son admirateur enthousiaste,

Featuring blobbed-on paint, streaky, crude outlines, distorted figures and erratic proportions, this painting looks as if a child could have done it. Yet Utrillo's naive style was intentionally simple and unrefined, as he focused on the streets and buildings of Montmartre, which was still a relatively quiet artists' quarter during the 1920s. His purpose was not to capture a photographic likeness of the scene but to convey his own inner solitude and feelings of isolation, brought on by his severe alcoholism.

watercolour
and gouache
on paper
24 x 31.5 cm
(9³⁄₈ x 12³⁄₈ in.)
Private
collection

Utrillo's street scenes inspired other artists to re-examine their approach and return to a focus on figurative images rather than abstraction. His influences were broad and included his mother and her close friends Henri de Toulouse-Lautrec, Edouard Manet, Amedeo Modigliani, Camille Pissarro, Paul Cézanne and Alfred Sisley.

THE FACTORY
MAURICE UTRILLO
1923

From about 1917, Maurice Utrillo (1883–1955) used a more colourful palette, freer brushwork and a more rudimentary style of drawing than he had during his 'white period' of 1909 to 1914. Although childlike and simple, *The Factory* displays a mature and instinctive understanding of the portrayal of space and tone. Five figures stand in the centre of the composition, framed on either side by a tree and a building. Behind them, walls, trees and buildings give the impression of distance. In 1902, in order to try to cure his debilitating alcoholism, which had been a problem since childhood, Utrillo's artist mother, Suzanne Valadon, encouraged him to paint. Although he had many relapses, to a large extent painting helped him to escape his own neuroses. He painted prolifically, concentrating on the streets, dilapidated houses, factories, windmills, cafes and ageing, cracked walls of Montmartre. This lively watercolour appears to have been painted quickly and spontaneously, capturing the atmosphere of the back streets of Paris and its workers. Until this point, Utrillo had been unrecognized, but in the year he painted this he shared an exhibition with his mother and found instant acclaim.

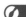

Place du Tertre, Montmartre, 1911
Norton Simon Museum, Pasadena, CA, USA

The House of Berlioz, 1914
Musée de l'Orangerie, Paris, France

A self-taught painter, Utrillo was initially influenced by the Impressionists and particularly by his mother, but he soon developed his own distinctive style. Frequently working from postcards, he painted with thick pigment and raw brushstrokes. During his 'white period' (1909–14), he used zinc white lavishly, sometimes mixed with plaster.

One of the most influential artists of the avant-garde, van Doesburg wrote the journal for De Stijl and was involved in Neo-Plasticism, Constructivism, Dadaism and Suprematism. In 1926, he expanded what he saw as the limitations of Neo-Plasticism with his theories of Elementarism, in which diagonals were acceptable.

oil on canvas
100 x 180 cm (39⅛ x 70⅛ in.)
Gemeentemuseum Den Haag, The Hague, Netherlands

COUNTER-COMPOSITION OF DISSONANCES, XVI
THEO VAN DOESBURG
1925

Theo van Doesburg (1883–1931) had the same aim as Piet Mondrian: to create a new art that would help to cleanse the world of its problems. The artists aimed to inspire a free and harmonious society through art that communicated intuitively. An energetic, intelligent man who was fascinated by theosophy and other philosophical and spiritual dogmas, van Doesburg lectured and wrote, designed and painted. Among several other art groups, he founded De Stijl in 1917 in collaboration with Mondrian, J. J. P. Oud, Bart van der Leck, Vilmos Huszár and Antony Kok. They reduced lines, forms and colours to their most basic elements, creating variations based on repetition, rotation or reflection. *Counter-Composition of Dissonances, XVI* is not an abstraction of perceived reality but an independent, balanced image, reflecting van Doesburg's belief in the universe being organized methodically. He advocated this pure abstraction to express his utopian ideal of universal harmony, and sought to bring about a similar equilibrium to society with his comparable architecture, using the same straight lines and limited palette of primary colours, plus black, white and grey. For a while, he focused solely on horizontal and vertical lines, but this work is an example of his reintroduction of the diagonal in paintings, which he called counter- or contra-compositions.

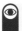

Composition VIII, c. 1918
Museum of Modern Art, New York, USA

Counter-Composition VI, 1925
Tate Collection, London, UK

Counter-Composition XIII,
1925–26 Peggy Guggenheim Collection, Venice, Italy

Most children could paint strong black outlines and angled rectangles in flat, pure colours, but not for the same reason as van Doesburg. When he painted this, he was ahead of his time in his search for a new, pure art—an art that did not concern itself with the superficial representation of things. Instead, he was aiming to uncover inner mysticism through balance and harmony.

Early on, van Doesburg wrote poetry and painted figuratively, but after reading Wassily Kandinsky's theories in 1913 he sought to create a more spiritual art. His painting and architecture, focusing on space, primary colours and geometrically simple elements, had a formative influence on modern architecture.

In 1924, Mondrian and van Doesburg fell out, it is thought, over van Doesburg's use of diagonals. The pair were, nevertheless, reconciled five years later.

Most children enjoy creating collages but would not be able to integrate the subtle allusions that Dove has here. This balanced work can be read in several ways, as Dove interpreted his surroundings with humour and subtle nuances of atmosphere through the simplification of form.

collage of bamboo, denim shirt sleeves, buttons, wood and oil on wood
54 x 64.5 cm (21¼ x 25½ in.)
Phillips Collection, Washington, DC, USA

As a pioneer of modern art in the United States, Dove was inspired by the Fauves, particularly Henri Matisse, and also by Cubism and Dadaism. As well as being influenced by Kandinsky's early abstractions, he also drew inspiration from his friends Alfred Stieglitz, Georgia O'Keeffe, Max Weber and Alfred Maurer.

GOIN' FISHIN'
ARTHUR DOVE
1925

In 1910, after an extended trip to Paris, Arthur Dove (1880–1946) returned to his native America and began producing abstract paintings. Recalling Wassily Kandinsky's abstractions of the same time, Dove reduced natural forms, modifying colours, simplifying contours and building rhythmical patterns. From the early 1920s, he also produced collages, using a variety of materials, such as bamboo, fabric and wood, as seen in this work. Aware of the Dadaist collages being produced in Europe at the time, he also revealed his appreciation of US folk art, which was experiencing a revival in the 1920s. *Goin' Fishin'* evoked the spirit of rural America, and Dove always insisted that his starting point was simply an African American man sitting on a pier, fishing—there was nothing deeper to it. The cut-up sleeves of a denim shirt represent the fisherman's clothes, while the radiating pieces of bamboo represent the fishing rod. The arrangement of the materials also indistinctly alludes to natural elements and parts of the human body, such as the sun's rays and fingers. Particularly narrow pieces of bamboo create an arc near the top of the image, implying the tense curve of the fishing rod as it stretches over the water.

The Critic, 1925
Whitney Museum of American Art, New York, USA

Foghorns, 1929
Colorado Springs Fine Arts Center, CO, USA

Dove produced the first purely abstract paintings in the United States. He referred to his method as 'extraction', as he took essential forms from a natural scene. Using bright colour, he experimented with media and techniques, combining paints such as hand-mixed oil or tempera over wax emulsion or collage.

Acknowledging his admiration for expressive and animated abstract painting styles, Stieglitz aimed to evoke similar expressions of emotion through his abstract photographs. Many of his works have non-figurative themes—sky, for example—in which the elements appear to be intangible contrasts, textures and patterns, but all his photographs also express his inner thoughts. In 1925, Stieglitz wrote: 'My photographs are ever born of an inner need—an experience of spirit.'

gelatin silver print
12 x 9 cm (4¾ x 3½ in.)
Private collection

Georgia O'Keeffe, 1921
Metropolitan Museum of Art,
New York, USA

*Georgia O'Keeffe,
Hands and Grapes*, 1921
National Gallery of Art,
Washington, DC, USA

Equivalent, 1926
Metropolitan Museum of Art,
New York, USA

EQUIVALENT
ALFRED STIEGLITZ
1929

The speed of modern life and persistent change during the first half of the 20th century concerned Alfred Stieglitz (1864–1946), particularly between the two World Wars. Using a camera instead of brushes and paint, he captured fleeting moments, aiming to reflect on the modern world and his emotions. *Equivalent* is one of a series of more than 200 photographs of clouds that Stieglitz photographed between 1922 and 1935—each one titled *Equivalent*—and they became recognized as the first photographs that were free from literal interpretation, making them some of the first completely abstract photographic works of art. In a letter of 1923 to the London photographer Ward Muir, Stieglitz described his thirty-five-year fascination with photographing clouds. Most of his *Equivalents* are similar to this one, with no horizon; they are purely clouds in the sky, featuring strong contrasts to evoke atmosphere. He said: 'I know exactly what I have photographed. I know I have done something that has never been done . . . I also know that there is more of the really abstract in some "representation" than in most of the dead representations of the so-called abstract so fashionable now.'

An admirer of diverse European artists such as Jean-François Millet, Adolf von Menzel, Robert Demachy, Henri de Toulouse-Lautrec, Gino Severini and Charles Sheeler, Stieglitz was also inspired by his photographer friends, including Edward Steichen and George Davison. He helped to transform the conception of photographic images into an independent art form, subsequently influencing photographers such as Ansel Adams and Edward Weston.

In considering this black-and-white photograph of clouds, with its lack of form or focus, and no foreground, background or figure to impart definition, viewers might conclude that a child had taken it. However, the photograph is a metaphor for Stieglitz's experiences and feelings. The metaphor emerged directly from one of Wassily Kandinsky's ideas—that abstract shapes and lines could represent a person's inner state and ideas, which Kandinsky described as 'vibrations of the soul'.

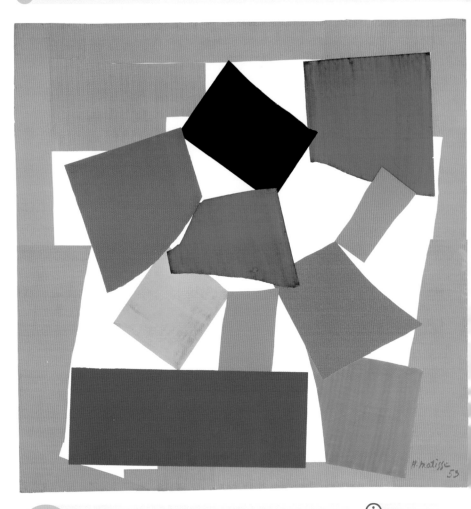

*H. matisse
53*

The title of this massive work, made of pieces of painted paper, often elicits comments by viewers that a young child could have done it. Indeed, many primary school teachers use it as a basis for an art project with their classes. Matisse made it when he was eighty-four and confined to bed through illness, but by that time he was renowned for his revolutionary and expressive art that celebrated life through colour, harmonious compositions and fluid draughtsmanship. 'I have attained a form filtered to its essentials,' he said.

gouache on paper, cut and pasted on paper mounted on canvas
286.5 x 287 cm (112⅝ x 112¾ in.)
Tate Collection, London, UK

THE SNAIL
HENRI MATISSE
1953

At first glance, this work appears to be an abstract arrangement of large, randomly coloured shapes. However, Henri Matisse (1869–1954) was representing a snail to communicate happiness and enthusiasm for life. One of his last and largest works, *The Snail* was made with the help of assistants. Matisse mixed the water-based paint and then instructed the assistants to paint and cut out the paper, which he arranged on an even larger sheet of paper. His genius is in the balance of the composition and the harmony of colours he achieved. The brilliant colours against the white background were inspired by the light of North Africa, the decorative qualities by Islamic art, the angularity by African art and the flatness by Japanese prints. He called the method that he used 'painting with scissors', and he believed that with *The Snail* he had gained 'greater completeness and abstraction'. The idea of a tiny snail being used as the theme for such an enormous work was part of the light-heartedness that he was aiming for, as was the outline of a snail that he cut out in the lilac shape at the top left of the work. Years earlier, Matisse had said he wanted to create art that would be 'a soothing, calming influence on the mind'.

Matisse's innovations altered the course of art. His diverse skills included painting, drawing, sculpture, graphic arts, paper cut-outs and book illustration, and his subjects comprised still life, landscape, portraiture, interiors and the female figure. From 1904, he began to explore many styles, embracing unusual brushwork ranging from thick impasto to flat areas of pure pigment, sinuous and harmonious contours, vivid light effects, brilliant colour and dynamic compositions.

Although Matisse's subject matter was not pioneering, his innovative approach to colour, line and expression was extremely influential.

One of the most influential artists of the 20th century, Matisse first emerged as a Post-Impressionist, and then, using colour and form expressively, he attained prominence as the leader of Fauvism, derived from the French *les fauves*, meaning 'wild beasts'. The movement did not last long, but was influential to countless artists, including Mark Rothko, Robert Motherwell and Dan Flavin.

Open Window, Collioure, 1905
National Gallery of Art, Washington, DC, USA

Danse (I), 1909
Museum of Modern Art, New York, USA

Odalisque in Red Trousers, c. 1924–25
Musée de l'Orangerie, Paris, France

By the late 1950s, Kaprow began to see the actions of the Abstract Expressionist painters, who moved around their vast canvases, throwing, pouring and dripping paint, as far more important than the end products. In 1958, he started the phenomenon 'Happenings'. These improvised events were set up in lofts, basements, empty shops and other unlikely locations for art. At his instigation, viewers became active participants in the Happenings, which he described as 'demonstrating the organic connections between art and its environment'.

ⓘ

car tyres, tar paper, Kaprow and son installation (Happening; Environment)

YARD
ALLAN KAPROW
1961

In 1961, the Martha Jackson Gallery in New York presented the exhibition 'Environment—Situations—Spaces'. It featured the work of six artists: George Brecht, Jim Dine, Walter Gaudneck, Claes Oldenburg, Robert Whitman and Allan Kaprow (1927–2006). In a small outdoor space behind the gallery, Kaprow created *Yard*, which consisted of a huge pile of car tyres. Visitors to the exhibition were invited to interact with the tyres, clambering over or crawling through them, and jumping, standing or sitting on them. By encouraging participation, Kaprow purposefully destroyed barriers between viewers and art. Directly inspired by Dada, his 'Happenings' were intended to be connections between art and the environment, events that were accessible, participatory, improvised, ephemeral and not saleable. 'Environments' was his original term for Happenings, which he described as 'a number of activities engaged in by participants for the sake of playing'. With this work, there was no structured beginning, middle or end, and no distinction or hierarchy between the artist and viewers. He staged *Yard* again in ten other locations. In 1993, he published his book *Essays on the Blurring of Art and Life*, writing: 'The line between art and life should be kept as fluid and perhaps as indistinct as possible.'

18 Happenings in 6 Parts, 1959
Reuben Gallery, New York, USA

Push and Pull. A Furniture Comedy for Hans Hofmann, 1963
Museum of Modern Art, New York, USA

Hello, 1969
film still

◎

Inspired by John Cage and Dada, Kaprow trained as an Abstract Expressionist. His Happenings, or 'un-art', called for an end to craftsmanship and permanence. He influenced other artists and movements, including Vito Acconci and Claes Oldenburg, and Minimalism, Conceptualism, Pop, Performance and Installation art. Happenings are now termed New Media art.

Most children would relish the idea of creating a huge pile of car tyres in an outdoor space and then inviting everyone to jump or climb on them. However, Kaprow's objective was not to create a play area. It was to move art beyond the confines of traditional art materials and museums, to abandon craftsmanship and permanence, and to enable the involvement of the viewers to reshape the artist's work.

The Bechers' methodical photography of functionalist architecture brought them recognition as Conceptual artists and Minimalists as well as photographers. Through what became known as the 'Becher School', many artists and photographers were inspired by them, including Thomas Ruff, Andreas Gursky and Candida Höfer.

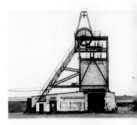

WINDING TOWERS
BERND AND HILLA BECHER
1966–68

For more than forty years, Bernd Becher (1931–2007) and his wife, Hilla (1934–), produced a series of black-and-white images of industrial structures. The couple met as painting students in Düsseldorf in 1957 and soon began photographing the disappearing industrial landscape. They systematically photographed buildings from different angles and objective viewpoints with an 8 x 10-inch view camera. Fascinated by the shapes and designs of the buildings, they called their work 'anonymous sculptures'. These images of pitheads at British collieries were taken as part of a series made between 1965 and 1973. Within a few years of completing the series, almost all the structures had been demolished. To avoid shadows, the Bechers photographed only on overcast days and early in the morning. They exhibited the images in grids in strict configurations grouped by subject and called these grids 'typologies'. Their captions noted only the time and place the photographs were taken.

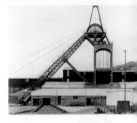

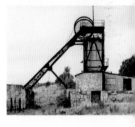

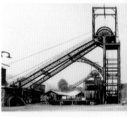

The Bechers avoided details that would interest technical or social historians, so these photographs of industrial architecture remain analytical and objective. Every shot was taken from the front, in almost identical flat lighting conditions and without human presence, and each retains uniformity in print quality, sizing, framing and presentation.

Framework Houses, 1959–73
Museum of Modern Art,
New York, USA

Water Towers, 1980
Solomon R. Guggenheim
Museum, New York, USA

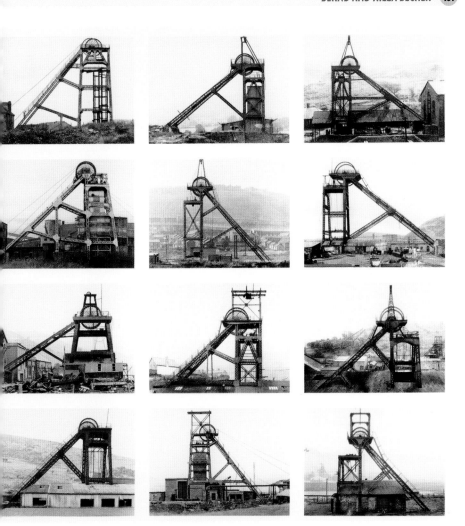

These photographs appear simple enough for a young child to have taken them, but the imagery is much more complex and sophisticated than it seems at first, and the images form a clear group. The contrasts of focus and balanced arrangements are not produced easily, and the use of rhythm and repetition in each documentary-style sequence is achieved only through coherent and mature treatment.

black-and-white photographs
193.5 x 234 cm
(76 x 92 in.)
Sonnabend Gallery, New York, USA

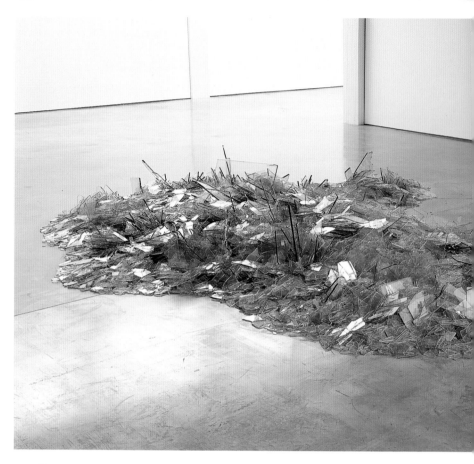

At first, this looks as if a child has dropped sheets of glass on the floor, but the broken pieces were arranged specifically to form a shape that illustrates the hypothetical lost island of Atlantis. When the work is viewed from the side, this is not apparent, but from an aerial perspective the shape becomes clear. As the glass glittered under gallery lights, the work appeared like a magical relief map and offered a new approach to sculpture that could not be categorized, and that abandoned traditional materials and defied expectations.

Smithson was fascinated by entropy, which roughly describes an irreversible condition or situation moving towards a state that nothing can change. He viewed the world energy crisis as a form of entropy, in which finite resources would eventually be used up.

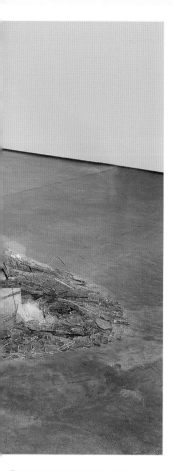

Smithson was one of the most influential postmodernists of his generation. He founded the Land art movement, which inspired a new generation of artists to create art beyond their studios. Like the environment, his *Site* works naturally eroded.

MAP OF BROKEN GLASS (ATLANTIS)
ROBERT SMITHSON
1969

A writer as well as an artist, Robert Smithson (1938–73) used texts, films, photographs and drawings to expound his theories on, among other things, thermodynamics, geology, science fiction, postmodern literature and horror films. He pushed art beyond the confines of museums and galleries, especially after 1967, with his two new forms of sculpture: *Sites* and *Non-sites*. For his *Sites* projects, he travelled to various natural settings and placed several mirrors in each location, photographing the resultant altered landscapes. For *Non-sites*, he created similar sculptures inside, often with mirrors, glass and materials he collected on his trips. Many of these *Non-sites* directly reflected his *Sites*. The pile of shattered glass forming *Map of Broken Glass (Atlantis)* is a *Non-site*. It was made to be seen as elements from the environment and as a map of the legendary lost island. By creating it, he contrasted several concepts at once, including actual and illusory, within and without, and entire and shattered.

broken glass
dimensions variable
installation

Corner Mirror with Coral, 1969
Museum of Modern Art, New York, USA

Spiral Jetty, 1970
Salt Lake City, UT, USA

Broken Circle, 1971
Emmen, Netherlands

Initially Smithson was a painter, but soon moved into other genres and created huge works that redefined conventional image-making, particularly in sculpture. A Minimalist and postmodernist, he used glass and neon lighting to explore refraction and reflection.

Although the paint splodges and blots in this work can be conceived as indiscriminate and immature, Dine deliberately incorporated them along with the heart motif in his distinctive extension of Pop art. The apparent random nature of the marks and colours actually embodies important underlying personal connections for the artist.

mixed media
on acetate
76 x 90 cm
(29⅞ x 35⅜ in.)
Private
collection

From 1959, Dine became known for his Happenings, which he pioneered with Allan Kaprow, Claes Oldenburg and John Cage. During the 1960s, he became associated with the development of Pop art and the Neo-Dada movement.

UNTITLED (8) I

JIM DINE

1970

Although the painterly effect produced here by Jim Dine (1935–) may not be instantly recognizable as Pop art, the heart motif gives a prominent clue. The work can be seen as a blend of the fluency of Abstract Expressionism and the directness of Pop art, with a sense of spontaneity that derived directly from Dine's involvement with Happenings, which later developed into Performance art. For more than half a century, Dine has incorporated familiar objects in his work in order to fuse commonplace elements with autobiographical notions, including his personal passions and memories. His recurrent use of objects such as hearts, articles of clothing and tools has become an identifiable trademark that he uses to communicate his various emotional and artistic objectives. For example, the apparent unpredictability of the marks in this painting illustrates his rejection of established artistic conventions. By repeating favoured motifs, often in several media, he explores and communicates a new kind of aesthetic that remains distanced from the major art movements that emerged after World War II, such as Minimalism and Conceptualism. When asked about the significance of the heart motif for him, Dine replied: 'I use it as a template for all my emotions.'

Four Hearts, 1969
Tate Collection,
London, UK

*The Sound of Your
Cold Voice*, 1991
Cincinnati Art
Museum, OH, USA

Dine is known for his highly refined draughtsmanship, a warm palette and diverse techniques using a wide range of media. He produces large numbers of paintings, drawings, prints and sculptures, as well as illustrated books and stage sets, while constantly maintaining his animated, energetic and gestural style.

An instigator of Minimalism, Andre was influenced by Constantin Brancusi and Frank Stella, as well as by Constructivism and Neo-Plasticism. In turn, he influenced the development of Conceptual art and the work of artists such as Richard Serra, Donald Judd and Walter de Maria.

UNCARVED BLOCKS
CARL ANDRE
1975

'Just as we say that a painter is a "colorist", I think of myself as a "matterist"', said Carl Andre (1935–) of his sculpture, which highlights materials' inherent qualities and properties. His plain, geometric arrangements are often low-lying and in simple configurations. This work consists of forty-seven blocks of red cedar wood, all of identical dimensions and shapes, laid out over a rectangular space. The blocks are placed at both vertical and horizontal angles, touching each other but never stacked on top of each other. Each group includes a single vertical block, and variations are made by the number and positions of the horizontal blocks around them. These indicate the four points of the compass, while each vertical block signifies the fifth point of the Chinese compass—the location of the observer. In his elimination of all extraneous elements, Andre aims to 'reveal the properties of materials', inviting viewers to consider space and how artists can modify it.

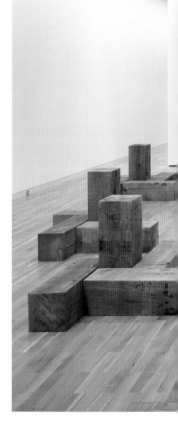

Focusing on the simplicity and singularity of objects made for other purposes, and using everyday industrial materials, Andre detached sculpture from processes of carving, modelling or constructing.

red cedar, 47 blocks
30 x 30 x 90 cm
(11¾ x 11¾ x 35⅜ in.) each
Kunstmuseum, Wolfsburg, Germany

Equivalent VIII, 1966
Tate Collection, London, UK

10 x 10 Altstadt Copper Square, 1967
Solomon R. Guggenheim Museum, New York, USA

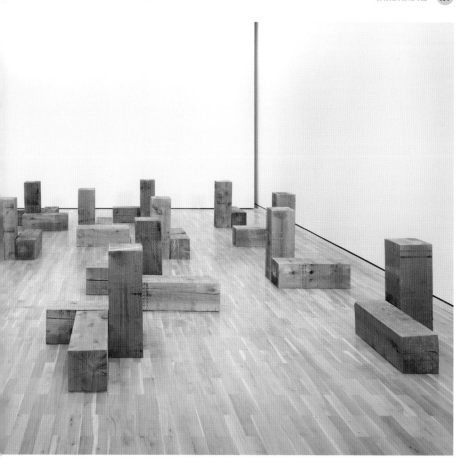

Andre is frequently accused of producing art that a child could do. Indeed, his work is calculatedly simple, and he effects no modifications. This composition resembles giant pieces of a wooden puzzle and epitomizes his straightforward sculptural approach to Minimalism. While a child might like to move blocks of wood around a room, Andre arranged the pre-prepared objects in particular mathematical configurations in order to emphasize the scale of the room and his focus on the properties of matter.

At around the time Andre produced *Uncarved Blocks*, another of his pieces caused a huge controversy. *Equivalent VIII*, usually referred to as 'The Bricks', triggered one of the most notorious public debates about contemporary art of the last century.

Inspired by a range of artists and art movements, including Marcel Duchamp, Henry Moore, Arte Povera, Conceptualism and Land art, Cragg has influenced numerous sculptors, and stimulated questions about our relationships with the world in particular.

NEW STONES, NEWTON'S TONES
TONY CRAGG
1978

This work is part of a series in which Tony Cragg (1949–) placed discarded objects in formations in gallery spaces. *New Stones, Newton's Tones* is made up of bits of plastic that Cragg found in the streets near his home in Wuppertal, Germany. 'I didn't sort or select the materials I collected until later when black, white, silver, printed and multi-duplicating objects . . . were set aside,' he said. 'All remaining objects were laid out, more or less evenly distributed in a rectangular format . . . in an approximate sequence of Newton's spectrum: dark red, red, orange, yellow, green, blue, dark blue, violet.' The work constitutes part of Cragg's search for a new metaphor in sculpture. His ideas are multilayered: for example, this work suggests that urban waste is to towns and cities what fallen leaves are to the natural environment, and he calls attention to society's excessive avarice and wastefulness that potentially threaten future generations. The work is reminiscent of stone floor works by Richard Long. From a distance, it is a rainbow of shiny colours, but close up individual objects can be discerned as broken, no longer useful, thus forcing viewers to make connections between environmental problems and everyday life.

Cragg expresses opinions about environmental and social issues in his work. He allows the qualities of his materials to dictate the form of each piece and uses plastic, clay, stone, bronze and mixed media, particularly discarded items. Frequently, as here, they are materials that will not easily decompose. His compositions are arranged to resemble geological formations.

plastic
366 x 244 cm
(143⅞ x 95⅞ in.)
Arts Council
Collection,
London, UK

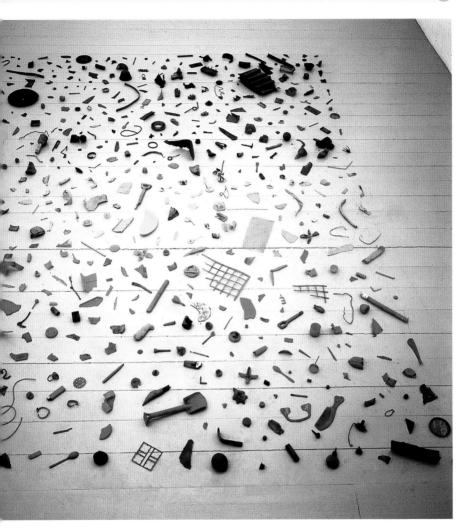

Although any child could find unwanted bits of broken plastic and arrange them in colour groups in a rectangle on the floor, Cragg was using the activity and resultant work to call attention to people's nonchalant dismissal of artificial objects as junk, without considering wider issues of industry, consumption, the environment and national economy.

Britain Seen from the North, 1981
Tate Collection, London, UK

Grey Moon, 1985
Museum of Modern Art, New York, USA

New Forms, 1991–92
Museum of Fine Arts, Houston, TX, USA

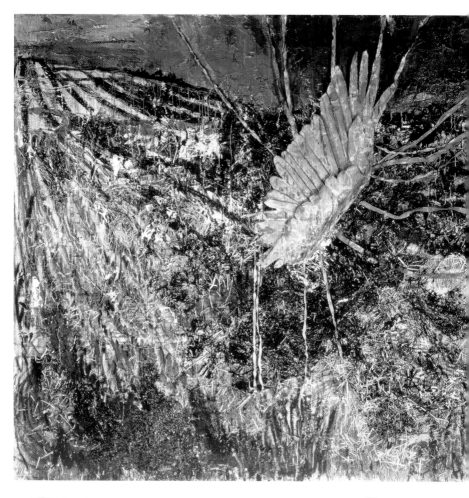

Born in Germany at the end of World War II, Kiefer grew up in a divided country bearing the scars of decades of conflict, hardship and anxiety. So although this painting may look as if a child could have done it, the work conveys a shattered landscape—with its apparently furrowed fields disappearing into the distance—painted to express sadness for the country. The thick paint represents layers of painful history, whereas the silver wing symbolizes a mythological bird, there to cleanse the past.

oil, emulsion, straw, photograph on canvas with lead wing
280 x 380 cm
(110 x 149⅜ in.)
Saatchi Collection, London, UK

Urd Werdande Skuld (The Norns), 1983
Tate Collection, London, UK

Nigredo, 1984
Philadelphia Museum of Art, PA, USA

Kiefer initially studied law to learn about human behaviour. He later studied art with Joseph Beuys and became inspired by various figures, including Richard Wagner, Albert Speer and Arnold Böcklin, as well as German Expressionists such as Emil Nolde and Max Beckmann. He is often labelled a New Symbolist.

**WAYLAND'S SONG
ANSELM KIEFER
1982**

Profoundly affected by the aftermath of World War II, Anselm Kiefer (1945–) draws upon a wide range of traditions in his art, including the Bible, the occult, the Kabbalah, the Holocaust and astronomy, as well as emotive art styles—particularly Symbolism and Expressionism—spiritualist theories and ancient myths. This work grew out of a fascination he developed for an ancient Norse mythical character, Wayland, who possessed magical powers and helped to repair the past. Kiefer made Wayland his alter ego—a personification of himself who, through his paintings, could purify history, encourage rebirth and renewal, and instigate new standards for his nation's future. In the myth, Wayland was symbolized by wings; in this painting, Kiefer painted a lead wing on the surface of his thickly encrusted canvas. Of the opinion that artists have powers to portray natural forces that are imperceptible to others, Kiefer also believed that he imbued all his work with almost mystical powers that would repair Germany and restore it from the shadow of its past. Focusing in this way on Germany's cultural legacy, *Wayland's Song (Wolundlied)* was an uncomfortable reminder that the country still needed to heal itself.

Since the 1970s, Kiefer has produced paintings, sculpture, woodcuts and photographs, depicting creation, resistance, violence and other apocalyptic notions with reference to German history. He is best known for his huge, heavily layered paintings, which he creates with combinations of oil paint, acrylic, shellac, gold, clay, straw, lead, wood and broken glass.

CRACK IS WACK
KEITH HARING
1986 (REPAINTED 1990)

Crack is Wack is a painting on the wall of an abandoned handball court in East Harlem, New York. Keith Haring (1958–90) chose the site for its prominence—it was visible to thousands of motorists driving by on the nearby highway. Haring began his anti-crack campaign in a bid to urge the government to respond to New York's growing drug epidemic. The local authorities painted over the original work but later, realizing what it was about, asked Haring to paint another version. Featuring enormous childlike lettering and Haring's characteristic lively figures, the work portrays the anti-crack message powerfully. The artist's inclusion of two skulls indicates the prospect of death. By the time he painted this work, Haring was internationally renowned and had recently opened his 'Pop Shop', a retail store in the city selling T-shirts, toys, posters, buttons and magnets, all bearing his images. *Crack is Wack* is one of his many works bearing social messages, and since his untimely death at the age of thirty-one it has become a New York landmark.

Haring was inspired by Jean Dubuffet, Andy Warhol and graffiti art. During his brief but intense career, he collaborated on many projects with performers and artists such as Warhol, Madonna and Grace Jones.

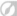

Obsessed with spray painting since childhood, Haring began drawing in New York's subway in the early 1980s. Soon attracting positive attention, he was often commissioned to work on public and private projects.

latex house paint on brick wall
4.9 m (16 ft) high x
6.1 m (20 ft) wide
handball court, 128th Street
and Second Avenue,
New York, USA

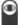

Untitled, 1982
Museum of Modern Art,
New York, USA

Altarpiece, 1990
Ludwig Museum,
Budapest, Hungary

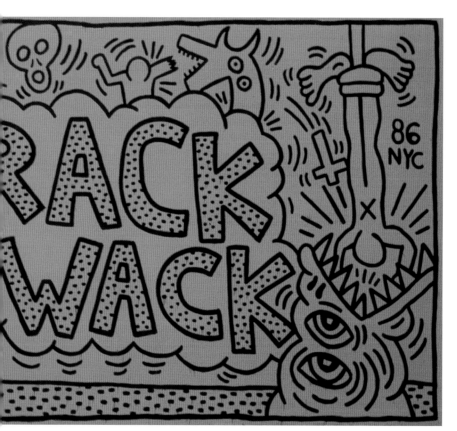

Wriggling lines on a wall, stick men jumping and leaping about, and big spotty letters—it would probably not be possible for a five-year-old to create this, but a ten-year-old could. Or could they? Haring combined his art with the life that he knew. By paring down his figures and other elements, he created recognizable icons that instantly communicated social messages. He created his lively caricatures not only for amusement, but also to express his views—and to attempt to change attitudes, as here, where he conveys a powerful anti-drugs message.

Haring created this work to help his friend who was having difficulties coming off the highly potent and addictive drug crack, which was used in epidemic proportions during the 1980s. The direct image was Haring's way of shocking the US government into doing more to assist crack addicts.

**GENEVA CIRCLE TWO
RICHARD LONG
1987**

Geneva Circle Two is one of many huge configurations made of natural materials that Richard Long (1945–) has been creating since the 1970s. His work comprises several layers and manifestations, usually starting with solitary walks through rural and remote areas. He creates sculpture as he walks, using local materials found on the way, or makes ephemeral and almost imperceptible alterations to the landscape as he passes through. He documents all his journeys with maps, texts, photographs and sculpture, often creating large works such as this in a studio or gallery when he returns, inspired by a recently visited location. This huge stone circle is assembled meticulously; the irregular pieces are almost tessellated as Long investigates relationships between time, distance, geography and measurement. Inspired by experiences within the environment, the work also suggests correlations with primitive or prehistoric structures and their more spiritual implications. His outdoor work always informs his indoor creations, and he says he likes 'the fact that every stone is different, one from another, in the same way all fingerprints, or snowflakes (or places) are unique, so no two circles can be alike'. Over the years, he has explored different ways of interpreting aspects of his walks in galleries, and this type of monumental structure serves to highlight the concepts of solitude, isolation, transience and visibility.

A greater public awareness of the environment has developed partly through Long drawing attention to it. Known as one of the first Earth, Land, Environmental and Conceptual artists, he has influenced others, including Andy Goldsworthy and Tony Cragg.

Long has explored the landscape since 1967, when he walked through a field and photographed the trampled path he made. He continues to record journeys and to assemble elements from the land, thus making creative connections with the environment.

 Although the stone pieces that make up this work would be too heavy for a child to move, this entire structure does appear to be something that children might like to help arrange in a garden or park, to create a space for play. They are not stepping stones or a play area, however, and Long's objectives in making this work are more about evoking the landscape as earlier artists have done, forcing a reconsideration and appreciation of the environment, stimulating primitive notions of spirituality and reverence, and drawing parallels between contemporary sculpture and prehistoric forms.

stone
5 m (16½ ft) diameter
Private collection

Red Slate Circle, 1980
Solomon R. Guggenheim
Museum, New York, USA

Berlin Circle, 1996
installation

Riverlines, 2006
Hearst Tower,
New York, USA

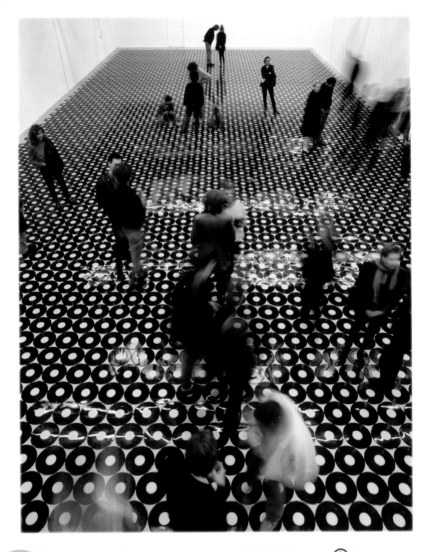

? Any child could cover a floor with records and invite people to walk over them, but Marclay created this installation to explore relationships between sight and sound. He has spent his career composing and combining music, Performance art and Marcel Duchamp's legacy in order to create what he calls his 'theatre of found sound'.

ⓘ 3,500 vinyl records installation Shedhalle Galleries, Zurich, Switzerland

FOOTSTEPS
CHRISTIAN MARCLAY
1989

In 1989, for six weeks Christian Marclay (1955–) covered the floor of a gallery with 3,500 vinyl records that had been recorded, on one side, with the sounds of footsteps. Visitors to the gallery had to walk over the records, and the marks and scuffs they made unwittingly became part of each record's sound. At the end of the exhibition, the records, which were fixed in place with double-sided tape, were removed, and Marclay subsequently sold 1,000 of them—complete with scratches—as a flagrant record of the damage people do to the world. To make his commentaries about society's behaviour, he always uses vinyl records rather than CDs or more modern technology, and he scratches, cuts and reassembles them, mixing various types of music, using damaged turntables and gluing pieces of unconnected records together to make collages of sound and image. He said of his work: 'When different, unrelated records are combined, they can have the power to trigger memories . . . Music has such powers in triggering memory, collective memory and private memory.' Destruction and deconstruction are important aspects of his work: for example, the clicks and pops in the records from *Footsteps* became significant elements of this installation. He described the damaged sound as: 'An expressive power in itself. When something goes wrong . . . something unpredictable happens . . . something new and exciting.'

For thirty years, Marclay has fused visual and aural art, transforming sound and music through performance, photography, video, collage, sculpture and installation. He initiated the use of vinyl records, turntables and musical instruments in the late 1970s, and continues to create artworks based on both sound and sight, by fracturing, reconstructing and manipulating records on and off turntables. Some of his more recent work has been particularly ambitious, with complex installations either carefully planned or freely improvised.

Marclay destroys records to create new sounds because, he says, old records have the quality of time passed and a sense of loss that he aims to bring back to life.

Marclay was inspired artistically by Joseph Beuys and musically by John Cage. He was also influenced by the Fluxus movement of the 1960s and 1970s, which revived the spirit of Dada. He has been dubbed the 'unwitting inventor of turntablism'.

Video Quartet, 2002
Tate Collection, London, UK

The Clock, 2010
Museum of Modern Art,
New York, USA

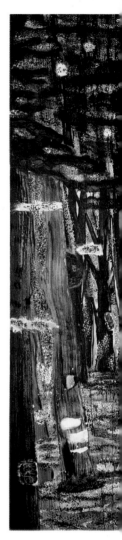

Doig continually challenges his own methods, and his expressive colours and compositions are unlike anything else that was being produced in the art world during the 1990s. They are inspired by several influences, including Fauvism and the landscape painting of Claude Monet, Paul Gauguin, Andrew Wyeth, David Milne and Paterson Ewen.

CONCRETE CABIN
PETER DOIG
1991–92

In 1991, Peter Doig (1959–) visited the Unité d'Habitation apartments in Briey-en-Forêt in north-east France, one of several post-World War II projects designed by the revolutionary architect Le Corbusier. Envisioned as ideal living spaces, the apartments were opened in 1961 but subsequently fell into disrepair.

Thirty years later, Doig worked on the site with other architects and artists. Using a handheld video camera, he filmed the surroundings as he moved through the woods towards the building, and later painted from his film stills. Over eight years, he produced a series of paintings, of which this is one, in which the architecture seems to emerge and vanish through the mesh of trees. By cropping the image to exclude ground or sky, he heightened the atmospheric tension. Like a tapestry, the paint is built up in layers, projecting a compelling yet disorientating aura and inducing impressions of loneliness and uncertainty. Doig described his inspiration for the work: 'It was not until I saw the photographs I had taken of the building through the trees that it became interesting . . . I was surprised by the way the building transformed itself from a piece of architecture into a feeling.'

Doig originally painted in a brightly coloured Fauvist style, reminiscent of Henri Matisse or André Derain, but soon developed a softer approach. Using a wide range of media, including watercolour, ink, charcoal, oil, coloured pencil and acrylic, he works from direct observation, photographs and his imagination.

oil on canvas
200 x 240 cm
(78⅛ x 94⅜ in.)
Victoria Miro
Gallery, London,
UK

A cursory glance at the powerful colours and shapes could give the impression that a child had painted this work, but on closer inspection Doig's sophisticated brushwork reveals that his aim is to create ambience and mystery rather than a photographic likeness. The painting invites viewers to consider a world beyond reality.

The House That Jacques Built, 1992
Tel Aviv Museum of Art, Tel Aviv, Israel

Ski Jacket, 1994
Tate Collection, London, UK

This is one of fifty-six photographs of Concorde taken by Tillmans. It appears simple and spontaneous, and something that many children could replicate, but it was actually the result of a meticulous process. Deceptively mundane, the image expresses several ideas, including the admiration many felt for Concorde, even though it was environmentally untenable.

photograph
32 x 22 cm
(12⅝ x 8⅝ in.)
Tate Collection,
London, UK

CONCORDE GRID
WOLFGANG TILLMANS
1997

Concorde Grid is a series of colour photographs of equal dimensions featuring Concorde, arranged four rows high and fourteen columns wide. Wolfgang Tillmans (1968–) took the images as part of a commission for the Chisenhale Gallery, London, from several sites, including Heathrow Airport and private gardens. This particular image is of Concorde dramatically descending and is slightly blurred deliberately in order to convey velocity. Other photographs in the series feature Concorde taking off, soaring over fields and flying above railway tracks and parked vehicles. Depicted in varying scales and angles, the jet sometimes resembles a bird and sometimes looks more like a stingray. In several images it appears indistinct, seen through the atmospheric haze and heat of its engines. The photographs emphasize the utopian idea of Concorde and the feelings of wonder it stimulated, despite it being ecologically unsustainable. Tillmans wrote: 'In the spring of 1997 for a few weeks, I became a plane-spotter. It was a fascinating thing, standing under the flypass near the perimeter fence of Heathrow, or in Richmond or Clapham, watching the very distant dot in the sky as it approached. Concorde seemed like a perfect machine that would go on forever.' In 1997, Concorde was still a symbol of progress and glamour, and Tillmans consciously contrasted that idea with the drabness of the surrounding suburban landscape.

In his early twenties, Tillmans took photographs in a Hamburg nightclub and sent them to the editor of the British magazine *i-D*, who commissioned him to take more fashion and clubbing shots. He soon began producing portraits, documentaries, still lifes, landscapes and abstractions (patterns of colour created without cameras). His innovative forms of presentation, such as hanging prints on walls with tape and displaying mixed montages, are an essential element of his work.

Tillmans makes his images appear mundane and uncontrived. They all suggest deeper, underlying meanings, such as political themes of homelessness, racism, gay rights and the environment.

In 2000, Tillmans was the first photographer and German artist to be awarded the Turner Prize. He cites Felix Gonzalez-Torres as one of his greatest influences. His work has helped to popularize the concept of the realist 'snapshot' style of photograph.

Lutz and Alex Sitting in the Trees, 1992
Tate Collection, London, UK

Lighter 46, 2008
Solomon R. Guggenheim Museum, New York, USA

Mehretu's work belies categorization. Her influences encompass architecture (from Baroque to Modernism, including Le Corbusier, Mies van der Rohe and Tadao Ando), maps, calligraphy, landscape painting, graphics and graffiti, which all create an entirely new form of artistic expression.

EMPIRICAL CONSTRUCTION, ISTANBUL

JULIE MEHRETU

2003

Although this work is abstract, it includes many representational elements and different perspectives to convey the sense of a bustling city. Formerly known as Byzantium and Constantinople, Istanbul is the largest city in Turkey and, mainly because of its position on the border of Europe and Asia, it has been extremely important historically. It was the capital of the Roman, Byzantine and Ottoman Empires, which Julie Mehretu (1970–) reflects in the work's vast scale. She has also included layers of symbols, including a star and crescent, flags, rectangles and architectural signs. At the centre of the composition is the Hagia Sophia, an Eastern Orthodox Church that was converted to a mosque, then to a museum. Radiating from that, the layers of images and symbols convey elements of the city's past and present. Mehretu intended this to be an abstracted and indefinable map of history and geography, or of time and place.

ink and synthetic polymer paint on canvas
305 x 457 cm (119⅞ x 179⅝ in.)
Museum of Modern Art, New York, USA

Explaining her method, Mehretu says: 'I work with source material that I am interested in conceptually, politically, or even just visually, I . . . project it, trace it . . . re-contextualize it, layer [it], and envelop it into the DNA of the painting.'

This artwork could be construed as a scribble or doodle, and as something that a child could do; however, the mix of painting and ink drawing has been carefully planned to represent specific elements of the city of Istanbul, including rich historical, geographical, social and political references. Even aspects of the image that resemble explosions are composed deliberately to portray layers of Istanbul's creation and development.

Rouge Ascension, 2002
Museum of Modern Art,
New York, USA

Stadia I, 2004
San Francisco Museum of
Modern Art, San Francisco,
CA, USA

Entropia (review), 2004
Studio Museum,
New York, USA

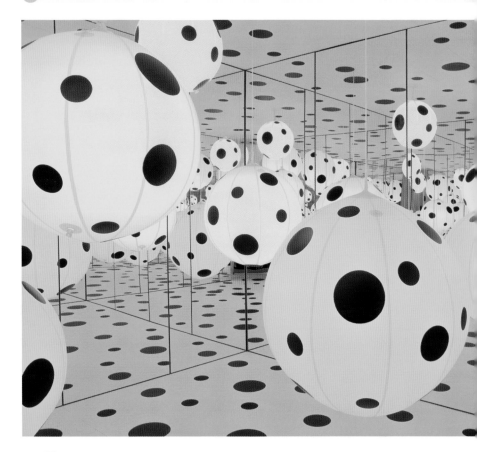

This space, with its dotted floor and ceiling and different-sized dotted balloons, resembles a child's playroom. A room like this would appeal to many children; they would enjoy painting the black dots and playing there. However, Kusama, who has been creating obsessively repeated patterns and forms since the 1950s, sought to overwhelm viewers and stimulate hallucinations as they stood in the space.

mixed media
installation
dimensions variable
balloon diameters:
2 m, 3 m, 4 m, 6 m
(6½ ft, 9¾ ft, 13 ft, 19½ ft)

In the 1960s, Kusama became associated with Pop art and exhibited with Andy Warhol and Claes Oldenburg. She also organized a series of Body Festivals in which naked people were painted with brightly coloured dots.

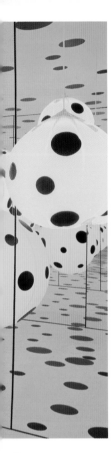

Inspired early on by Abstract Expressionism, Kusama subsequently influenced Pop art and Minimalism. Without conforming to any movement, she expresses both her neuroses and her place as a female Japanese artist in the male-dominated Western art world.

DOTS OBSESSION— INFINITY MIRRORED ROOM
YAYOI KUSAMA
2008

The softly lit, black-spotted interior with its huge, hovering balloons is typical of installations by Yayoi Kusama (1929–). Having studied the formal style of traditional Nihonga painting in Japan, which aimed to prevent the influence of Western art, she became attracted to more experimental concepts and moved to New York City in 1958. Since 1977, she has lived voluntarily in a psychiatric institution, and most of her art explores her own psychological issues. *Dots Obsession—Infinity Mirrored Room* derives from her experiences of living in rural Japan, New York and Tokyo, and the patterns created by the compulsively repeated black dots, glowing light and reflections develop from her inner visions. However, she remains mindful of viewers' responses, and the work is intended to be both therapeutic and overwhelming. Her idea is that, on entering the installation, viewers are immediately affected by the almost cocoonlike surroundings that are enhanced by the yellow light and floating forms. The effects can be unnerving or relaxing as visual senses are bombarded. The floor and ceiling are covered with the black dots, while the mirrored walls emphasize and multiply them, thus creating an apparently endless space. These elements force viewers to experience various feelings of infinity, enclosure, perhaps childhood memories or even a sense of floating or other-worldliness.

Repetitive Vision, 1996
installation

The Passing Winter, 2005
installation

Ascension of Polka Dots on the Trees, 2006
installation

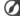

In the 1950s, Kusama became interested in avant-garde art and began producing Abstract Expressionist-style paintings, working with a broader variety of media. She continuously reinvents her style as she explores themes of infinity and repetition.

Influenced by Marcel Duchamp and Joseph Beuys, in 1978 Ai founded the Chinese avant-garde art group the 'Stars' with six other artists. The group disbanded in 1983 while Ai was living in New York and inspiring others with his Conceptual works.

SUNFLOWER SEEDS
AI WEIWEI
2010

Ai Weiwei (1957–) was born in Beijing and grew up in an artistic family; his father was one of China's most important poets. However, soon after Ai's birth, Mao Zedong's communist government exiled the entire family to a labour camp in Manchuria for supposedly supporting capitalism. Later, while working as an artist within the 'Stars' group, Ai created art that showed influences of Cubism and Surrealism, which had been banned in China. While living in New York during the 1980s, he began to experiment with Conceptual art and explored social and political ideas in particular, which he has continued to do in both the West and the East. In 2010, he exhibited *Sunflower Seeds* in London. It consists of millions of individual pieces that together form a single surface; each tiny element resembles a sunflower seed, and the whole is a massive carpet of seeds. Although incredibly realistic, each sunflower seed was in fact made of porcelain, individually sculpted and painted by skilled artisans in the Chinese city of Jingdezhen. The traditional method of crafting porcelain is quintessentially Chinese, and *Sunflower Seeds* invites viewers to reconsider the workers of China and various related social, cultural, political and economic issues.

Blending ideas from capitalism, communism and traditional Chinese culture, Ai says that he bases his work on 'essentiality'. In his art, he examines China's indiscriminate adopting of Western values and the threats that this poses to his country's heritage. He also comments on such notions as people's collective and individual significance, the environment and the future.

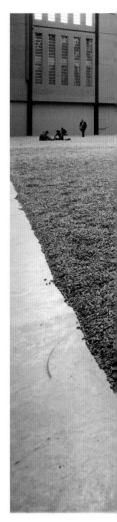

approximately eight million porcelain sunflower seeds installation

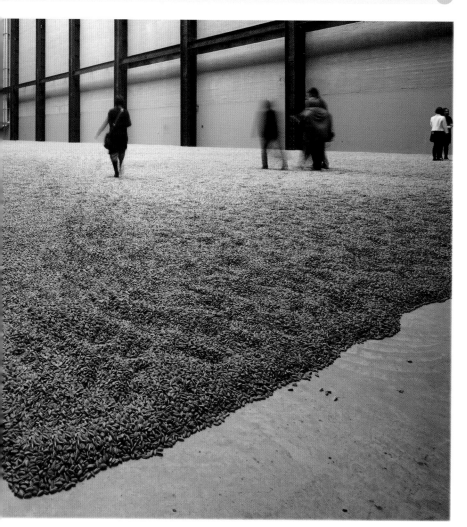

Children could have sprinkled sunflower seeds all over a vast floor, but this carpet of porcelain seeds was cryptic. Made up of handcrafted works of art, representing China, the precious nature of porcelain and the effort of production, it articulated the realities of the 'Made in China' label and highlighted the human condition.

'Forever' Bicycles, 2003
installation

20 Chairs from the Qing Dynasty, 2009
installation

Snake Bag, 2011
installation

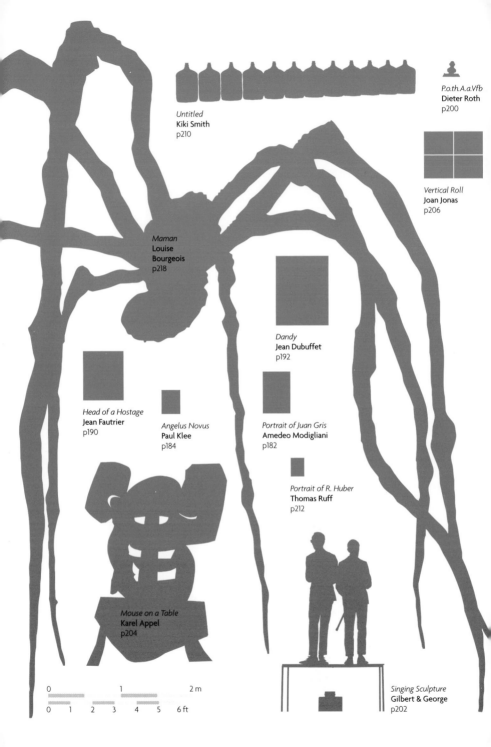

P.o.th.A.a.Vfb
Dieter Roth
p200

Untitled
Kiki Smith
p210

Vertical Roll
Joan Jonas
p206

Maman
**Louise
Bourgeois**
p218

Dandy
Jean Dubuffet
p192

Head of a Hostage
Jean Fautrier
p190

Angelus Novus
Paul Klee
p184

Portrait of Juan Gris
Amedeo Modigliani
p182

Portrait of R. Huber
Thomas Ruff
p212

Mouse on a Table
Karel Appel
p204

Singing Sculpture
Gilbert & George
p202

| 0 | | 1 | | 2 m |
| 0 | 1 | 2 | 3 | 4 | 5 | 6 ft |

CHAPTER FIVE
PEOPLE / MONSTERS

Although the term 'celebrity' was coined in the mid-19th century, it was the burgeoning mass media of the post-World War II era that created the phenomenon that is so familiar today. However, artists have been perceived as celebrities since the 16th century. Indeed, art academies made a great effort to establish their celebrity status, but it is precisely this element that many modern artists have sought to eliminate. In this chapter, for example, Jean Dubuffet's *Dandy* and *Woodmen* by Georg Baselitz were created using traditional materials, yet both artists sought to challenge art's pretentiousness. Other works in this chapter, such as Pablo Picasso's *Reading* and *P.o.th.A.a.Vfb* by Dieter Roth, re-present the ancient genre of portraiture with a wealth of implication and an economy of production.

A restless innovator whose sufferings informed his creative work, Munch believed that artists should record the impact of remembered scenes and feelings rather than produce objective portrayals. His graffiti-like scrawls of non-representational colour contradicted traditional painting practice. Much of his work is autobiographical, redolent with symbolism expressing themes such as misery, fear and death.

When he was five, Munch's mother died of tuberculosis. Nine years later, his sister died of the same disease.

oil, tempera and pastel on cardboard
91 x 73.5 cm (35¾ x 28⅞ in.)
National Gallery, Oslo, Norway

Ashes, 1894
National Gallery, Oslo, Norway

Puberty, 1894–95
National Gallery, Oslo, Norway

The Dance of Life, 1899–1900
National Gallery, Oslo, Norway

**THE SCREAM
EDVARD MUNCH
1893**

Edvard Munch (1863–1944) painted *The Scream* to express his inner anxieties. After a bleak childhood in Oslo, raised in a home full of sickness, melancholy and religious zeal, he grew up with a negative view of life.

The contorted, skull-like figure in the foreground of this painting, stripped of details—its mouth and eyes open in a shriek of horror—came to him in a vision as he walked one evening at sunset with two friends. He described the moment in his diary: 'One evening I was walking along a street, tired and ill, with two friends. The city and the fjord lay below us. The sun was setting and the clouds turned blood red. I stood there, trembling with fright and I felt a loud, unending scream piercing nature.' Undulating and diagonal lines of the sea and sky intensify the unnerving impression, almost swallowing up the screaming figure, while the scream itself appears to have no effect on the two men in the distance, thus suggesting that the suffering exists only in the main figure's mind. Munch produced two oil paintings, two pastels and numerous prints of this vision. The image defies accepted artistic traditions and the naturalistic approach of his mentor, the painter Christian Krohg. It expresses the artist's personal anguish and helped to relieve the bouts of depression and occasional fits of terror that he experienced throughout much of his life.

After seeing the emotionally charged work of Paul Gauguin and Vincent van Gogh in Paris, Munch developed his individual style. He was perceived as the pioneer of the Expressionist movement and inspired artists including Käthe Kollwitz, Ernst Ludwig Kirchner, August Macke and Francis Bacon.

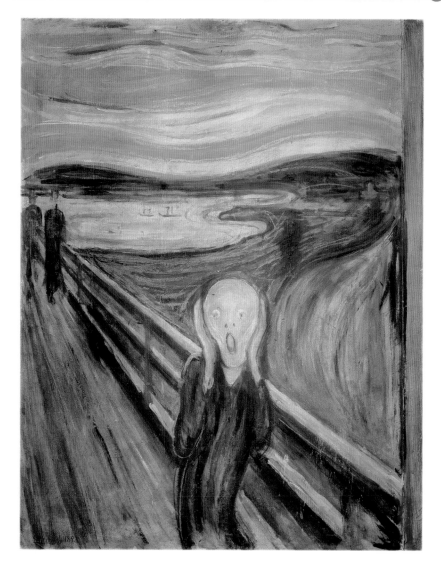

This is an iconic painting that many children have replicated, but the psychological complexities of the agitated mind that produced it are rare. Painted three years after Munch's father's unexpected death, *The Scream* was deliberately childlike and naive in its visual language. Munch was consciously untainted by society's expectations. He explained how he captured memories: 'I do not paint what I see but what I saw.'

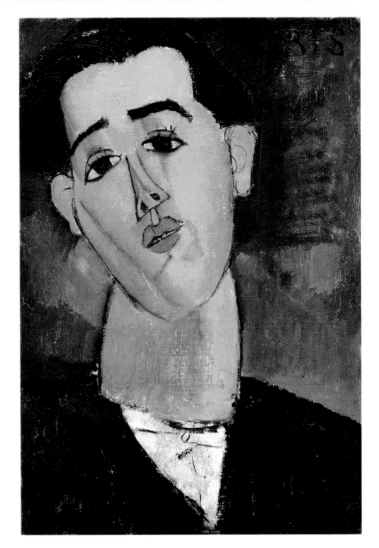

? Working as an artist at a time when naive art was in vogue, Modigliani sought to express a childlike ingenuousness. Therefore, declaring that a child could have painted this portrait would not have offended him. Nevertheless, as an amalgamation of influences, including African masks and the works of Paul Cézanne, Henri Rousseau, Picasso and Constantin Brancusi, as well as the radical philosophies of Friedrich Nietzsche, this work is far more complex than anything a child could have produced.

PORTRAIT OF JUAN GRIS
AMEDEO MODIGLIANI
1915

Juan Gris and Amedeo Modigliani (1884–1920) became friends in 1906 when they both moved to Paris: Gris from Spain and Modigliani from Italy. Modigliani painted portraits only of people he knew, but even so, as in this work, none expresses the idiosyncrasies of his sitters' personalities. In this portrait, with its blank eyes and angular features, he has effectively objectified the image of his friend. The eyes are flat, black and without pupils, so the direction of the portrait's gaze cannot be established, and the work becomes almost as detached as a still life. From 1914 to 1916, Modigliani was particularly influenced by the Cubists, especially the friends he associated with in Paris at the time—Pablo Picasso, Georges Braque and Gris—and his portraits during that period are usually of his contemporaries. The pared-down angularity of this portrait, with its elongated neck, almond-shaped eyes and oval face—stylized, simplified and almost painted to a format—is nevertheless a strong likeness of Gris, as if he has captured the underlying soul of the man. Although Modigliani admired the angular styles of the Cubists, he never fragmented his artwork as they did nor aimed to depict anything from more than one angle at once. His main aim was to give his paintings 'a tight skin of paint'.

Paris in the early 20th century was the centre of the avant-garde art world, and the term 'Ecole de Paris' was used to describe the countless innovative artists who flocked there. Modigliani became linked with it as he developed his style, which was inspired by Cubism, the sculptor Brancusi, Henri de Toulouse-Lautrec, Edvard Munch, and the writer Max Jacob.

Inspired by a broad range of art, from ancient to modern, Modigliani demonstrated few elements of contemporary art styles and rarely changed his approach. From the start of his career, he actively avoided joining in academic debate or specified art movements, but quickly established his distinct and enduring linear method in both his painting and his sculpture.

The sinuous lines of Art Nouveau and of Brancusi's art were the most perceptible influences on Modigliani.

oil on canvas
55.5 x 38 cm (21¾ x 14⅞ in.)
Metropolitan Museum of Art, New York, USA

Female Nude, 1916
Courtauld Institute Galleries, London, UK

Reclining Nude, 1917
Staatsgalerie, Stuttgart, Germany

Jeanne Hébuterne in a Yellow Sweater, 1918–19
Solomon R. Guggenheim Museum, New York, USA

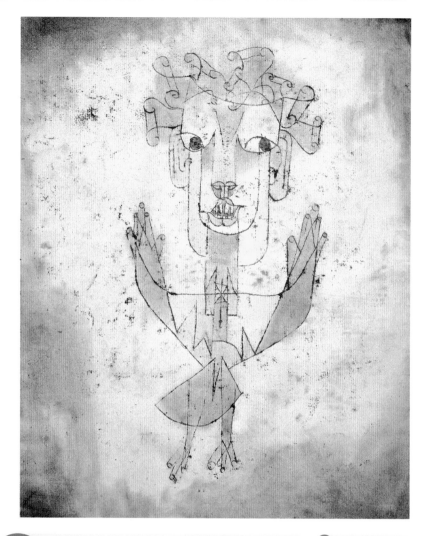

Klee greatly admired the art of children and their free and expressive ways of drawing. In this work, he endeavoured to achieve a comparable instinctive simplicity. So although a child could have made a similar doodle, this bizarre part bird, part man and part angel was created to interpret the memories and threats of war that surrounded everyone living in Europe at the time.

oil transfer, watercolour, India ink and brown wash on paper
32 x 24 cm (12⅝ x 9⅜ in.)
Israel Museum, Jerusalem, Israel

ANGELUS NOVUS
PAUL KLEE
1920

This hybrid creature was painted in the year that the Swiss-German artist Paul Klee (1879–1940) had his first large-scale exhibition in Munich, was about to join the Bauhaus as a teacher and had just written his book on art theory, *Creative Confession*, describing his metaphysical beliefs. It was also a time of political and social turbulence, and although *Angelus Novus* resembles a child's rendering, it is a supernatural being from Klee's imagination, reflecting current events. When the philosopher and literary critic Walter Benjamin bought the work in 1921, he described it in 'Theses on the Philosophy of History': '*Angelus Novus* shows an angel looking as though he is about to move away from something he is fixedly contemplating. His eyes are staring, his mouth is open, his wings are spread. This is how one pictures the angel of history. His face is turned towards the past . . . a storm is blowing from Paradise; it has got caught in his wings with such violence that the angel can no longer close them. The storm irresistibly propels him into the future to which his back is turned . . . This storm is what we call progress.' As a transcendentalist, Klee believed that the material world was just one among many others existing on different levels. This work demonstrates how he explored these metaphysical philosophies using an instinctive and intuitive process.

Klee was inventive and independent. He worked with a variety of media, including oil paint, pastel, watercolour, ink and etching, on diverse supports, such as canvas, muslin, cardboard, foil, wallpaper and newsprint, using many techniques, including spray paint, glazing and impasto. His work comprised geometric forms, letters, figures or complete abstraction. He became known for his colour palettes, which varied from vibrant to almost monochromatic. A musician, Klee also explored rhythm and resonance in his work.

(!) According to one theory, this painting was inspired by Adolf Hitler, who lived in Munich at the same time as Klee.

(◎) Although associated with several art movements, including Cubism and Surrealism, Klee's work is hard to classify. After the 1950s, he especially influenced the Abstract Expressionists and Colour Field painters, particularly those interested in mythology, the unconscious, children's art and primitivism.

On a Motif from Hammamet, 1914
Kunstmuseum Basel, Basel, Switzerland

Heroic Roses, 1938
Kunstsammlung Nordrhein-Westfalen, Düsseldorf, Germany

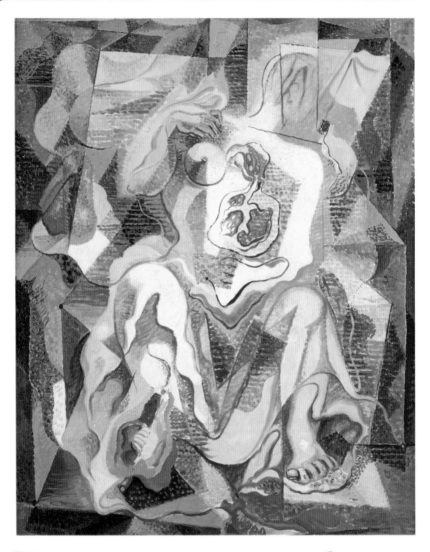

Sharing the contemporary avant-garde fascination with the directness of children's art, Masson expressed a similarly guileless style. *Woman* (*Femme*) illustrates much of the anti-academic, childlike approach he aimed for, but a child could not replicate the underlying sophistication of the composition and mature handling of the paint.

oil on canvas
73 x 59 cm
(28¾ x 23¼ in)
on loan to
Hamburger
Kunsthalle, Hamburg,
Germany

**WOMAN
ANDRÉ MASSON
1925**

During World War I, André Masson (1896–1987) was seriously wounded. He spent two years in hospitals to treat his wounds and the consequences of shell-shock. For the rest of his life, he endured physical pain, nightmares and insomnia, and was deeply scarred emotionally, which inspired his contemplation of human destiny, the universe and life being ruled by conflicting, antagonistic forces. He was initially inspired by Cubism, particularly by Juan Gris and André Derain, and art became the conduit for expressing his ideas. By the time he painted this work, he had joined the Surrealist movement in Paris. It shows evidence of his pioneering method of automatic drawing, in which he expressed his subconscious thoughts, demonstrating his belief in universal power. The curved and angled lines, writhing undulations and textured patches of colour were laid down unconsciously, yet still reveal his respect for the ingenuousness of child art and the simplicity of what was then termed primitive art. To attain the state necessary for automatism, he said that he often denied himself food or sleep, or worked under the influence of drugs. Beneath the patterns that flow across the composition, a seated female figure can be discerned, reminiscent of a Renaissance Madonna, floating in an indeterminate space. Her roughly indicated internal organs represent evidence of connections between the universe and life forces.

Having originally worked as a pattern-drawer in an embroidery studio, Masson began his art career painting landscapes. He moved on to explore Cubist methods and then experimented with automatism, including making sand pictures, in which he threw sand and glue on to canvas and made oil paintings based around the shapes that formed. By the end of the 1920s, he began working in a more structured style, often producing violently themed works. Later, he also created sets and costumes for theatre, and book illustrations.

When Masson pioneered automatism in 1923, he instigated the Surrealists' break from Dada. A focus on the unconscious brought about their independence.

Pedestal Table in the Studio, 1922
Tate Collection, London, UK

La Belle Italienne, 1942
Art Institute of Chicago, IL, USA

Masson was inspired initially by Cubism, Gris and Derain, and subsequently joined the Surrealists from 1924 to 1929. After World War II, he moved to the United States, influencing numerous artists, including Arshile Gorky, Jackson Pollock and Mark Rothko.

The dominant artist of the 20th century, Picasso invented Cubism with Georges Braque and made key contributions to several other art movements. He was primarily a painter but also worked in printmaking, collage, sculpture and ceramics. He constantly developed his style, trying new techniques and revolutionizing attitudes and approaches to art.

When Paris was occupied in World War II, Picasso's art was not allowed to be shown, as it contradicted Nazi ideals.

oil on canvas
130 x 97.5 cm (51⅛ x 38⅜ in.)
Musée National Picasso, Paris, France

Les Demoiselles d'Avignon, 1907
Museum of Modern Art,
New York, USA

*Women Running
on the Beach*, 1922
Musée National Picasso,
Paris, France

Guernica, 1937
Museo Reina Sofía,
Madrid, Spain

READING
PABLO PICASSO
1932

Pablo Picasso (1881–1973) painted *Reading (La Lecture)* five years after meeting Marie-Thérèse Walter, and in it stressed his love for her in a new style. Although the work expresses some of his Cubist ideas, including elements painted from different angles on one flat picture plane, it also features bold, bright colours, harmonious, curvilinear lines and an underlying eroticism. Picasso produced a sequence of portraits of Marie-Thérèse from 1931 to 1932 in his studio at the Château de Boisgeloup, when she was twenty-two years old and had embarked on a long-term relationship with the fifty-one-year-old artist. As in almost all his paintings of her, she is portrayed as a series of sensuous curves and lyrical circular shapes. Even the arms—both hers and those of the chair—have been exaggerated to echo the rounded forms of her body. Picasso has painted the lilac-coloured left hand to vaguely resemble the wing of a dove, because he sometimes associated her with the symbol for peace and love. These paintings of Marie-Thérèse instigated the acrimonious break-up of Picasso's first marriage. In contrast, the imagery symbolizes procreation, sexuality and happiness. The face, almost heart-shaped, can be read as a double portrait: it is both Marie-Thérèse's face and Picasso's profile kissing her on the lips.

Influenced early on by Edvard Munch and Henri de Toulouse-Lautrec, Picasso soon began responding to Paul Cézanne, Henri Rousseau and several Old Masters, as well as primitive art. After developing Cubism with Braque, he initiated innumerable creative directions, establishing himself as a profound and far-reaching influence on modern art's evolution.

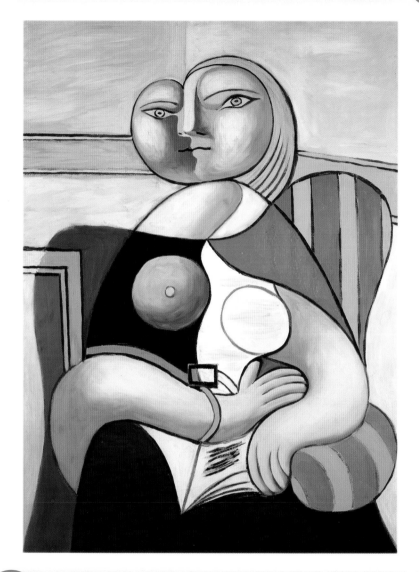

Picasso famously said: 'It took me four years to paint like Raphael, but a lifetime to paint like a child,' and 'Every child is an artist. The problem is how to remain an artist once we grow up.' His intention with this work was for it to appear innocent and childlike, but he also incorporated several complex and advanced ideas that a child could not have conceived, such as painting from several angles at once and mixing diverse styles.

Parisian-born Fautrier studied art briefly in London and worked as both a painter and sculptor, creating abstract images that bear strong yet often ambiguous resemblances to elements from the real world. Best known for his *Hostage* paintings, he used various expressive methods, including scumbling and heavy layering of vividly coloured paint with an almost dry brush, often thickened with plaster. Although he stayed detached from contemporary art groups and movements, his work influenced many others with their evocations of mystery, power and insight.

oil on paper
64 x 54 cm (25⅛ x 21¼ in.)
Private collection

HEAD OF A HOSTAGE
JEAN FAUTRIER
1944

While studying art in London, Jean Fautrier (1898–1964) was inspired by the paintings of J. M. W. Turner. In 1917, he returned to France to serve in the army, but was discharged in 1921 because of poor health. During World War II, he joined a Resistance circle of writers, poets and artists in Paris and consequently he was arrested by the Nazis in 1943. When a friend intervened, Fautrier was released and immediately withdrew to a mental asylum in the Paris suburbs. However, the Nazis used the forest surrounding the asylum to torture and execute prisoners and, although their actions were out of sight, he could hear the screams of the victims. From 1943 to 1945, he produced a series of thirty-three paintings and bronzes that became known as *The Hostages* (*Les Otages*) to express the revulsion and anguish he felt. Semi-abstract, distorted and disturbing, the works are symbolic representations of victims of war. This painting was made from a thick layer of plaster, which was then built up further with daubs and layers of paint, applied roughly with a palette knife on thinly scumbled paint. The lone head, severed from its body and set on a dark, dusty background, suggests the brutality of Nazi atrocities and is an enduring and powerful testimony to the violent acts of horror that Fautrier heard but did not see.

Head of a Hostage, 1943–44
Tate Collection, London, UK

Head of a Hostage, No. 1, 1944
Museum of Contemporary Art,
Los Angeles, CA, USA

Head of a Hostage, 1945
Centre Georges Pompidou,
Paris, France

Fautrier worked in isolation and was not connected to any groups, but he is often described as one of the forerunners of Art Informel and one of the most important practitioners of Tachisme. Both terms describe a wide range of abstract art predominant in the 1940s and 1950s in Europe. Fautrier influenced many other artists, particularly Jean Dubuffet.

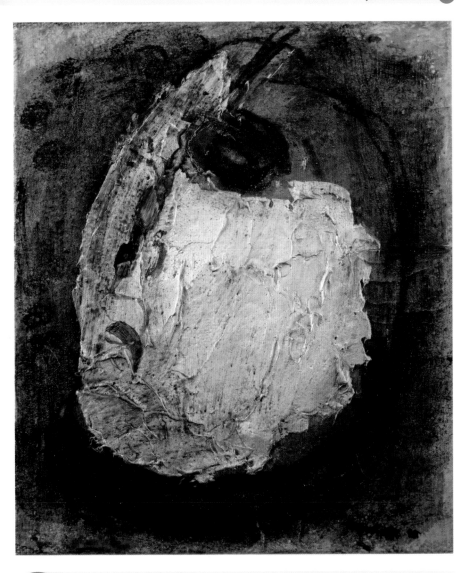

When the background story of this painting is told, it ceases to look like a misshapen blob that a young child might have painted. The formlessness of the image becomes emotive and tragic: the deliberately disfigured image a mature visual description of the brutality of war and a powerful evocation of a victim of mass murder. No child could produce such a painfully expressive work.

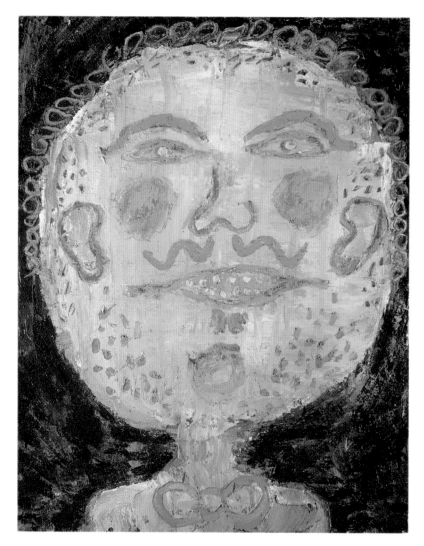

Dubuffet was not only attracted to the art of children, he also consciously determined to paint like them, with simple, unaffected lines and marks, as free from intellectual and academic concerns as possible. He believed that spontaneous and childlike art was more honest and expressive of true emotions or visions than conventional, skilfully executed art. Dubuffet would have been delighted if viewers thought a five-year-old could have produced *Dandy*, because that was exactly his goal.

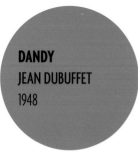

DANDY
JEAN DUBUFFET
1948

Although he studied painting as a young man, Jean Dubuffet (1901–85) soon abandoned art, returning to it in 1942 at the age of forty, when he started to collect what he called ugly art, or *Art Brut* (raw art). This was art created by children and others who were untrained in traditional techniques. From about 1945, he began visiting mental institutions to collect art produced by psychiatric patients. In 1948, when he painted this portrait, he was already known for his disparagement of traditional artistic values, skills and approaches, and for his preference for the simplistic and naive styles of children, the untutored and the insane, which he believed incisively expressed meaning without speciousness. He also promoted 'anti-art', instigated by the Dadaists during World War I as they tried to discredit traditional concepts of art. A man of exceptional intelligence, Dubuffet caused outrage with his art. This face, created with impasto paint and a vehement, childish vigour, reveals his bold rebelliousness and his sardonic sense of humour. For Dubuffet, the rawness of the image, with its crudely depicted features, made the painting more perceptive than any analytical or technically finished work. Although other post-World War II artists shared many of his ideas, none were as fascinated as he was by the truths that could be revealed by unaffected, unrefined art.

Using coarse textures and what appeared to be derisively childlike depictions, Dubuffet explored many approaches with a variety of materials, including cement, tar, gravel, foil and dust. He was looking to express unadulterated feelings, but in the aftermath of two world wars he was also suggesting that society should accept its failings and begin to rebuild itself once more.

By 1945, Dubuffet created his *hautes pâtes* (matter paintings) of reduced colour on thick paste surfaces of tar, asphalt and lead.

oil on canvas
92 x 73 cm (36⅛ x 28¾ in.)
Private collection

Inspired originally by Jean Fautrier, Dubuffet referred to his own anti-aesthetic, naive style as *Art Brut* (raw art); it is often also referred to as Outsider art. The idea that art could be freed from conventional constraints in this way influenced many other artists, including Julian Schnabel and Georg Baselitz.

Joë Bousquet in Bed, 1947
Museum of Modern Art,
New York, USA

Propitious Moment, 1962
Solomon R. Guggenheim
Museum, New York, USA

Vicissitudes, 1977
Tate Collection, London, UK

With his expressive, gestural style, de Kooning was the best known of the Abstract Expressionists after Jackson Pollock. Although he produced many abstract works, he was most known for his distorted paintings of women that feature free, sweeping and fairly aggressive brushstrokes. He frequently reworked his canvases and left them unfinished to suggest dynamism and ambiguity.

Deciding it was a failure, de Kooning nearly destroyed this work before he finished it.

oil on canvas
192.5 x 147.5 cm (75⅝ x 58 in.)
Museum of Modern Art,
New York, USA

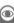

Woman V, 1952–53
National Gallery of Australia,
Canberra, Australia

Woman VI, 1953
Carnegie Museum of Art,
Pittsburgh, PA, USA

The Visit, 1966–67
Tate Collection, London, UK

WOMAN I
WILLEM DE KOONING
1950–52

Woman I is the first of a series of six paintings made by Willem de Kooning (1904–97) between 1950 and 1953 that depict a female figure. Although the painting looks spontaneous, de Kooning worked on it intermittently over many months, adding and scraping off paint, then abandoning and returning to it. The paint is alternately thick and thin, rough and slick, opaque and translucent. When de Kooning exhibited this with his other five 'Woman' paintings for the first time in March 1953, many artists and critics were dismayed that he had betrayed the ideals of abstraction. However, the female figure was his way of both linking and contrasting his work with established artistic traditions. As he said, 'Flesh is the reason oil paint was invented.' The seated woman, with her threatening gaze and ferocious grin, appears as a hybrid of several female archetypes, from a Madonna to a Palaeolithic fertility goddess and a 1950s pin-up. De Kooning said that the Mesopotamian figurines at the Metropolitan Museum in New York inspired him, with their wide eyes, smiles, prominent breasts and tapering arms. The grinning mouth is thought to derive from his habit of cutting out mouths from photographs in magazines and attaching them to his work.

Inspired by numerous artists from Peter Paul Rubens to Pablo Picasso, de Kooning maintained that Arshile Gorky had the greatest influence on him. He said: 'I met a lot of artists, but then I met Gorky.' Labelled an Abstract Expressionist, he fused Cubism, Surrealism and Expressionism with his action paintings and influenced many others, including Robert Rauschenberg, Franz Kline and Cecily Brown.

? Absurd and angry-looking, *Woman I* is built up with emotive marks and jarring colours. There is no attempt to portray depth. The ludicrously large eyes, strange, gaping mouth and massive body appear like a parody, as one would expect from a small child. But no child would paint in this way to emphasize the process of art while identifying with man's repressed sexual desires, as de Kooning did. Abstract Expressionism aimed for non-objective themes; de Kooning deliberately defied that notion.

Frequently likened to a child's doodles, this scribbled image, which remained stubbornly at variance with US art after World War II, appears easy enough for a young child to have done. Yet the spare, messy and often indistinct scribbles were not created through a lack of skill or understanding of depth. They are an exploration of human existence, reflecting on and connecting with classical art and literature. This challenging and reflective existential element was contrary to the confident approach of the Abstract Expressionists.

oil-based house paint, lead pencil, coloured pencil and wax crayon on canvas
200 x 264 cm (78⅝ x 103¾ in.)
Private collection

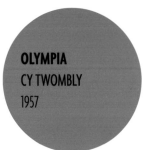

OLYMPIA
CY TWOMBLY
1957

Fascinated by classical antiquity, Cy Twombly (1928–2011) rejected the ideas of prevalent art movements, although he was influenced by Franz Kline's gestural Expressionism and Paul Klee's childlike imagery. In 1952, he travelled to North Africa, Spain, Italy and France, and on his return to the United States in 1953 he served in the army as a cryptologist. From 1955 to 1959, he worked in New York and Italy, finally settling in Rome. It was during this period that he produced *Olympia*, drawing inspiration from cryptology, poetry and mythology, and expressing it in his own invented vocabulary of signs and marks, which include some legible text and numbers. The white canvas is covered with scribbles and scratches in crayon, pencil and paint, as Twombly aimed to contradict viewers' conventional appreciation of art, and blur established distinctions between drawing and painting. Almost inscrutable, the marks resemble graffiti in a public toilet, but also allude to motifs and legacies of classical history, as can be discerned in words such as 'Roma' and 'Amor', which can just be deciphered as the eye is drawn around the work.

Twombly was inspired by the gestural brushstrokes and compositions of action painters, and by Dada and Surrealism. His unique style made him a major figure in the international art world and a huge influence on Neo-Expressionism.

The Song of the Border-Guard, 1952
Tate Collection, London, UK

Untitled, Rome, 1960
Solomon R. Guggenheim Museum, New York, USA

Filled with references to his adopted home as well as to a broader classical tradition, Twombly's art alludes to legends, Renaissance artists and places or events in Italy. He continuously reinvented his technique, experimenting with fine pencilled lines and thick paint to cross boundaries between high and low art, considering the process of writing and sketching words and codes directly and spontaneously on to his canvases. He developed his large-scale scribbled style after working in the army as a cryptologist.

Baselitz works as a sculptor and a painter. His sculptures are often uncompromisingly and jaggedly carved, usually in wood such as maple, beech or cedar. He paints large, disquieting, energetic and colourful works, which are perceived as insightful, not necessarily for their subjects, but for the manner in which they are created. With his focus on distortion, assured handling of paint and strong colours, Baselitz became known for painting inverted images, ignoring the realities of the physical world so that viewers would consider the paint application before the subject.

charcoal and synthetic
resin on canvas
249 x 200 cm (97⅞ x 78⅝ in.)
Museum of Modern Art,
New York, USA

Rebel, 1965
Tate Collection, London, UK

The Lamentation, 1983
Museum of Fine Arts,
Houston, TX, USA

*Volkstanz—Marode
(Folkdance—Tired)*, 1989
National Gallery of Modern
Art, Edinburgh, UK

WOODMEN
GEORG BASELITZ
1967–68

During the early 1960s, Georg Baselitz (1938–) began producing representational images, characterized by thickly painted surfaces and often emotional themes, that drew inspiration from Germany's artistic and cultural heritage. Between 1967 and 1969, he executed a series of 'Fracture Paintings', in which he painted his subjects, which included animals, shepherds and woodsmen, in irregular, broken fragments. Seemingly standing on his head against a tree trunk, the upside-down woodsman here was one of the first of Baselitz's inverted figures. The painting evokes the confusion and insecurities that Germans experienced after their war-damaged nation was partitioned in 1946. Baselitz painted this after he left the divided city of Berlin to live in a small village. Disparaging his own skills, he once termed his technique a 'non-style'. However, the upside-down, fragmented figures and emotive brushstrokes that expressed the feelings of a nation became highly recognized and admired. The work was produced at a time when German society was rebuilding itself in the image of US consumerism, and it represented a refusal to conform. The style of painting expressed much of what the Nazis had prohibited, and it also can be seen as a protest against aspects of modern life.

Influenced by African sculpture, Mannerism and artists including Edvard Munch, Jean Fautrier, Jean Dubuffet and his teacher Hann Trier, Baselitz pioneered Neo-Expressionism, a raw, aggressive approach that followed the earlier German Expressionist movement, gaining momentum in the 1970s in reaction against Conceptual art and Minimalism.

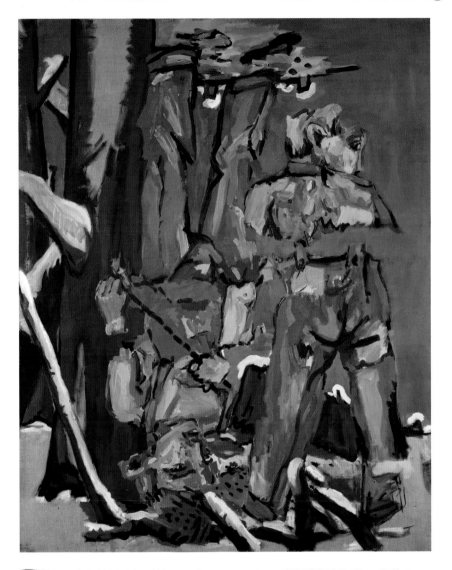

? The figures are fractured, and one is upside-down—ostensibly something a child might have done. Baselitz, however, was confronting the modern world. He believed that the dominant abstract art movements of Minimalism and Conceptual art were ineffective. His broken, inverted images aimed to stress the artifice of art and draw attention to the application of paint rather than the subject.

P.O.TH.A.A.VFB
DIETER ROTH
1968

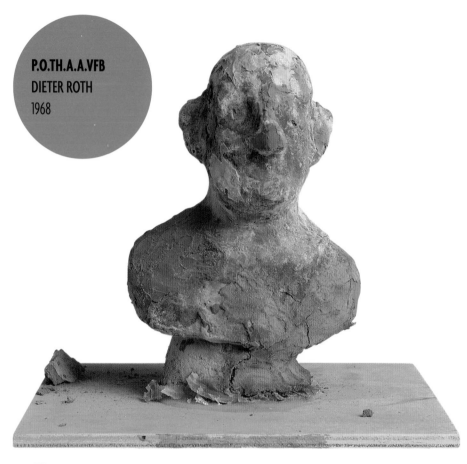

? This odd-looking bust is a self-portrait of the artist
made out of chocolate and birdseed. While countless
children would love to make their own heads out of
chocolate, this work was created to satirize established idealistic
notions about art, including paintings and sculpture attaining
iconic status, the veneration of individual artists, and inflated
esteem for traditional materials—such as oil paints, marble and
bronze—and to mock viewers for their acceptance without
questioning. Just as a child would play with banal materials such
as modelling clay, here Roth has transposed traditional media
with chocolate to ridicule artistic conventions and snobbery.

ⓘ chocolate cast
with birdseed
additions
c. 21 x 14 x 12 cm
(8¼ x 5½ x 4¾ in.)
installation

In 1968, Dieter Roth (1930–98) placed a bust of himself made of chocolate and birdseed in a garden where it was pecked apart by birds. The work became known as *P.o.th.A.a.Vfb*, an acronym for *Portrait of the Artist as Vogelfutterbüste* (birdseed bust, in German). Roth was intentionally drawing attention to the transitory nature of art, while parodying and mirroring society's opinions of it, and considering how people venerate some traditional art, often without any deep or individual thought. This self-portrait depicts the thirty-eight-year-old artist as an old man, and highlights the way artists are frequently held in the highest regard whether they deserve to be or not. The title also derides the highly respected novel by James Joyce, *Portrait of the Artist as a Young Man*, which Roth controversially dismissed as mawkish. In line with the Dadaists, Roth aimed to reduce art to a basic level, to break down invisible barriers and pretentious attitudes towards it. Much of his other work was also made out of food, such as chocolate, cheese, spices, sugar or bananas, and left to rot, and he produced books that were left for viewers to rearrange as they chose. He used chocolate frequently, to connote naive, childlike delight, but also treated it as a menacing, claustrophobic substance that would decay. This installation was one of his 'multiples'— almost identical artworks made of unconventional materials that he produced during the 1960s. He had thirty copies cast in chocolate and birdseed, each one intended to be placed in gardens and devoured by birds.

Roth trained as a commercial artist but soon began making other forms of art. As well as being a graphic designer, he worked as a sculptor, poet and musician, producing sculpture, installations, videos and books, and was also known for his book illustrations. Roth's work constantly evolved, thus resisting categorization. Time and chance were his main considerations. In order to explore these themes, he often produced art that decomposed or disintegrated.

In 1970, in his first US exhibition, Roth created a scandal with thirty-seven different types of case, each stuffed with smelly cheese.

Roth was inspired by Dadaism and originally experimented with Constructivist and Op art ideas. Although associated with the avant-garde movement Fluxus and also with Conceptualism, Pop art and its European counterpart Nouveau Réalisme, he did not conform to any one description or group. His collaborators included Daniel Spoerri, Robert Filliou, Arnulf Rainer and Richard Hamilton.

3 Knights, 1970
Tate Collection, London, UK

Retouched Clothes Picture, 1984–87
Dieter Roth Museum, Hamburg, Germany

Tablemat, 1991–98
Dieter Roth Museum, Hamburg, Germany

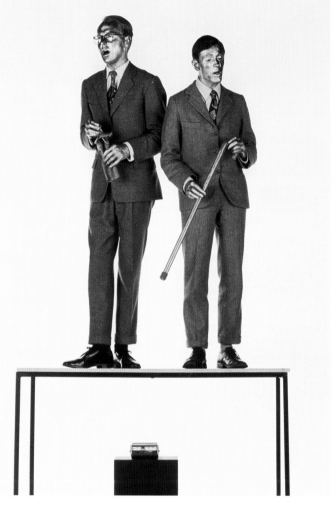

? Many children would love to stand on a table, with their faces and hands covered in bronze powder, and sing along and dance for an audience. However, Gilbert & George were seeking to communicate more than just movement. By making what they describe as 'Art for All', they aim to communicate globally, to use a universal language that reaches people from all races and backgrounds, which can be interpreted by anyone, no matter what their outlook or experiences, so effectually breaks down barriers between individuals, nations and societies. In their own words: 'Art for All'.

SINGING SCULPTURE
GILBERT & GEORGE
1969

When Gilbert (1943–) and George (1942–) stood together on a table in 1969, moving and singing along to a song written in 1931 by Flanagan and Allen, they became living art. The song, 'Underneath the Arches', is about the pleasures of sleeping rough, relayed by two tramps. For their presentation, Gilbert & George coated their heads and hands in multicoloured metallic powder and wore tailored suits that have since become their trademark. Through the suits (which they call 'Responsibility Suits'), the song and their movements, they evoked the atmosphere of pre-war British music halls, while at the same time relating to the peripheries of society as described in the lyrics. They presented *Singing Sculpture* all over the world, sometimes for eight hours at a time. Subsequently, through their art and their daily routines, immaculate attire and haircuts, they have continued projecting themselves as 'Living Sculptures', thus sacrificing their separate identities, revoking differentiations between art and the artist, and inverting the notion of creativity. Inspired by London's East End, Gilbert & George's art remains multilayered and deadly serious. At the same time it explores universal themes such as death, life, hope, fear, sex, poverty, religion, identity and youth culture, and reflects their belief that art can break down barriers and taboos.

Gilbert & George have said: 'We believe very much that art is about re-inventing life. How we walk, how we speak, how we behave . . . That is art. That is creative . . . Art is about having new ideas. We don't care who or what it actually is, as long as it is re-inventing something.' Known for their large coloured pictures—incorporating text and grids—that were made originally with conventional darkroom facilities but more recently are created digitally, Gilbert & George refer to all their art as pictures.

Life without End, 1982
Williams College Museum of Art, Williamstown, MA, USA

Nineteen Ninety-Nine, 1999
Museum Moderner Kunst Stiftung Ludwig Wien, Vienna, Austria

Fates, 2005
Tate Collection, London, UK

Gilbert & George, handmade suits, metallic paint, table, recording by Flanagan and Allen, first performed in Cable Street, London, UK

Although their work has been compared to that of artists such as Marcel Duchamp, Yves Klein and Joseph Beuys, and they have been categorized variously as Conceptualists, Minimalists and Performance artists, Gilbert & George acknowledge no artistic influences and remain elusively unclassifiable.

MOUSE ON A TABLE

KAREL APPEL

1971

A painter, ceramicist sculptor, graphic artist, designer and poet, Appel is regarded by many as the most powerful of the post-war generation of artists from the Netherlands. He works in an Expressionist style, and his art appears illogical, childlike and ingenuous—brash, clashing colours, paint often squeezed straight from the tubes, and fast, frenzied brushwork. Relief paintings and sculptures made from painted wood, aluminium and used materials form a large part of his oeuvre, and he also produced colourful ceramics, carpets, stained glass and set designs.

Karel Appel (1921–2006) was a founder member of CoBrA, an artists' group that was established in Paris in 1948. CoBrA artists aimed to challenge the formal, geometric styles that were popular at the time, to work spontaneously and to emphasize expression, abstraction and fantasy. Artists involved in the group included Asger Jorn (from Copenhagen), Joseph Noiret and Christian Dotremont (from Brussels), and Constant, Corneille and Appel (from Amsterdam). Copenhagen, Brussels and Amsterdam gave them the name 'CoBrA'. Although the movement ended within three years, the sentiment of peering into the human psyche through art remained with Appel throughout his career. *Mouse on a Table* follows the theory of working in the free, impulsive spirit of children unrestrained by adult concerns, to stimulate imaginations and interpretation. He wanted viewers to experience diverse feelings, such as a sense of spirituality, warmth or fear. Taking ideas from several other artists, including the biomorphic shapes of Hans Arp and Willem de Kooning, Appel initially focused on painting but later turned to sculpture. The friendly colours of this sculpture, loosely based on the image of a cartoon mouse, contradict the grotesque undertones created by the distorted, grimacing features.

aluminium with car enamel
269.5 x 177 x 120 cm
(105⅞ x 69½ x 47⅛ in.)
Private collection

People, Birds and Sun, 1954
Tate Collection, London, UK

Chanteurs de Rue, 1964
Didrichsen Art Museum,
Helsinki, Finland

Aggressive Personality, 1967
Ludwig Museum of
Contemporary Art,
Budapest, Hungary

Inspired by Pablo Picasso, Henri Matisse and Jean Dubuffet, Appel is often linked with Art Informel, a loose term for a range of abstract art prevalent during the 1940s and 1950s that focused on spontaneity and emotion. He was also highly influential to Neo-Expressionism, which began as a German art movement in the early 1960s.

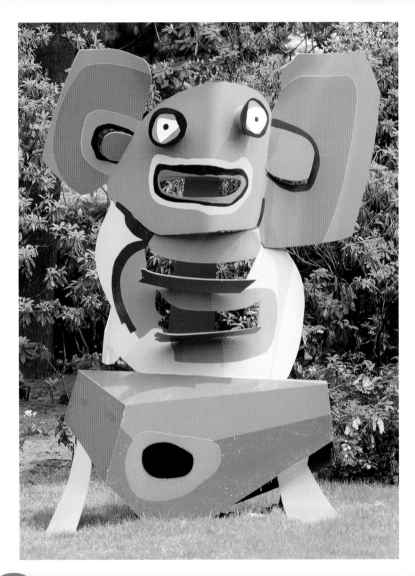

'My art is childlike,' Appel declared. In this spirit, he created this work to look as if a child had made it. It is a characteristic example of his uninhibited, sometimes alarming style, which incorporates discordant colours and powerful forms, and conjures impressions of nonchalance and artlessness. Although the work could be perceived as abstract, certain elements suggest an animal or a distorted cartoon.

VERTICAL ROLL
JOAN JONAS
1972

Jonas started her career in the United States in the 1960s, when several artists were mixing painting, sculpture, music and film, and when Performance art was relatively new. Initially, she drew on many diverse influences to investigate both meaning and the methods by which she communicated ideas. Exploring concepts such as ritual, myth, perception, the body, gesture, thought processes and attitudes, she began to exploit video technology during the late 1960s. She used it as a tool for drawing, evoking thoughts and reflections, and for presenting herself and her concepts through fragmented images that intentionally provoked viewers' reactions.

Joan Jonas (1936–) began creating videotapes when new technology made the practice relatively easy and affordable. Drawing on literary, theatrical and musical influences, as well as ideas that were emerging from the New York avant-garde art world, she employed various special effects. In *Vertical Roll*, she presented a stream of consciousness, displaying dislocated sections of her body on a fractured, endless roll of footage. She appears on screen between black horizontal bars, sometimes clothed as her quirky alter ego—showgirl Organic Honey—sometimes naked, sometimes vertically aligned and sometimes horizontally. Occasionally she is viewed as a whole, but more often she appears simply as a pattern of moving arms, legs or torso. While the vertical roll continues, her movements and gestures change constantly: she appears masked, wearing a feathered headdress and in a belly dancer's costume. The entire staccato work highlights ways in which women are portrayed in society and, particularly, how men are traditionally invited to view them. In the final moments, Jonas looks directly at viewers—free of make-up and emotionless—and the vertical roll continues behind her. It appears as if her head is being hammered down.

Mirror Piece, 1969
Solomon R. Guggenheim Museum, New York, USA

Songdelay, 1973
San Francisco Museum of Modern Art, CA, USA

Volcano Saga, 1989
Museum of Modern Art, New York, USA

Jonas helped to pioneer Performance art and was inspired by several people and ideas, including James Joyce, US Imagist poets, Jorge Luis Borges, Japanese Noh and Kabuki theatre, Happenings, John Cage and Jack Smith. During the 1970s, she developed her alter ego, Organic Honey, a move that subsequently influenced a number of artists, including Cindy Sherman and Matthew Barney.

ⓘ videotape
running time: 19:38
minutes
Museum of Modern
Art, New York, USA

⚠ Inspired by the Happenings of such artists as Claes
Oldenburg, Jonas stopped producing sculpture in the mid-
1960s and made a radical move to work as a Performance
artist. After living in a village on the island of Crete for a
year, she began to utilize influences of ancient history,
culture and literature.

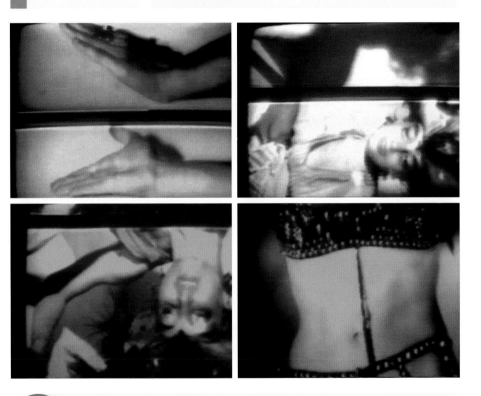

❓ This footage, accompanied by discordant, homemade sounds, resembles
something a child might produce if they took hold of a video camera without
knowing how to use it. Yet through the use of deceptively sophisticated imaging
techniques, Jonas has condensed time and space deliberately: the disjointed images, the
broken horizontal black bar, the incessant, incoherent noises. Drawing on literary and
musical innovations of the previous fifty years, she was concentrating on the mesmerizing
effects of film and on isolating society's attitude towards women in particular.

At the start of his career, Guston worked as a figurative painter, but by the early 1950s he had become interested in mural painting and began to produce abstract works. As his paintings were subtler and more understated than the work of most other Abstract Expressionists, they were described by one journalist as 'Abstract Impressionism'. Persistently restless, however, by the late 1960s he returned to figurative painting and expressed the traumatic personal and external experiences that affected him as he grew up with crude, bizarre and cartoon-style imagery. His paintings strongly echo elements of the comics that he read when he was a boy, and his savage brushwork and inscrutable narratives are suggestive of various themes, including fear, racism and violence.

IN THE STUDIO
PHILIP GUSTON
1973

Philip Guston (1913–80) refused to conform to accepted styles of art and gained notoriety for his late work. He believed that his raw, comic style communicated more directly with others who had grown up in the post-World War II consumerist society than his earlier abstract paintings. Intentionally clumsy in its execution and reminiscent of images from boyhood comics, *In the Studio* depicts several of Guston's recurring symbols, including a light bulb, easel, lampshade, boot and the suggestion of a head. The image evokes his studio, and the red-browns imply blood and death. He was responding to events, including the Holocaust and the Vietnam War, political turmoil, social discontent and his personal experiences of prejudice. As the youngest of seven children in a Jewish family who had fled to the United States from Russia, he saw his father struggle to find work and witnessed racism in the expanding Ku Klux Klan. At the age of ten, he found his father's body; he had hanged himself. Seven years later, an older brother had both legs amputated after a horrific accident and died soon after the operation. Uneasy and uncomfortable, this work expresses many of these traumas simultaneously.

Originally inspired by Mexican Muralism, American Scene Painting and Regionalism, Guston became a key exponent of Abstract Expressionism from 1967. Three years later, contrary to prevailing attitudes, he abandoned abstraction and returned to a figurative style, producing apparently tasteless and unrefined paintings. He subsequently influenced Neo-Expressionism and a number of artists, including Julian Schnabel and Sean Scully.

Gladiators, 1940
Museum of Modern Art,
New York, USA

For M, 1955
San Francisco Museum
of Modern Art, CA, USA

oil on canvas
122 x 137 cm
(48 x 53⅞ in.)
Private
collection

Guston initially shocked the art world with his post-1970 figurative paintings based on comics, but in erasing boundaries between abstract and figurative art his work suggested how gestural painters could address Pop culture.

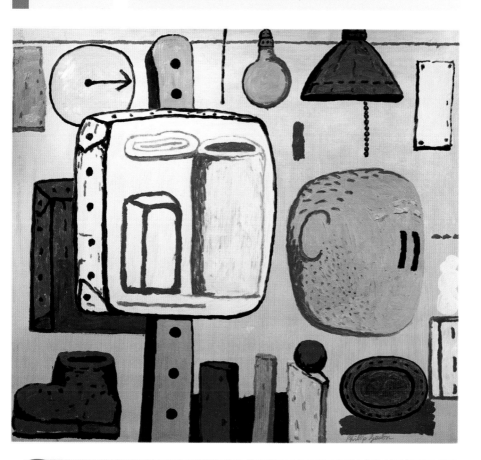

The rough brushstrokes and bizarre group of objects, crudely and inelegantly painted, resemble a child's painting. However, with a limited palette and little attempt at depicting reality, Guston aimed to express something unrefined, sinister and obscure that embodied some of his own harrowing life experiences, and encouraged viewers to consider darker elements of the human condition.

? Like specimens in a museum, these twelve large, mirrored glass bottles standing in a line are labelled with the names of different bodily fluids. However, the labels mean nothing—the bottles are empty. Any child could stand several bottles in a straight line and pretend that they contain something. They would not, however, be exploring themes of mortality, as was Smith.

In her investigations concerning the human body, Smith employs various materials, including beeswax, glass, clay, fabric and paper to create sculpture, prints, installations, drawings and even books, fusing craft-based and conceptual techniques.

After working briefly as an emergency medical technician, Smith began creating life-size, lifelike human figures from beeswax.

silvered glass water bottles
each bottle 52 cm
(20³⁄₈ in.) high
29 cm (11³⁄₈ in.) diameter
Museum of Modern Art,
New York, USA

UNTITLED
KIKI SMITH
1987–90

Using the body as a metaphor for various aspects of existence, Kiki Smith (1954–), daughter of the Minimalist sculptor Tony Smith, produced this work, among several others, to explore the concept of bodily fluids as an imperative part of the balance between the human psychological and physiological experience. After seeing her sister die of AIDS, Smith concentrated on the human body, at a time when most other artists focused on human consciousness. In this work, the suggestion of what these bottles might hold is the key element to the work, rather than the objects themselves. The engraved Gothic lettering on each bottle identifies its contents as bodily fluids, from semen, saliva, blood and tears to pus, urine and vomit. The contents can be envisaged as both life-sustaining and disease-enhancing, and they also exemplify the continuation of life. Smith declared that the piece was inspired by the Book of Hours, a medieval, Christian devotional book that provided thoughts for meditation—'something you could think about or believe in'—for every hour of every day. By reinvestigating the body and bodily processes, Smith chose to represent 'fluids everyone knows about that come out of the body' to provoke thoughts about elusive religious beliefs and our understanding of existence. The intimate, internal processes that form the bodily fluids also force viewers to consider physical frailties.

Ribs, 1987
Solomon R. Guggenheim
Museum, New York, USA

Standing, 1998
University of California,
San Diego, CA, USA

Citing Asian art as a dominant influence, Smith also says she was inspired by other female artists such as Louise Bourgeois, Eva Hesse, Frida Kahlo, Lee Bontecou and Nancy Spero. She is usually classed as a feminist and a Conceptual artist.

PORTRAIT OF R. HUBER

THOMAS RUFF

1988

Since the early 1980s, Ruff has experimented with photography, working on small and massive scales—in black and white and colour—capturing landscapes, buildings, interiors and people. His early portraits were monochrome, but he later started working in colour, and from 1986 he began experimenting with large formats. In the 1990s, he also enlarged newspaper photographs, used a night-vision enhancer to render images of night-time streets and produced series of digitally manipulated photographs of nudes, Japanese manga cartoons and Mies van der Rohe's modernist architecture.

In 1980 Thomas Ruff (1958–) began a series of photographic portraits of friends and fellow art students. Viewing the nature of photography as inherently unreal, he consciously avoided the traditions of portrait photography and evaded all attempts to create a 'story' or reveal his subjects' personalities. He aimed for complete neutrality and detachment—contradicting conventional expectations that portraits should provide psychological illumination. Every sitter was photographed sitting on a stool, wearing ordinary clothes, facing the camera with impartial expressions and bathed in flat, uniform lighting. Sharp and finely detailed, the images are deliberately comparable with passport photographs. The lack of information and the greatly enlarged dimensions obscure any emotional evaluation or revelation of an underlying personality. Although each portrait is identified by name, the subject remains anonymous in a manner similar to documentary photography. Ruff explained: 'I wanted to do a kind of official portrait of my generation . . . I wanted to blot out any traces or information about the person in front of the camera. I also wanted to indicate that the viewer is not face-to-face with a real person, but with a photograph of a person. I did not want the photograph confusing viewers with reality.'

 C-print
24 x 18 cm (9½ x 7 in.)
David Zwirner Gallery, New York, USA

 Portrait (Stoya), 1986
Tate Collection, London, UK

H.t.b.03, 1999
Art Institute of Chicago, IL, USA

Portrait (M. Roeser), 1999
Solomon R. Guggenheim Museum, New York, USA

Like fellow students from the Academy of Fine Arts in Düsseldorf—Andreas Gursky, Candida Höfer and Thomas Struth—Ruff was strongly influenced by his teachers, Bernd and Hilla Becher. Technically efficient, his conceptual work also reveals influences of other artists, such as the photographer Walker Evans.

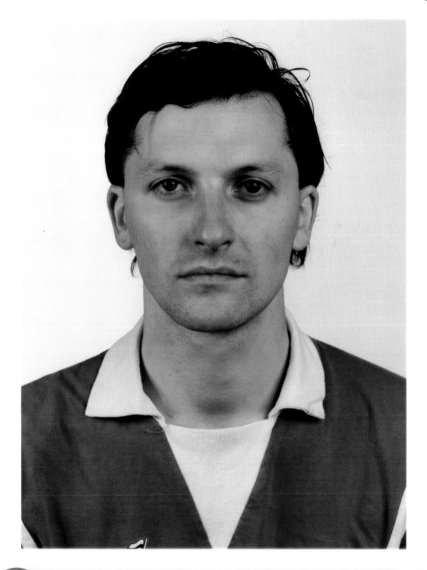

This straight-faced photograph of a person facing the camera directly, with no attempt at evoking atmosphere or emotion, looks like the type of picture anyone could take, even a young child. However, unlike most snapshots of friends and family, this high-resolution, starkly real and deceptively complex image was taken in an effort to deconstruct the portrait genre and to explore impartiality.

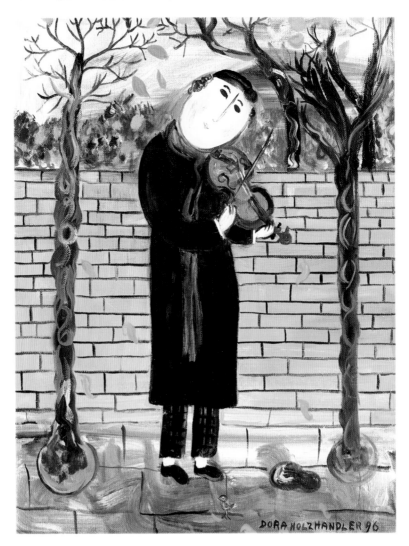

? Recognizing how Holzhandler's childlike style disguises her mature
perceptiveness, the art critic Eric Newton wrote of her work in 1962: 'These
are pictures invented by a mother but painted by a child—a sophisticated but
immensely amiable child.' The novelist Edna O'Brien also wrote: 'Dora is that rare thing—a
mother and child in one; as an artist she captures the apparent simplicity of life and
infuses it with a depth I find eerie.' A child could not paint with such subtle complexity.

THE VIOLINIST
DORA HOLZHANDLER
1996

Dora Holzhandler (1928–) was born in Paris to Polish refugee parents. She paints from her imagination, and her work recalls childhood memories of being fostered by a Catholic farming family in Normandy, returning at the age of five to live with her poor, extended Jewish family in Paris, and then moving in 1934 to London's East End. Families, children and lovers are favourite themes. Her vibrant colours and deliberate shunning of perspective, tone and lifelike proportion result in images that are not dissimilar to medieval manuscripts. The fresh, simplistic pictures have also always been infused with hidden depths, as she says: 'All my paintings have esoteric secrets in them.' The subject of this work recalls her beloved maternal grandfather, Solomon, who died in Auschwitz during World War II. Standing against a wall, the mild-faced busker plays his violin. He is no longer young and is probably lonely. There are no coins in his cap. The painting is emotive, but also detached. The violinist's situation is echoed by the autumnal leaves that fall around him and the solitary bird at his feet. Through the suggestion of a haunting violin melody, Holzhandler evokes memories of her own heritage and the violinist's childhood, and exposes his lost hopes for the future.

Holzhandler describes herself as 'a mystic, proud of my Jewish origins'. She is fascinated by traditions within Judaism, as well as Christianity, Buddhism, Hinduism and Islam, and she includes elements of these in many of her works. All her paintings feature details, colours and patterns that emphasize the flatness she seeks. She explains how she works intuitively: 'You have to be in quite a meditative state. It's very magical. You have the empty canvas. Once the picture has begun, it's a question of just finding it. The picture is telling you what to do, as it were.'

oil on board
45.5 x 35.5 cm (17⅞ x 14 in.)
Private collection

Although Holzhandler's work has been influenced by her personal life, it has also been inspired by Persian miniatures, Byzantine mosaics, Oriental watercolours, the artists Amedeo Modigliani, Chaïm Soutine, Marc Chagall, Henri Rousseau, Henri Matisse and Pablo Picasso, and the writers Charles Baudelaire, Arthur Rimbaud, Isaac Bashevis Singer and Jacques Prévert.

The Library, 1984
Rona Gallery, London, UK

Ice-cream Vendor, Menorca, 1986
Rona Gallery, London, UK

A Mother Buying Bagels, 1993
Museum of London, UK

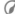

Reflecting contemporary culture, Maloney expresses concepts of greed, materialism and domesticity.

With its thick, smooth paint, rejection of perspective and almost palpable energy, Maloney's art celebrates the ordinariness of people in general and reveals his astute and witty observations of contemporary culture.

Crooked lines, streaky paint, bright colours and little attempt at tonal variation or perspective: these can be seen in children's paintings anywhere. Yet the infantile, awkward marks in *Sony Levi* have been intentionally applied by Maloney to be childishly endearing, banal and amusing, in an effort to reflect aspects of the media-led and consumerist society at the end of the 20th century.

oil on canvas
173.5 x 298 cm (68⅛ x 117⅛ in.)
previously Saatchi Gallery,
London, UK

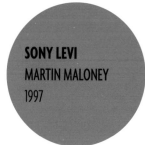

SONY LEVI
MARTIN MALONEY
1997

Destroyed during a fire in 2004 at the Saatchi Gallery where it was displayed, this work is typical of the artist's exuberant style. Martin Maloney (1961–) creates expressive, gauche, boldly coloured paintings that often appear trite and unsophisticated. He consciously paints clumsily to deflect viewers from his technical skills. With its skewed, lounging figure, listening to earphones and surrounded by misshapen objects, including a Sony sound system, a pair of roller blades and a game of Scrabble, this work refers directly to consumerism, but it is also full of humour and purposefully flouts all that has been revered in traditional art. The figure, although rendered guilelessly and imperfectly, remains recognizable, and the overall image is almost anecdotal, like a snapshot of an individual's life. For this, it can be compared to 18th-century genre paintings by such artists as Jean-Antoine Watteau or Jean-Honoré Fragonard, as it highlights 20th-century everyday life and the 'common man'. The pencil-on-paper preliminary study Maloney created for it is generalized, since he believes that, if he were to prepare for a painting in detail, he would lose the spontaneity, spirited brushstrokes and relaxed, harmonious and patterned compositions he ultimately achieves.

Equal Opportunities, 1999
Saatchi Gallery, London, UK

Planters, 2004
Saatchi Gallery, London, UK

Categorized as a Young British Artist (YBA) in 1997, Maloney has been inspired by various artists and styles, including Willem de Kooning, Cy Twombly, Edouard Vuillard, Georg Baselitz and Franz Marc.

A massive spider with spindly limbs looks a little like a class project in a primary school. Although this work is in bronze, the idea of making a giant spider seems childlike and lacking in the heroic implications of traditional sculpture. However, Bourgeois was examining her past, using myth, psychological references and memories of her mother.

bronze, marble and stainless steel
9.2 m (30¼ ft) high
several casts in temporary locations

Through investigations of emotions and memories, Bourgeois's work is both universal and personal. She first came to prominence in the 1940s with Surrealist-inspired work, and in the 1960s she influenced the burgeoning feminist art movement. Among others, she inspired Eva Hesse, Bruce Nauman and Lynda Benglis.

**MAMAN
LOUISE BOURGEOIS
1999**

The French-American artist Louise Bourgeois (1911–2010) created symbolic works of art expressing themes such as loneliness, conflict and vulnerability. *Maman* is a huge, 9-metre (30-ft) high sculpture of a spider, with a mesh sac under the body containing marble eggs. It is one of several spider sculptures that Bourgeois created in the late 1990s. *Maman* is French for 'Mummy', and this term of endearment used by a child for its mother was chosen deliberately for this work's title. Bourgeois's mother died when she was twenty-one, and this sculpture represents her mother as well as mothers' strength in general. Bourgeois said: 'The spider is an ode to my mother. She was my best friend. Like a spider, my mother was a weaver. My family was in the business of tapestry restoration, and my mother was in charge of the workshop. Like spiders, my mother was very clever. Spiders are friendly presences that eat mosquitoes. We know that mosquitoes spread diseases and are therefore unwanted. So, spiders are helpful and protective, just like my mother.' Although she emphasized the spider's positive traits, the dark, towering structure and pointed feet evoke more menacing associations, to represent more ambiguous aspects of motherhood.

Quarantania,
1947–53
Museum of
Modern Art,
New York, USA

Always at the forefront of new artistic developments, Bourgeois explored painting, printmaking, sculpture, installation and performance, using diverse materials including wood, stone, latex, rubber and plaster. She became renowned for her highly personal content, often involving mythological and archetypal imagery.

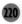

INDEX

PICTURE CREDITS

First published in the United Kingdom in 2012 by
Thames & Hudson Ltd, 181A High Holborn,
London WC1V 7QX

Reprinted in 2013, 2014, 2015

This book was designed and produced by
Quintessence
The Old Brewery, 6 Blundell Street,
London N7 9BH

Editors	Helen Coultas, Becky Gee
Designers	Tom Howey, Christine Lacey
Picture Researcher	Jo Walton
Production Manager	Anna Pauletti
Editorial Director	Jane Laing
Publisher	Mark Fletcher

British Library Cataloguing-in-Publication Data
A catalogue record for this book is available from
the British Library

ISBN 978-0-500-29047-7

Printed in China

To find out about all our publications, please visit
www.thamesandhudson.com.
There you can subscribe to our e-newsletter, browse or download
our current catalogue, and buy any titles that are in print.